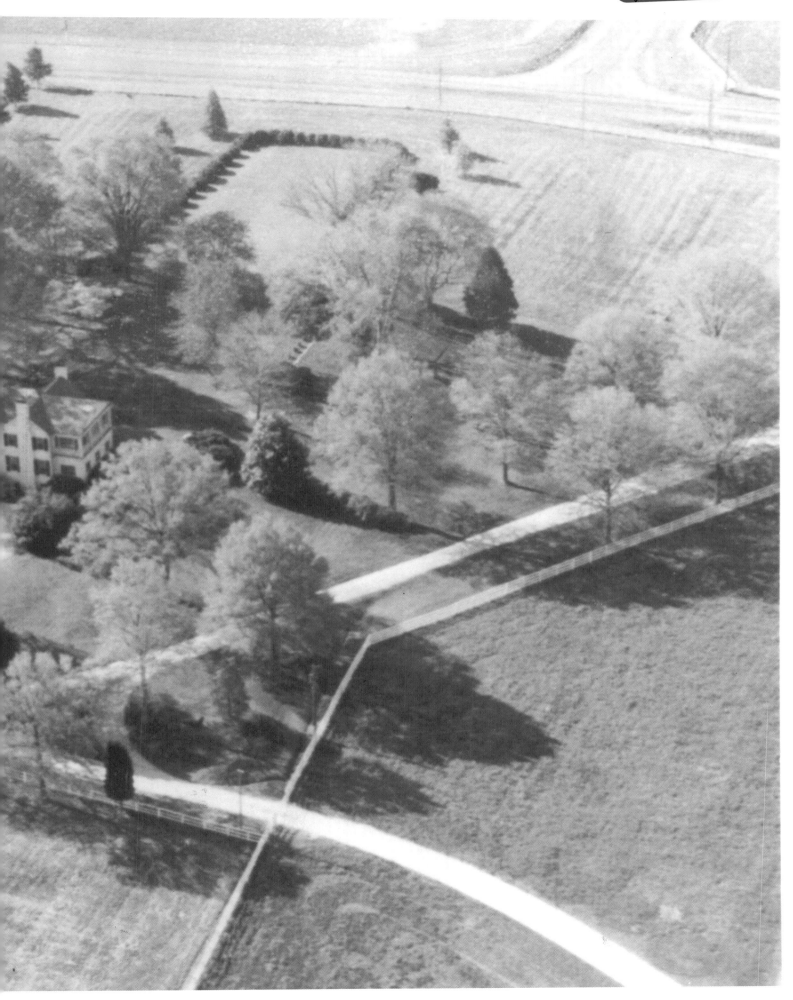

This book was donated in honor of volunteer

Emily Barker

November 9, 2010

 New Hanover
Friends of the
Public Library

SECRETARIAT'S MEADOW

THE LAND · THE FAMILY · THE LEGEND

KATE CHENERY TWEEDY LEEANNE LADIN

First Printing

Copyright © 2010 by Trifecta Authors

Cataloging-in-Publication data for this book is available from the Library of Congress.

Co-Authors

Kate Chenery Tweedy and Leeanne Meadows Ladin

www.secretariatsmeadow.com

Publisher/photographer

Wayne Dementi

Dementi Milestone Publishing, Inc.

Manakin-Sabot, VA 23103

www.dementimilestonepublishing.com

ISBN: 978-0-9827019-0-4

Graphic design by:

Jayne E. Hushen

www.HushenDesign.com

jehushen@verizon.net

Richmond, Virginia

Proofreading by:

Monica S. Rumsey

Scholarly Editing, Inc.

Richmond, Virginia

Printed in China

Cover portrait: *Secretariat* by Jamie Corum. Prints available at www.secretariat.com.

*Author Kate Chenery Tweedy
with her mother Penny Chenery
at the Kentucky Derby, 2008.*

Foreword by Penny Chenery

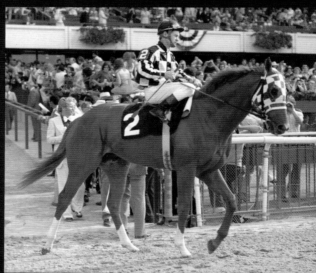

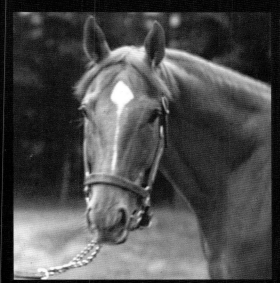
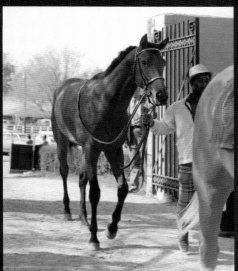

DEDICATION

I dedicate this book with gratitude to my grandfather, Christopher T. Chenery,

whose generosity, love of horses, and habits of excellence

brought us The Meadow and its equine champions;

and to his daughter, my mother, Penny Chenery, who had the vision

and the heart to keep his dream alive long enough

to deliver Secretariat to the world.

Kate Chenery Tweedy

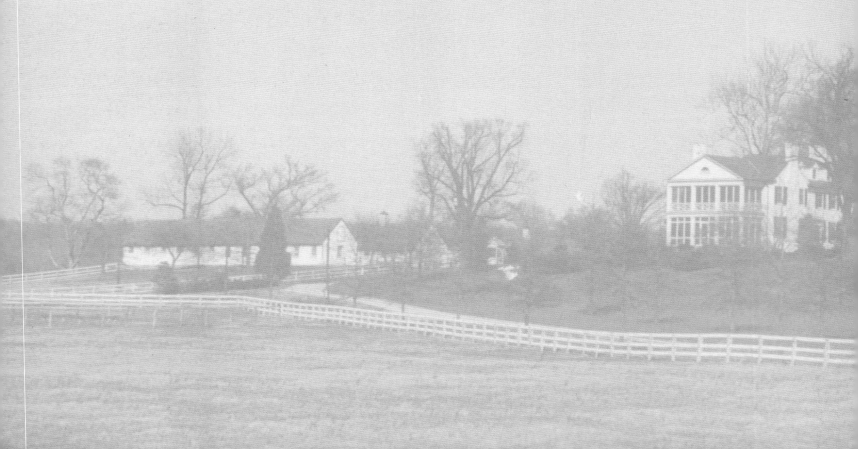

FOREWORD

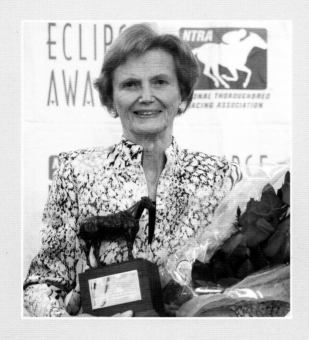

To get to the old Morris place —The Meadow—in the 1930s from Doswell, Virginia, you followed a narrow dirt road east from the railroad crossing of the Chesapeake & Ohio and the Richmond, Fredericksburg & Potomac over a plateau that suddenly dropped steeply toward the North Anna River. The sharp curves cut into the red clay bank so abruptly that cars had to blow their horns to negotiate it safely. You couldn't see around it nor could you see ahead to the long narrow bridge high above the leisurely stream. Through centuries, this waterway had smoothed out the vast fertile fields of a storied farm that nourished generations of my family, both the people and the horses that brought fame to The Meadow.

My teenaged first view of it came during a low point in its fortunes—worn out fields, a poisoned well, a gasoline station at the gate. Still the grandeur of the land overcame all that.

It is fitting that the full story of The Meadow is now being told by Kate. The farm was always close to my father's heart and remains dear to mine as well. My father's dream of breeding the perfect horse grew from its fields and found its fulfillment there. It is long since time to add its tale to the legend of its greatest and favorite son, Secretariat.

Penny Chenery

FIFTY CENTS

JUNE 11, 1973

TIME

SUPER
HORSE

Secretariat

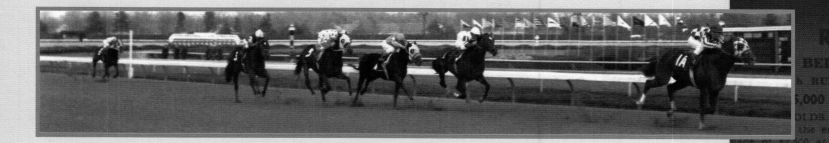

The Paragon

The buzz at Saratoga Race Course on that sticky Saturday, August 16, 1972, was not about Jane Fonda visiting Hanoi, the enemy capital of North Vietnam, nor about the ongoing Watergate cover-up. Track insiders didn't even glance at the latest times of the Kentucky Derby winner, Riva Ridge.

No, the hot topic of the day concerned who would win the Sanford Stakes, a contest for two-year-olds, worth only $25,000. Seasoned horse fans hoped for clues to Saratoga's favorite parlor game: who will win the next Kentucky Derby? In particular, folks wondered if the unbeaten favorite, Linda's Chief, could hold off a newcomer, a big, handsome chestnut who, in just three races, had shown promise. His name was Secretariat.

His owner, my mother, Penny Tweedy (known now as Chenery), viewed the Sanford with a wait-and-see attitude. True, her good-looking red colt had just posted a blistering workout, but as they say, "pretty is as pretty does." He had not yet displayed real talent. That, she thought, resided in Riva Ridge, her ugly duckling with speed, a three-year-old who almost set a record in his Kentucky Derby win three months earlier. Besides, who can expect to win back-to-back Derbies?

Though relatively new to the sport, Mom had charge of a stable with a distinguished history—Meadow Stud, in Doswell, Virginia. Technically it belonged to my grandfather, Christopher Chenery. He had grown up shoeless in rural Virginia, horse-crazy and hungry for economic security. A driven man, he made millions as a New York financier, but success came at a steep price—a heart attack in 1936 at age fifty. That year he returned to Virginia to reclaim the old family farm, The Meadow. To satisfy his passion for horses, he restored the dilapidated house and created a first-class Thoroughbred breeding and racing farm. By 1962, The Meadow had boasted four national champions. For thirty years, it represented Granddaddy's passion, his redemption, and his glory.

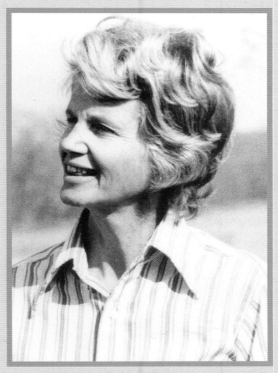

My mother, Penny Chenery, at the Meadow in 1972.

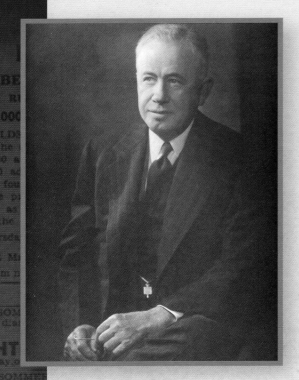

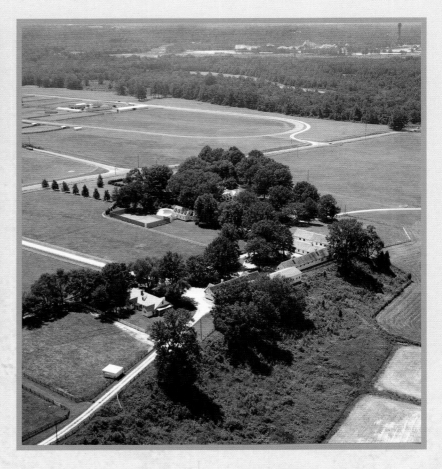

Above— My grandfather, Christopher T. Chenery, came back to Virginia to rescue the old family farm and breed the best horses he could. Right— aerial view of The Meadow, 1978.

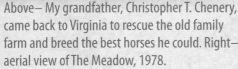

Yet the prize he coveted most—the Kentucky Derby—always eluded him. Soon his health began to flag and with it the stable's bottom line. Meanwhile Mom's role of dutiful wife in suburban Denver had begun to pall as well. So in 1968, when her ailing father had to retire, Mom grabbed the stable's reins with gusto. Faced with lukewarm support from her siblings and a bloated budget, Mom struggled to keep the stable, and her father's dreams, alive. Then, in May of 1972, she struck gold. Home-bred Riva Ridge trounced his Kentucky Derby rivals, drawing tears of joy from her bedridden father. Riva not only achieved her father's highest goals, but his earnings stopped her siblings from pushing for dispersal of the stable. Even people who don't relish racing love trophies.

Riva's Derby win thrilled me too, but as a Colorado girl of the 1960s, I viewed my family's success in the blueblood "Sport of Kings" as a bit surreal. Still, when Mom invited me to Saratoga, I willingly shed my bellbottoms, scrounged up some pantyhose and a nice dress, and joined her at the historic spa.

On that muggy Saturday afternoon we toured the backstretch where the horses were stabled before the race. As a Derby winner, Riva had gotten accustomed to visitors. Calm and magnanimous, he allowed me to stroke his black nose. But his younger stablemate didn't want company and wheeled away from my outstretched hand, flashing glimpses of gleaming copper as he danced in his stall. I had last seen Secretariat as a yearling at The Meadow, and he was a stunner even then. Now his intensity, his extra-large girth, the muscles that rippled under his shining coat all conveyed images of power. His presence was electric.

In the saddling paddock Mom explained his record. The first time out, he'd gotten bumped and struggled to find his stride. When he finally did, he rushed to the leaders, managing to finish fourth. In his

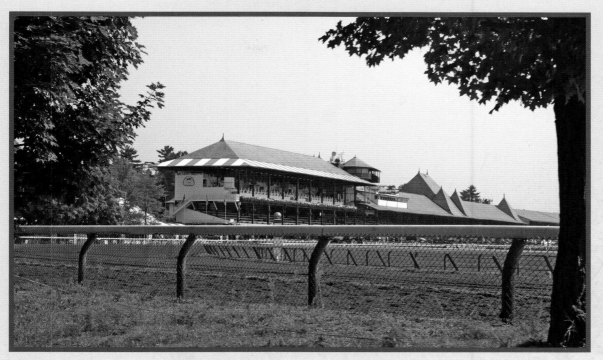

The striped tents of Saratoga, legendary proving ground for Thoroughbreds.

next two races, he also broke last, but came from behind to win easily. As she reminded me, two-year-olds are still learning to race, and what looks like lightning might just be momentary fireworks. In the Sanford, Secretariat would face proven quality for the first time.

In the starting gate, Secretariat waited beside Linda's Chief. The starter's bell clanged. "They're off!" shouted the announcer. The horses leapt forward, found their legs, and raced into the straightaway, their hooves rhythmically pounding the dirt. The first four moved together like a phalanx while the red horse trailed as usual. His legs struck the dirt with heavy strides, as if he couldn't get into his gear. The others flew along the backstretch ripping a speedy first quarter-mile as Secretariat still lagged. Slowly his movements began to synchronize, becoming smoother. His legs pumped faster, more powerfully. By the far turn, Secretariat had caught up to the crowd. They had run a sizzling half-mile in :46 ⅕.

Around the turn, two horses battled for the lead on the rail, with Linda's Chief at their heels on the outside. Sailing now, Secretariat held the spot on the rail right behind the leaders with Sailor Go Home beside him on the outside. As one, the leaders raced along the rail leaving Secretariat no room to go around or through them.

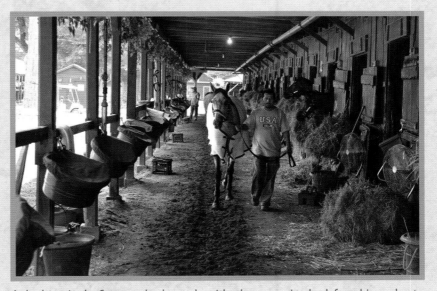

A shed row in the Saratoga backstretch, with a horse coming back from his workout.

Entering the homestretch, Linda's Chief gained on the leaders and now edged past them, while Sailor Go Home still had Secretariat pinned to the rail. The race clearly belonged to Linda's Chief.

Then everything changed.

In one astonishing second, the leaders on the rail parted and jockey Ron Turcotte and Secretariat seized the moment. They shot through the gap like an arrow. The crowd gasped. In no time Secretariat gained a length-and-a-half on his blockers and eclipsed Linda's Chief. He crossed the finish line the winner by three lengths in the blazing time of 1:10 for three-quarters of a mile.

"Wow!" was all I, or anyone, could say. The speed and daring of Secretariat's move electrified the crowd. Most two-year-olds are just getting used to hurtling around tracks in a straight line and avoiding contact with other horses. This juvenile not only summoned a powerful burst of speed but also sliced between horses like a butter knife. He showed brains, brawn and bravura. Secretariat gave jaded turf-writers thrills they had not felt in years. A few picked their Derby candidate right then.

That day I realized that Secretariat was not just another horse. Beautiful, yes, and fast, no question, but qualitatively superior in heart and soul. It was my first inkling that Mom's rollercoaster ride in racing might not end with Riva. But the dawning realization of Secretariat's potential did little to prepare any of us for what he would become to racing—and to the world.

I was twenty when Mom's horse etched the image of equine perfection across the sky. Decades after Secretariat won the Triple Crown and the nation's heart, my mother still receives letters, emails, songs, poems, paintings and pictures of him from fans all over the country. At events, I've watched fans young and old wait hours for Mom to autograph their precious Secretariat memorabilia. I mulled over his enduring appeal and wondered—how did this phenomenon come to belong to our family?

The culmination of two centuries of history, Secretariat represents a direct legacy of both the land on which he was born and the people who owned, bred and raised him. One of his origins lies in the story of my grandfather, who, by breeding the perfect horse, tried to heal the scars the Civil War had inflicted on his family. Another source emerges from the hopes, skills, toil and

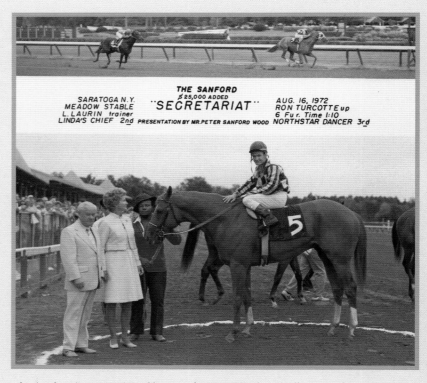

THE SANFORD
$25,000 ADDED
SARATOGA N.Y. "SECRETARIAT" AUG. 16, 1972
MEADOW STABLE RON TURCOTTE up
L. LAURIN trainer 6 Fur. Time 1:10
LINDA'S CHIEF 2nd PRESENTATION BY MR. PETER SANFORD WOOD NORTHSTAR DANCER 3rd

Lucien Laurin, our trainer, Mom, and groom Mordecai Williams in the winner's circle of the Sanford Stakes, August 16, 1972, at Saratoga.

tears of those who nurtured Secretariat and the other Meadow champions. Many of those workers' ancestors had lived on The Meadow under slavery. A third wellspring is The Meadow, whose fabled fields have captured a place in history and in many hearts.

Like my grandfather and my mother before me, I am called back to The Meadow, not to renew or revive the land, but to put into perspective what passed there. It has been two hundred years since my ancestors took up residence at The Meadow and forty years since the cold March 30, 1970, when Secretariat drew his first breath of air. The saga of the land and the people who bred and raised Secretariat—the tale that never made it into newsprint or film—is finally here.

More than three decades after Secretariat won the Triple Crown, fans still want Mom's autograph.

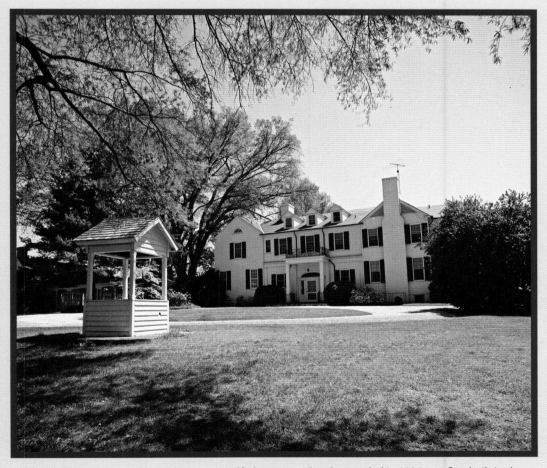

The old Meadow manor house that my grandfather restored and expanded in 1936 was first built in the 1700s with additions in 1808 and 1851.

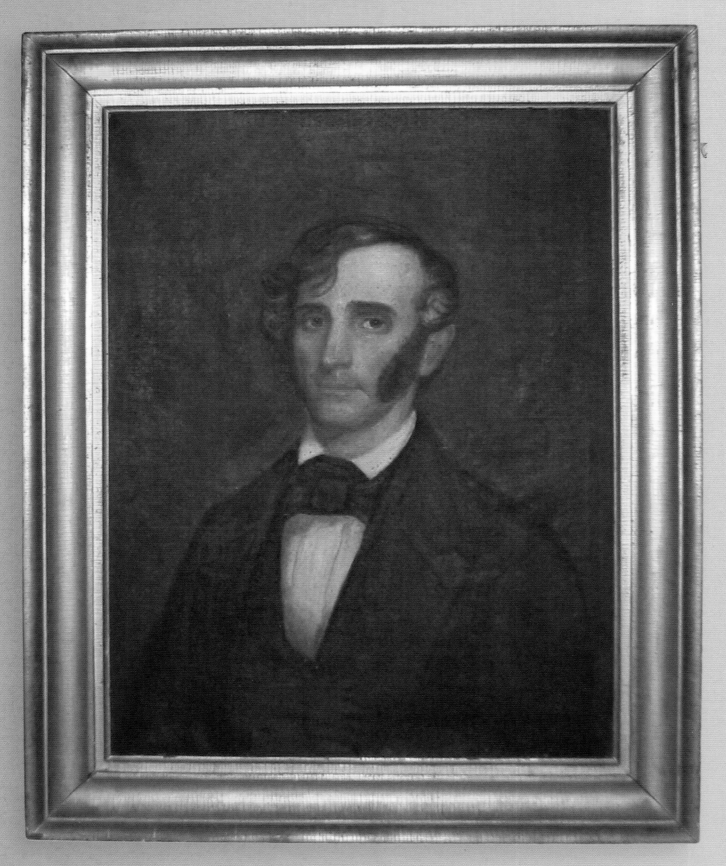

CHRISTOPHER TOMPKINS (1776-1826) OF RICHMOND, VIRGINIA, FOR WHOM
MY GRANDFATHER, CHRISTOPHER T. CHENERY, WAS NAMED.

The Meadow's Early Years

The history of a land colors the lives of the families who live there. The Meadow's history is a saga of hope triumphing over tragedy, determination over loss, and success over defeat. All of these helped to create the phenomenon of Secretariat.

Long before Thoroughbred horses galloped on its grasses, the land of The Meadow felt the quiet footfalls of the Youngtamunds and the Pamunkeys, who hunted and foraged for centuries along the North Anna River, on The Meadow's western edge. Virginia Indians didn't believe in owning land; instead they defended territorial borders.

Unfortunately, the British asserted title to these lands almost from their first landing at Jamestown in 1607. Soon royal governors began awarding tracts to any speculator who would bring new residents to the colony, which is how the tract of lands containing The Meadow first came under British ownership in 1674.

By 1724, the 3,000 acres known as The Meadow came into the possession of John Carter, the eldest son of Robert "King" Carter, the second wealthiest man in the American colonies. John Carter combined the new acreage with several other tracts to form the 10,000-acre North Wales Plantation, which dominated the southwestern section of the new county of Caroline.

When Carter died in 1742, North Wales and The Meadow passed to his son, Charles, who continued his father's practice of raising tobacco. When Charles died in 1805, his son Williams inherited North Wales and immediately sold the northernmost 4,000 acres to Dr. Charles Dabney Morris of neighboring Hanover County. That's when The Meadow became a place in its own right.

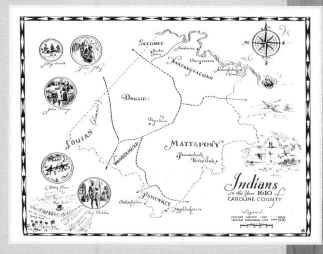

A 1954 map showing the Virginia Indians who lived in Caroline County in 1610. The Meadow straddled the line between the Youngtamunds and the Pamunkeys.

John Carter of Shirley Plantation purchased The Meadow in 1724.

The evocative name "The Meadow" comes from its topography. Much of the land consists of a wide open plain running along the North Anna River, a distinctive feature that stands out from the hilly terrain around it. A 1674 patent for a nearby parcel cites this area as a landmark, describing it as being near "ye Great Meadow on the freshies of the Pamonkey," meaning the North Anna, which meets the South Anna to form the Pamunkey six miles downstream of The Meadow.

For Dr. Morris, The Meadow represented a place of his own to raise a family, away from his miserly father, whom folks called 'Beeswax Billy' for his excessive frugality. In 1812, the young doctor married Emily Taylor of Cherrydale Farm in Hanover County. She was the youngest of Edmund and Ann Day Taylor's nine children. My grandfather would descend from two of Emily's siblings. (See family tree, pages 148-149.)

NAMES OF HEADS OF FAMILIES.	FREE WHITE PERSONS, (INCLUDING HEADS OF FAMILIES.)																										
	MALES.													FEMALES.													
	under 5	5 to 10	10 to 15	15 to 20	20 to 30	30 to 40	40 to 50	50 to 60	60 to 70	70 to 80	80 to 90	90 to 100	100, &c.	under 5	5 to 10	10 to 15	15 to 20	20 to 30	30 to 40	40 to 50	50 to 60	60 to 70	70 to 80	80 to 90	90 to 100	100, &c.	
Caroline County — Madison Henry	2	1	1				1										1		1	1			1				
Magee Joseph		1						1																			
Moon Jane		1																			1		1				
Mitchell Pascal		1	1		1														1				1				
Moon Coleman	1		1	1														1	1	1			1				
May Moses						1														1			1				
Mitchell Caleb	1		1	1			1											1	1	1			1				
Morris Charles	1	1	6	1	2	1	1												1			1	1				

1830 Federal Census showed Charles Morris and his free white and enslaved African American dependents without names, only hash marks.

Four years before, Charles Morris had begun remodeling an old farmhouse with handsome views overlooking the Cove, a large marshy area that lay in the bend of the North Anna. Probably the house of a former Carter overseer, it had a basement hearth for a kitchen with stone troughs for milk and water. Morris added a three-story ell which included a large dining room, two more bedrooms and an attic, with wide central halls on each floor to admit cooling breezes. He also built an outdoor kitchen to protect the house from heat and fire, along with a stable, a smokehouse, an icehouse and an office for his patients.

The Morrises apparently prospered at The Meadow for three decades. Census records, birth and death registers, wills and newspaper notices tell us that Emily bore and raised seven children to adulthood, and that Dr. Morris's medical practice flourished. Enslaved African-Americans made up much of his wealth, for the 1830 Federal Census lists eighty-two.

In 1842, after both Dr. Morris and his first son Charles died, things began to change at The Meadow. The other six children each inherited parcels of 600 acres on which most built homesteads with romantic names like Elangowan (for Ellen Hunter, the oldest), Glamorgan, Over Yonder and The Snuggery.

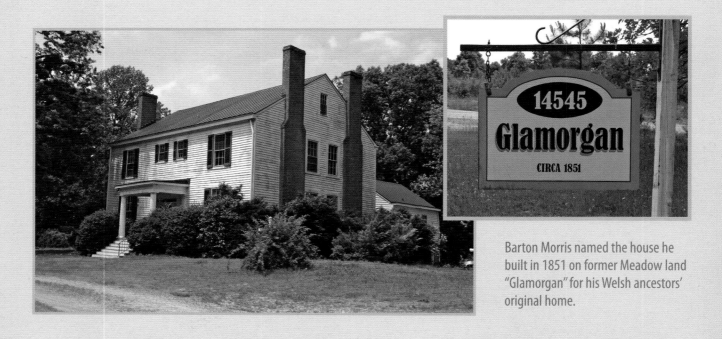

14545
Glamorgan
CIRCA 1851

Barton Morris named the house he built in 1851 on former Meadow land "Glamorgan" for his Welsh ancestors' original home.

8

Pendleton — 200

	SLAVES.											FREE COLORED PERSONS.												TOTAL.				
	MALES.						FEMALES.						MALES.						FEMALES.									
under 10	10 to 24	24 to 36	36 to 55	55 to 100	100, &c.	under 10	10 to 24	24 to 36	36 to 55	55 to 100	100, &c.	under 10	10 to 24	24 to 36	36 to 55	55 to 100	100, &c.	under 10	10 to 24	24 to 36	36 to 55	55 to 100	100, &c.					
		1				1																		11				
	2		3			1	2		1															10				
						1																		4				
		1					1																	7				
							1																	9				
																								3				
1	1		2			1	1	1	2															18				
0	18	14	13	4		0	0	4	2			2							1					102				

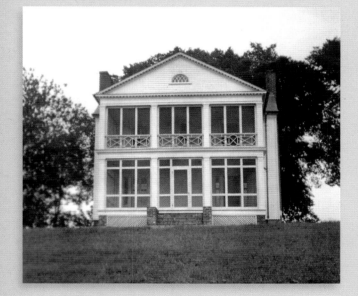

The porches that Edmund added were essentially the same as in this 1937 photo of the west side of the house.

The third son, Edmund Morris, a lawyer, inherited The Meadow house, the lands around it and the Cove, along with his mother's "widow's tenth." In exchange, he promised to support his mother for the rest of her life. In 1851, when his bride, cousin Mary Ann Pendleton, came to The Meadow, he tore down the oldest part of the house and replaced the living room and bedrooms above, adding sleeping porches facing the river.

Evidently the community regarded Edmund highly, for they sent him to Richmond in 1861 to represent Caroline County at the Secession Convention. There he voted to secede—twice.

From that decision forward, the Fates seemed to punish the Morrises, as it did much of the South, for the war brought a cascade of deaths, civilian and military, to every family. The oldest, Ellen, died sometime before the war and Barton, a doctor, died caring for the troops. The youngest, Kitty, lived through the Siege of Richmond, only to die in 1866. Edmund, who was tubercular, died in the fall of 1865, trying to keep The Meadow afloat. That left Alexander who had a wife and five children to feed, and John, who had disappeared. Only the old mistress Emily, her daughter-in-law Mary Ann, and her granddaughter Emily, remained at The Meadow. The younger women cared for Emily until her death in 1873, and then young Emily cared for her mother until she died in 1911. The next year, Emily, the last Meadow Morris, sold the farm and retired to Richmond. The Morris-Taylor family had lived at The Meadow for 100 years.

Emily Taylor Morris declared her life was over when both her husband and son died in 1842. She lived on for thirty-one years at The Meadow.

9

The recently discovered writings of a Morris great-granddaughter add to our knowledge of The Meadow. Hardenia Hunter Ferguson (1878–1974) or Cousin Deenie, as I knew her, was a granddaughter of Ellen Morris and James Hunter. She inherited Elangowan where she farmed, researched and wrote stories based on The Meadow. A historian by nature, Deenie gleaned her information from former enslaved workers and older relatives, particularly Mary Ann and her daughter Emily. When Elangowan became too dilapidated, Deenie moved to another Meadow homestead, Over Yonder.

In 1939, my grandfather interviewed Deenie about the Morrises. We still have the transcribed notes of those talks. In addition, we uncovered an unpublished manuscript in which Deenie fictionalizes historical events that actually occurred at The Meadow. Her comparatively sympathetic portrayal of African-American life there offers a far rosier image of slavery than likely existed, but it is our only source of information about The Meadow as a plantation. Unfortunately, we have no accounts from the enslaved workers to balance her perspective.

According to Deenie, the Morrises did not raise cash crops like tobacco; instead they operated a self-sustaining farm whose skilled workforce produced all the goods they consumed. They raised livestock such as horses, oxen, sheep, cattle, hogs and chickens. From the hogs, they smoked hams and bacon. From cow hides, tanners made shoes and harnesses. Dairywomen milked cows, made butter and gathered eggs. Seamstresses wove cloth on looms and then sewed, washed and ironed everyone's clothes. Workers made elderberry wine. They grew vegetables, beans, corn and wheat and threshed the grains with a mule-driven machine. They grew sorghum for feed and sweet syrup which they stored in barrels made from oaks and pines they had planted on the hillsides.

Deenie says the enslaved workers lived about half a mile east of the house up the hill and through the woods. She writes that each individual or family got a "comfortable and neat" cabin with a yard, fenced garden and one or two outhouses. They each received clothes and weekly rations, except for nursing babies. The most productive workers also earned a small monthly cash bonus. When they married, "Old Miss" Emily gave the bride sheets, bedding and some new crockery.

Weddings were celebrated on Sundays, the day of rest, with a ceremony at the doorstep of the groom's cabin and a cake inside afterwards. They sometimes had a "shout" after the nuptials with singing, dancing and merry-making. Deenie described one wedding where "Old Marse" (Dr. Charles) and "Marse Edmund" (his son), both said to have been deeply religious men, came down to the quarters. Old Marse read the marriage ceremony. When they left, the wedding party celebrated with a shout until Charles Dyson, the overseer, came to call lights out at the usual hour of 9:00 p.m.

Deenie quotes Dyson describing the African-Americans at the Meadow, "They know who their master is and he will take no slack work, but he takes good care of them, men, women and children. He sees to it that they are well-clothed and fed. Come Sunday, he gives them a dose of religion for good measure. It all pays in the long run for by and large they are the best negroes I have had any dealings with."

Through Dyson, Deenie commends Dr. Morris for neither buying nor selling his workers for profit or convenience. "He thinks it is his business not only to clothe and feed them, but he

wants them to be happy and most of them are." However, he added that "he is strict in his rules, thinks he is never wrong, and acts like he is God on earth, always knowing what is right no matter how hard."

We learn from Deenie that life at The Meadow was marked by certain traumatic events, like the year of the deep snow, the year of the big flood and the year of cholera, when all the hogs died. The most terrifying, however, was the year of "the sickness," most likely yellow fever.

Above: the graveyard in the garden at The Meadow never had any markers for the thirty-five relatives who are buried there. Inset: the cemetery for the enslaved workers lay a quarter-mile up the hill from the house. Each grave faced east and was marked with a cedar tree, according to Deenie.

"Grave after grave was dug on the hillside up on the Cove," Deenie wrote, and "there was many an empty chair in the cabins." The epidemic seemed to affect mostly the African-Americans, except Dr. Charles, who tended the sick and became the last victim of the sickness. He was laid to rest in the lower portion of the flower garden, the first of many interred there.

Eventually thirty-five graves were dug in the private cemetery that still occupies a little slope just south of the house. Although no headstones ever marked the graves, Deenie provided a list of who lies there, including Dr. Charles and Emily Taylor Morris, most of their children and grandchildren, as well as several Taylor, Tompkins, Pendleton and Chenery cousins. However, we lack a similar record of the many men, women and children born in bondage who were buried in the slave cemetery on the hill overlooking the Cove.

By the time the Civil War erupted in 1861, the roots of the plantation system had shriveled from soil exhaustion and slavery's moral and economic inequity. Neither land nor wealth could protect Southerners from the conflagration. After it passed, the social and economic landscape of the South was charred beyond recognition. Only the land of The Meadow remained the same.

Though The Meadow suffered through enemy raids, floods and pestilence, the land and its families endured.

11

The labels visible on the map include:

FREDERICKSBURG

5-7 May

5-7 May

THE WILDERNESS

VERDIERVILLE

CHANCELLORSVILLE

KING GEORGE C.H.

Arrived morning of 8 May; departed night of 20-21 May.

Arrived morning of 8 May; departed night of 20-21 May.

SPOTSYLVANIA C.H.

TODD'S TAVERN

PORT ROYAL

Rappahannock River

A.P. Hill resumed command of the III Corps 21 May, relieving Early.

A.P. HILL

ANDERSON

WRIGHT

EWELL

WARREN

BURNSIDE

HANCOCK

GUINEY'S STA.

MILFORD STA.

BOWLING GREEN

NEW MARKET

CHILESBURG

Sheridan rejoined Grant at the North Anna 24 May.

Burnside's IX Corps was incorporated in the Army of the Potomac 24 May.

CENTRAL R.R.

CHESTERFIELD STA.

Mattapony River

Arrived afternoon of 23 May, departed evening of 26 May.

BURNSIDE ...The Meadow

HANOVER JC.

HANCOCK

WRIGHT

WARREN

Arrived morning of 22 May; departed morning of 27 May.

DUNKIRK

South Anna River

HANOVER C.H.

ASHLAND STA.

Arrived 30 May

RICHMOND R.R.

Arrived 28 May.

HANOVER TOWN

HAW'S SHOP

KING WILLIAM C.H.

GOOCHLAND C.H.

YELLOW TAVERN

ATLEE'S STA.

Transports with Wm. Smith's X and XVIII Corps of the Army of the James began arriving 30 May

MECHANICSVILLE

COLD HARBOR

1-12 June

Chickahominy River

FORK RIVER

James River

RICHMOND

OTTSVILLE

MANCHESTER

RICHMOND and DANVILLE R.R.

RICHMOND and

Map from West Point Atlas of Military Battles.

GRANT AND LEE CHASED EACH OTHER FROM THE BATTLE OF
THE WILDERNESS SOUTH TO RICHMOND IN MAY 1864,
WITH THE MEADOW LYING RIGHT IN THEIR PATH.

In the Wake of the War

Although battle blood never spilled on The Meadow itself, the Civil War skulked close to the farm as the Federals tried twice to seize nearby Richmond. But by the war's end in 1865, nearly every part of Virginia had seen either battle or occupation. Everything had changed for better and for worse.

Two campaigns to take the Confederate capital of Richmond in 1862 and 1864 so scorched Caroline and Hanover counties that historians called them the Burned Counties. Several major battles raged nearby in 1862 at Hanover Court House and Cold Harbor. But by far the worst fighting near The Meadow occurred during Grant's Overland Campaign in 1864 at the battle of North Anna at Bullfield, Thomas Doswell's land just across from The Meadow. It was close enough for the Morrises to hear the gunfire.

In May of 1864, Generals Robert E. Lee and A.P. Hill were desperately trying to halt Meade's and Grant's progress as they marched south after the Battle of The Wilderness. The rebels dug effective fortifications on the south side of the North Anna, while the Union army camped on the north, a few miles above the Cove. They clashed repeatedly from May 23 to 26, resulting in over 4,000 casualties but no clear victory. Recognizing a stalemate, Grant withdrew back

Scene from the Battle of North Anna, showing a pontoon bridge and Yankee encampment.

13

Yankee soldiers bathing in the North Anna River, with the Hanover Junction railroad bridge that they had just wrecked in background.

The still-smoking railroad bridge over the North Anna at Hanover Junction (now Doswell), just after the Federals destroyed it, 1864.

across the North Anna, sending his army just southeast of the bluff above the Cove to connect to today's Routes 30 and 2/301. They were heading south into Hanover, and a few weeks later, into the bloody battle of Second Cold Harbor.

As the army passed, roving bands of Yankees scavenged The Meadow for animals, food and silver. The tale of how calm Mary Ann Morris remained while Northern soldiers ransacked her house greatly impressed my grandfather as a young boy. Apparently, Mary Ann's terrified daughter Emily sat as close as possible to her mother while soldiers ran up and down the stairs. One Northern soldier asked Mary Ann to hold one piece of silver for him while he hunted for another. She refused, retorting, "It is immaterial to me which Yankee thief gets my silver." But she succeeded in saving Grandmother Tompkins's silver tea service by burying it either in the garden or the well, depending on the source of the story. It remained in the family for 106 more years until thieves stole it when The Meadow was open for Garden Week in 1970.

Even as late as my own childhood, Granddaddy would show us a deep nick in the polished wood of the third-floor balustrade, insisting that it had come from a Yankee sword during the raid. Whether that was true or not, he steadfastly refused to replace that banister, no matter how wobbly it became.

Although the house escaped the torching that left many Southern farms in ashes, the Morrises lost everything else. Edmund barely survived the war. The $36,000 in assets he reported in the 1860 census began dwindling when the Cove's dike broke during the war. He couldn't rebuild it without mules, a team or an engineer to plan it, and all such resources were dedicated to the war. Cousin Deenie commented, "The [former] slaves had been wonderful and had not left, . . . [but] Edmund practically impoverished himself taking care of them. In addition, his health had begun to fail." He died at age forty-four in September 1865, just five months after Appomattox. He left nothing but some land, the house and the flooded Cove for his mother, his wife and his daughter to live on.

Two of his brothers, John and Alexander, survived the war, but neither could support their mother or sister-in-law. John had literally gone mad before the war over the simultaneous loss of his wife and his infant son. For years he roamed the countryside in an alcoholic haze. Alexander lived over in Hanover at Cherrydale, the old Edmund Taylor farm, but he also lacked money to pay newly-liberated workers or to

15

A rendering of Yankee troops wrecking rails and burning bridges, just as they did near The Meadow.

When Richmond burned in 1865, fourteen-year-old Jimmy Chenery spent the night sleeping on the counter of his father's store with a shotgun in hand to keep his fellow citizens from looting dry goods.

feed his family of seven. We don't know why, but by the 1870s he, his wife, and all but one of his children had been laid to rest at The Meadow in the little graveyard in the garden.

The Morris women at The Meadow had survived the war, but for what? Emily was seventy-seven, her widowed daughter-in-law Mary Ann was thirty-seven, and her grandchild, Emily, thirteen. They had no men, no food, and the land was flooded. Work had been viewed as "unfeminine" for women of wealth before the war, so they had little experience in the kitchen or in the fields.

By 1866, only one male in the extended Morris-Taylor-Tompkins family could bring in money. He was a tall, skinny sixteen-year-old named James Hollis Chenery. Scholarly Jimmy could spout Latin but couldn't abide commerce. Yet upon his slim shoulders fell the responsibility of supporting three families.

Jimmy's father, James Gunn Chenery, a Yankee, had moved to Richmond in 1842 from Montague, Massachusetts, after a plague of deaths had decimated his family. In Richmond, things looked better at first. He opened a dry goods store and seemed to prosper. He lodged at a good home, that of Mary Taylor Tompkins, a widow who had fallen on hard times, and who was a sister of Emily Taylor Morris of The Meadow. James wooed and married her daughter, Emily Tompkins. But Emily was diabetic and they lost their first son. They had two more children, Mary Sophia in 1846, and Jimmy in 1850. Then Emily died

suddenly at age thirty-two, leaving Jimmy, age two, bereft and confused. Emily had been in the habit of praying in her room for an hour everyday. After her death, Jimmy continued to sit outside her door daily hoping she would reappear.

After Emily died, the redoubtable Yankee married his wife's cousin, Anne Ferrell Winston, who gave him three more children: Tate, Richard, and Sally. Then came the war and the years of famine while Richmond was under siege. The next three babies all died in infancy.

By then, sixty-five year old James had embraced the politics of his adopted city. So on the night of April 2, 1865, when the Confederate government abandoned Richmond to the Federals, he was part of the regiment of old men and boys that tried to defend their city. Seeking to destroy ammunition and alcohol, the Rebels accidentally set fire to the city as they left town. Richmonders rioted in their wake. Fourteen-year-old Jimmy spent the night sleeping on the counter of his father's store with a shotgun in hand to keep his fellow citizens from looting dry goods. The disgust he felt at the sight of Richmonders slurping the whiskey that ran in the gutters from splintered barrels never left his memory.

If all the Chenerys survived the war, they had little to show for it. In October 1866, James went bankrupt from carrying all his friends and relatives on credit through the siege. A month later, he died of typhoid fever. Suddenly, the crushing responsibility of maintaining not only his stepmother and her youngsters, but also his tubercular older sister, fell to young Jimmy.

On top of that, the three Morris ladies at The Meadow also needed support. After Emily's death, Mary Ann Morris, Jimmy's much older first cousin, cared for him like a son. He always said his happiest days were spent at The Meadow. Now it was his turn to repay the favor. Two other penniless relatives, Jimmy's and Mary Ann's uncles, William Tompkins, sixty-four, and E. Ludlow Tompkins, fifty-eight, needed help too. William may have worked before the war, but Ludlow, a dandy, was "morally against manual labor." Uncle Lud so resisted the changed reality of the postbellum South that for decades afterwards, he demanded that Mary Ann saddle his riding horse for him.

After his father's bankruptcy, the proud but dutiful Jimmy Chenery took the only job he could get as a sales clerk in a shoe store. It was the sort of job he would keep, and resent, all his life. The anger and frustration he felt at having to take demeaning work would ignite in his son Christopher Chenery a passion to restore the family name to prominence. From the seemingly bottomless misery of 1866, the Chenery family and The Meadow would together make a slow but steady climb, culminating over a century later in the triumphs of a great red stallion.

IDA BURNLEY TAYLOR, THE MATRIARCH

Reduced Circumstances, Heightened Ambitions

At the age of thirty-two, Jimmy Chenery finally decided to marry. He chose a pretty cousin just out of high school, Ida Burnley Taylor.

Young Southern women faced slim pickings for husbands after the war. Even so, the tall, dour bachelor seemed ill-matched for such a lively, ambitious bride. But they shared important values: family, piety and education. Both loved books and ideas, both came from families that lost everything in the war, and both descended from that prolific pair, Edmund Taylor and Ann Day of Cherrydale in Hanover County. But if Ida thought she could pinch pennies before her marriage, she learned to squeeze blood from them afterwards.

Jimmy and Ida were married in March, 1882 at The Meadow, living in Dr. Morris's old office for the first few years. Their first son, James Hollis, died as a toddler and was buried in the family cemetery. Two years later, the Chenery clan welcomed a healthy boy, William Ludlow (1884–1972), named after the two Tompkins uncles. The little family moved to Richmond sometime before the next births, that of my grandfather, Christopher Tompkins (1886–1973), and my great-uncle Charles Morris (1888–1948).

Jimmy worked at the haberdashery of Breeden and Talley at 109 Broad Street, Richmond's main commercial row. The Chenerys rented rooms a few blocks away at 312 W. Grace Street, a drab three-story boarding house. In the era before urban parks, its small backyard would have offered the only safe place for Ida's rambunctious boys to play. Bill, who was serious and scholarly like his father, helped Ida keep track of the younger boys, while my hyperactive and hyper-curious grandfather led his affable younger brother into constant scrapes. When Alan Jeffries (1890–1984) joined the crew, Ida became desperate to move out of the city.

By then, Ida could see that her proud, intellectual husband lacked the temperament for sales, and she blamed the times for confining him to "uncongenial work." She vowed that her children would not endure such drudgery. College, she decided, was their best hope.

Jimmy Chenery, circa 1875.

19

In 1891, Ida managed to move the family to Ashland, fifteen miles north on the Richmond, Fredericksburg and Potomac Railroad, affectionately known in our family as the "Relatives and Friends Preferred." Ashland was safer, much closer to The Meadow, and it boasted a good men's college, Randolph-Macon. If they could scrape up the tuition, Ida hoped her sons could attend college while living at home.

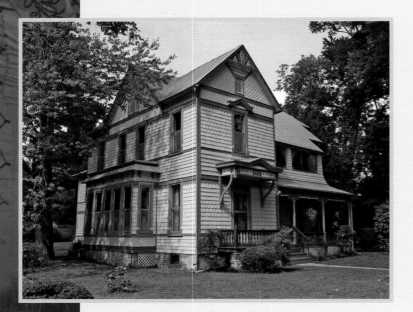

The Chenery's Ashland home today. Thanks to a wealthy sister's generosity, Ida and Jimmy built a Queen Anne-style house on Duncan and Racecourse Streets in Ashland beside a former racetrack.

Through the grace of Ida's well-married sister Blanche Browning, they built Ida's dream home, a Queen Anne-style house on Duncan and Racecourse Streets beside a former racetrack. It featured a turret, covered porches on two stories and steep sloping roofs. Ida even added some extras such as carved and tiled mantelpieces, arched detailing on the eaves and a stained glass window in the master bedroom. However, there was no plumbing or electricity.

In the beginning, life went well in Ashland. Ida had a big yard for growing vegetables and raising chickens, and four sturdy sons to chop wood, haul water, gather eggs and do errands. They went barefoot in summer to save shoe leather, but they had enough to eat. Ida's other great hope

20

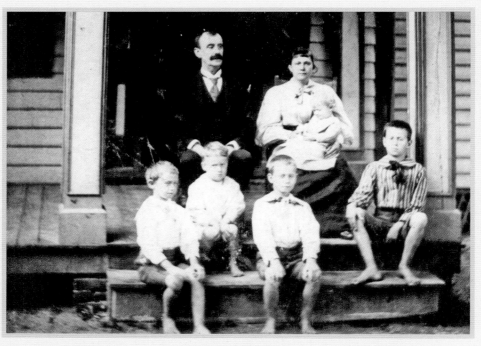

The young Chenerys at The Meadow: Jimmy and Ida with Blanche in back. On the steps: Charlie, Alan, Chris and Bill.

arrived in Ashland as well, a daughter, Blanche (1894–1973) named after Ida's generous sister.

The boys worked hard but played hard, too. In summer, Chris and Charlie would climb out their second-story window after dark to steal watermelons. Once an irate farmer peppered them with buckshot as they escaped. They had to pick pellets from each other's backsides to conceal the caper from Ida. If she had found out, she would have kept them in the yard for a week and made them chop an extra cord of wood.

Then came the financial panic of 1893, which eliminated Jimmy's job. Many months passed before he found another. Jimmy threatened to make Bill and Chris leave school to work as he had, but Ida simply overruled him.

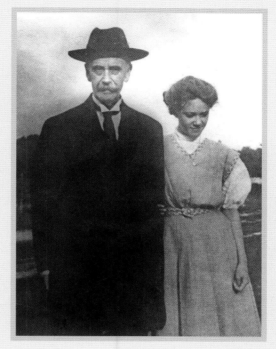

Jimmy at age 64, a few years before his death in 1918, with daughter Blanche. Charlie's wife, Marguerite Archambeault, called him "a kindly old gentleman who welcomed her into the family graciously."

Believing that God helps those who help themselves, Ida began to cook meals for professors at Randolph-Macon at fifteen cents a day for dinner, twenty-five cents for two meals. The older boys rose before dawn to light fires in the station house for the trainmaster. They cleaned the chickens that Ida would fry and sell for Sunday dinners. In later years, Chris and Bill bought an old mule so they could cut and haul timber to a mill. As a young child, Blanche remembered reciting the Lord's Prayer quite literally, praying for their next day's bread.

If marrying Jimmy brought Ida toil and worry, it also brought her joy. Jimmy adored her, and he sparked their children's intellectual curiosity. At dinner, the affairs of the day generated vigorous and often sharp debates. They used Webster's Dictionary, Shakespeare or the Bible to settle disputes, while Ida ruled on questions of speech and manners. Jimmy spiced his conversation with Latin phrases that he expected them to understand. The Chenery kids learned to stand up for themselves or lose out, and heaven help the tongue-tied!

Even though they had no more than many of their neighbors, the Chenerys drew strength from their former eminence, behaving as though they still had it. Mom remembers her Virginia relatives this way:

"They were remarkably well-read for not being well-educated and they prided themselves on their intellectual accomplishments. Speaking and writing well were as important as knowing their history, flowers, architecture and silver. They valued elegance of life. But after the war no one in the family, or in the community, had anything, so they simply rose above it. They kept what fine things they had salvaged and valued them."

21

Railroad tracks still run through the center of Ashland as shown in this 2010 photo.

The Chenerys kept not only ancestral pride but also memories of wartime injustices, savoring their ancestors' defiance and heroism. Ida treasured an old etching of a battle that hung in their parlor. When the boys protested its gloominess, Ida chided: "Your grandfather was in that battle, and don't you ever forget it!"

The Chenerys took pains to hide their relative poverty. Ida sent the boys after dark to haul the family's dirty laundry in a wagon to an outside washerwoman. In 1901, few Ashland homes had maids, yet Ida wanted to conceal the fact that she didn't. Growing up without plumbing so embarrassed my grandfather that he never pointed out his boyhood home to Mother. As adults, none of them ever lost their fear of poverty and they all worked together to rise above it.

Bill, though scholarly like his father, Jimmy, differed from him in valuing compassion and idealism. After doing social work in Chicago with Jane Addams at Hull House, he became a journalist known for principled stands. He lost the editorship of the *Rocky Mountain News* in 1914 when he sided with labor in condemning the Ludlow, Colorado, massacre of immigrant women and children that resulted from a miners' strike. Later, he served for many years as the distinguished editor and publisher of *Collier's Magazine* in New York.

Charlie, named after The Meadow's founder, Charles Morris, did not attend college and worked for my grandfather most of his life. But his good looks and charm made him beloved by all, especially women. His brothers loyally shielded him from his own misadventures right up until he died at age sixty.

Alan, the youngest, combined Bill's brains and Chris's dynamism to become an eminent Washington, D.C., urologist who founded the Doctor's Hospital, now defunct. A cultured and gentle soul, he counted President Franklin Roosevelt and the Washington Redskins among his many clients.

Creative and independent, Blanche adored her father but chafed at Ida's tradition-bound views. Her brothers put her through the University of Chicago, Class of 1916. She found

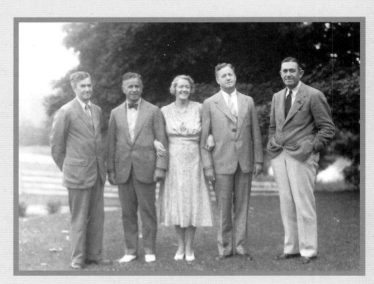

The closeknit Chenery siblings pose at The Meadow in the 1940s. From left: Bill, Chris, Blanche, Alan and Charlie Chenery.

22

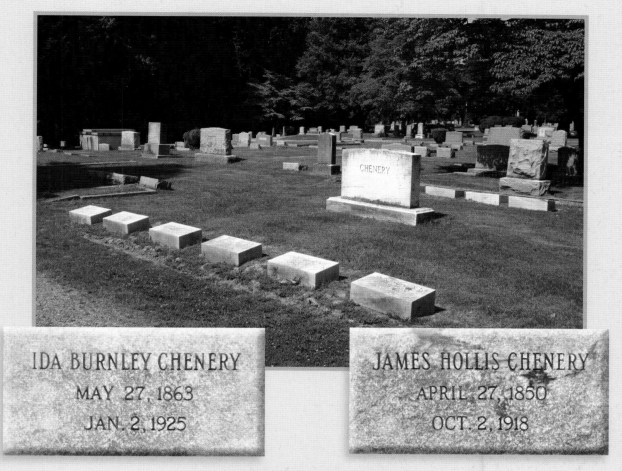

IDA BURNLEY CHENERY
MAY 27, 1863
JAN. 2, 1925

JAMES HOLLIS CHENERY
APRIL 27, 1850
OCT. 2, 1918

Woodland Cemetery, Ashland, Virginia.

early success penning advertising slogan; then she married an advertising executive, Edwin Perrin, with whom she had two children. Later, writing as "Blanche Perrin," she authored several successful novels, including *Born to Race,* her beloved children's novel based on The Meadow.

The powerful mixture of pride and shame that drove his mother, Ida, affected my grandfather Christopher most of all. He suffered when Ida's diabetes exhausted her, and he deeply resented his father's failure to provide well. It became his personal mission to restore the family's honor and place in society.

Granddaddy needed wealth to salve the sting of their early poverty, to become the person he wished his father had been. His ambition would drive him through college, then out west, and finally to New York to make the most of his engineering degree. By 1928, he had earned a fortune, but it came too late to help Ida, who died of "apoplexy" (probably a diabetic seizure) in 1925.

After her death, succeeding in New York wasn't quite enough. Granddaddy would have to return to Virginia to win the final victory over deprivation——to buy The Meadow, the remaining emblem of the Chenery-Taylor-Morrises' proud heritage. Restoring it became the next step in his resurrection of the family name. Then, and only then, could he indulge in his own dream, to breed and race beautiful, talented horses, and maybe, just maybe, to win the most coveted race of all, the Kentucky Derby.

23

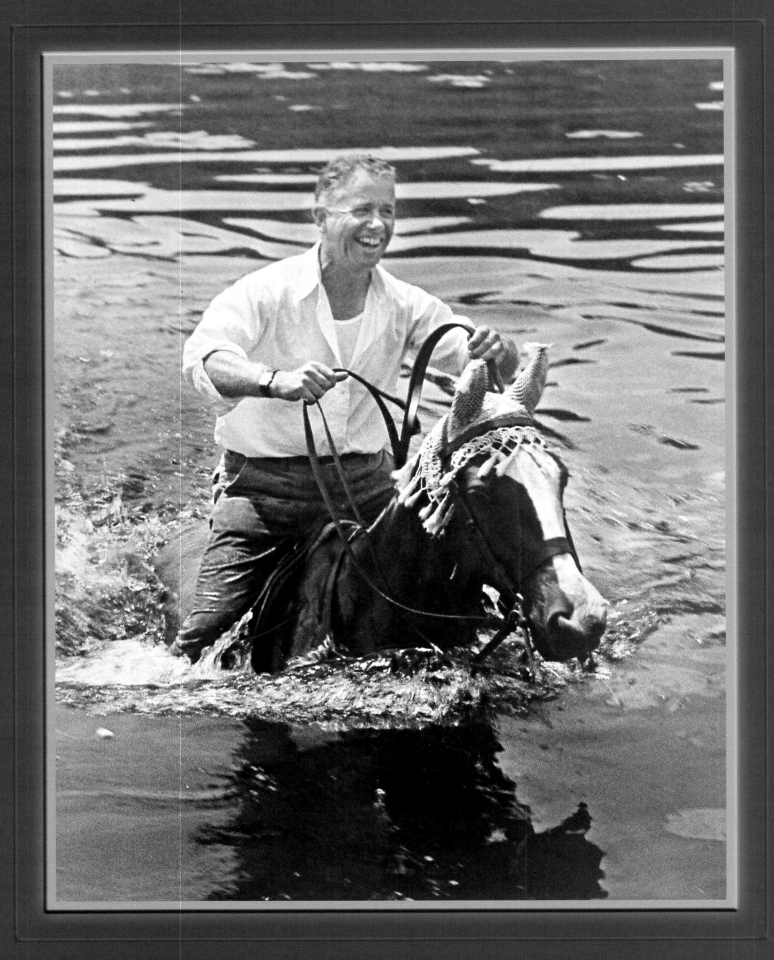

THIS IS THE FAMILY'S FAVORITE PHOTOGRAPH OF CHRIS CHENERY. IT MAKES YOU
WONDER, WHO IS HAPPIER ON A HOT DAY, GRANDDADDY OR HIS HORSE.

A Man Driven

My grandfather, Christopher T. Chenery, spent his life pursuing two great passions. The first was making money and providing financial security for himself and his loved ones. The second was horses.

Virginians in the 1890s still walked, rode horses, or drove wagons and buggies. My great-grandparents didn't have a horse and carriage, but that didn't stop their second son from learning to ride. Horses so entranced him that, once as a toddler in Richmond, he was accidently left behind when he stopped to stare at a horse-drawn cab. Later the horse-crazy boy would beg rides from any Ashlander who owned a horse. The neighbors said, "That boy will run any kind of errand as long as it involves a horse!"

Jimmy Chenery on a borrowed horse with toddler Chris in his lap in front of The Meadow house around 1888.

Visiting The Meadow was heaven to my grandfather because he could borrow a horse from Mary Ann Morris, his adopted Grandma. He would ride for hours, exploring wild places on horseback, especially The Meadow's treed uplands, the Cove, or the brambly riverbank. Five decades later, riding at The Meadow was still his favorite activity.

But his admiration for racehorses came from the neighboring farm, Hildene. Always searching to make money, Chris got work exercising racehorses for Bernard Doswell. Bernard was a cousin by marriage, having wed the lovely Ellen Morris, a granddaughter of The Meadow's Emily Taylor Morris. His farm, Hildene, was all that remained of the much larger Bullfield, where T. B. Doswell and his son Major Thomas Walker Doswell raised and raced champion Thoroughbreds from the 1830s through the 1880s. (See Bullfield Sidebar on pages 32-35.) By 1901, the champions of Bullfield were long dead, and the charming but dissolute Bernard owned only a few hundred acres and a couple of his own steeds. Bernard must have

Ellen Morris, granddaughter of Emily Taylor Morris, married Bernard Doswell of the famous Bullfield Stable.

seen unusual ability in the teenager to let him to ride his fine racers and to pay him for it. Strong for his age, Chris was a natural horseman with a good seat and an instinctive rapport with a horse.

Often after exercising the horses Chris would linger on the porch at Hildene while Bernard recounted tales, no doubt embellished by whiskey and time, of the glory days when the Doswells' "Red Stable" dominated the turf from New Orleans to New York. Bernard enthralled the horse-crazy boy with the exploits of champions like Planet, Nina, Bushwhacker and Knight of Ellerslie.

With such stories ringing in his ears, young Chris Chenery dreamed of racing glory as he galloped Bernard's mounts. To the poor boy, breeding fine horses must have symbolized everything he wanted: wealth, respect and honor. But in 1901, he had to tuck away his visions of grandeur for the future, knowing education was the key to creating wealth.

Smart, but not a natural scholar, my grandfather worked hard to enter Randolph Macon College at age sixteen. Boys of that age couldn't wear long pants yet, and the teasing he got for wearing short pants humiliated the proud youth. My great-uncle Bill studied for two years and then quit to earn money for Chris's studies. After two years at Randolph-Macon, Chris left and took Bill's job as a surveyor for a western Virginia railroad, allowing Bill to finish his degree. Then Chris studied again. In this way the boys put each other through college. With engineering as his major, my grandfather transferred to Washington and Lee University. He worked like a madman to graduate in 1908, and then remained at his alma mater to teach math and science for a year.

Christopher Chenery graduated from Washington and Lee in 1908 with an engineering degree and a Phi Beta Kappa key, which he wore proudly all his life.

Soon his love of the outdoors lured Chris Chenery to Alaska to survey a railroad route. Barely a decade after the Gold Rush of 1898, conditions were still primitive in the Yukon. His tales of roughing it on the Chilkoot Pass remained a highlight of his life.

In Portland, Oregon, the last civilized outpost before the frozen north, my grandfather made a discovery, not of gold, but of something more valuable. He met a professor's daughter named Helen Bates, a smart and pretty girl with spirit in her lively, deep-set eyes. She found him intriguing, charming, and even a little wild. But her family disapproved of the brash young Virginian with no money and no name. After three stormy years of courtship, Helen overrode their disdain and married the engineer from the South, leaving a permanent rift with her Oregon kin.

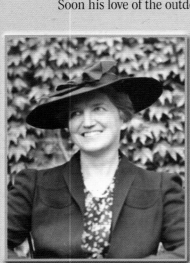

Pretty Helen Bates married brash Chris Chenery over her family's objections.

Helen and Chris bonded, perhaps unconsciously, over their mutual hunger for the affirmation of success. In Helen, this need stemmed, not

26

just from poverty, but also from growing up a virtual orphan. Her mother, Cora, had died of a ruptured appendix when Helen was only seven. Her father, Henry Liberty Bates, was so busy as principal of Tualatin Academy in Forest Grove, Oregon, that he felt unable to care for his three small children by himself. Helen, her little sister Margaret and brother Hal, were sent to live in Portland with Minnie and Carrie Nichols, maiden aunts who did not understand children very well. Losing her mother so young and then her father, too, made Helen yearn for something indefinable her whole life.

Young Chris Chenery in center with dark shirt at the surveyors' camp in Alaska, 1910.

My grandmother grew up with adequate food, but she lacked self-esteem. She wore hand-me-downs from wealthier cousins who teased her about it. Later her uncle Clarence Nichols generously sent her to Smith College in Massachusetts, but failed to give her any money for the cross-country trip. She spent a ravenous five days on the train from Oregon to Massachusetts with only an apple and a few chocolate bars to eat. At Smith, she lived in the drab dorm for the minority of girls who worked to supplement their tuition. All of these slights made her frugal and deeply status-conscious. She became an excellent seamstress and supported herself sewing clothes. Then, as a young wife, she made all the family's clothes. Later, she always kept two hundred-dollar bills hidden in a secret pouch under her dress, just in case. Chris would tease her about her "bank," but it rescued him from embarrassment many times.

Having money went

Chris Chenery (left) thrived in the great outdoors as a surveyor in the Yukon Territory.

27

My grandfather served with the Army Corps of Engineers at Fort Belvoir where he taught equitation. When an officer asked why the riding instructor was not a West Point man, his superior said, "Ride with Major Chenery and you'll know."

28

a long way to ease her sadness, but it couldn't fill the deep void her mother's death had left.

When Chris brought his new bride to meet Jimmy and Ida in 1917, his mother regarded her with the same prejudice as the Nicholses had viewed Chris. Ida reportedly said, "I thought there were only barmaids in Oregon." Helen found such rudeness—coming from a Southern woman no better off than herself—insufferable. Although Helen lived with Ida in Ashland during Chris's service in World War I, the ladies remained cool toward one another. Helen had her first two children there: Hollis (1918–1994) and Margaret (1920–1993). She and Ida kept an uneasy truce as long as Chris was away, teaching the Cavalry to ride while serving in the Army Corps of Engineers at Fort Belvoir. Jimmy Chenery's death in 1918 added to the strain in the household. As soon as he could, Chris took his little family north. His beloved Virginia couldn't offer him the future he craved, and there would be no peace as long as his feisty wife and his domineering mother shared a home.

Chris and Helen rented a house in Spuyten Duyvil, a waystation north of New York City full of Southerners looking for opportunity. In 1922, the Chenerys had a third child, Helen, whom they called Penny. Working as a consulting engineer, Chris struggled to provide for three children, a wife, a house, and his widowed mother back in Ashland.

Two traumas marked this time, both caused by lack of money. In the summer of 1924, Helen took the children to the West Coast to nurse her adored younger brother Hal, who had been gassed in the war while serving as a doctor in France. They stayed at Tioga, a beach camp in Washington State with nineteenth-century charm but no electricity or plumbing. It was so isolated that they had to flag down the train to send or receive word from the outside. Helen cooked, cleaned, washed, tended the children and nursed her brother for two months, all by herself. It literally ran her ragged and she contracted strep throat, which led to rheumatic fever and permanent heart damage. That fall, despite her best efforts, Hal died. My grandmother was devastated.

Just two years later, my great-uncle Bill lost his wife Dai under similar circumstances. They had three children nearly the same ages as Chris's and the two families lived close by. Two of Bill's children got sick at once, and Dai so exhausted herself caring for them that she developed a virulent form of meningitis and died overnight.

Both illnesses might have been averted had they been able to afford help, and none of them ever forgot it. My grandfather now redoubled his efforts to earn money. He applied his prodigious energy and determination to banish financial worries forever from the lives of his loved ones.

He set about studying finance, developing new theories which he shared with venture capitalist George Ohrstrom. Together they formed the Federal Water Service Corporation, buying up small utilities across the nation. Leveraging the assets of one to purchase another, they were able to operate them at greater profit as one company than as separate entities. Eventually, their corporate assets grew substantially, as did their net worth. In time the two men split and Granddaddy branched into gas and oil, forming Southern Natural Gas Corporation and much later, the Offshore Company. My grandfather became nearly as adept at high finance as he was at riding horses.

Hal Bates died after being gassed in France during World War I, despite his sister Helen's devoted nursing care.

My mother clearly remembers the day in 1928 when her father came home from the office and announced at the dinner table, "Well, now I've made a million dollars." If my mother, then only six, didn't quite get the full meaning of that thunderbolt, she knew that it meant the world to her parents.

From that day on, their lives changed considerably. Money went from being a constant source of worry to being a source of pleasure. The Chenerys moved to a nicer community, Pelham Manor, and built themselves a grand Tudor-style house with an ample garden for Helen's roses. Neither Ida nor Jimmy had lived long enough to benefit from their son's success, but at least his siblings did. My grandfather put all his assets into a new company, Chenery Corporation, and gave stock to his siblings. He had plenty to share. The utilities business survived the Great Depression because, as he said, people always needed gas and water.

He had finally made it. The Ashland boy who had gone barefoot in the summer to save his shoes was now a well-heeled captain of industry with an office in an elegant new building at 90 Broad Street, right around the corner from the New York Stock Exchange.

Now that he had the means, he could indulge in his passion for horses. He immediately created his own riding club. Mother explained:

In the early days he played polo and hunted foxes, but when we moved to Pelham Manor, there wasn't a good place for him to ride. As soon as he made his first million in 1928, he founded Boulder Brook, a riding club in Westchester County. They had few horses to begin with, and Dad was still pretty close to the dollar in those days, so he wired Mother's old friends from Smith College, Kingo Perry and Portia Mansfield, who had a ranch in Steamboat Springs, Colorado. They sent some wranglers with wild Bureau of Land Management mustangs on the train from Denver to New York. When Dad met the train in Scarsdale, the

cowboys unloaded the horses, but there was no way to transport them to Boulder Brook, a few miles away. So Dad and the boys just herded them on horseback down the main street of Scarsdale. Traffic was completely stopped, and everyone gawked as if a Wild West show had come to town. It was just the sort of thing Dad loved. When a policeman decided he had to intervene, he threatened to arrest the horses for going through a red light. Dad replied mildly, "Officer, you can't do that. Don't you know horses are color-blind?" They got to Boulder Brook without further incident.

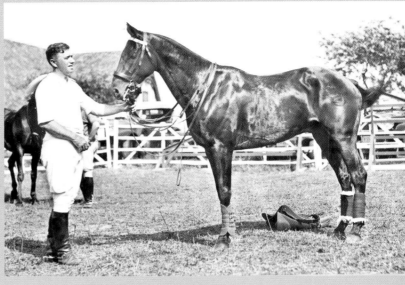

Granddaddy at Boulder Brook in the late 1920s.

Boulder Brook became a riding club, a polo club and a training center for equestrians, including young Jacqueline Bouvier (later Jackie Kennedy Onassis). The club's polo team played competitively against Ivy League schools. During the Depression, when many members couldn't pay their dues, my grandfather bought the club to keep it open. Today it still operates as Boulder Brook Equestrian Center, with one of the largest indoor riding rings in the country.

Chris Chenery founded the Boulder Brook Riding Club in Westchester County, New York. It still operates today.

Chris Chenery had driven himself mercilessly to achieve financial success. Now he wanted to have some fun, too. But his sort of fun didn't involve leisure. Penny says of her father: "He needed projects. He was very creative, smart and innovative. He loved to take risks, but first he had to sit alone with the numbers. Solving problems was fun for him. That's how he made a lot of money, which he enjoyed sharing with his family. And he was fearless. He liked nothing better than a challenge."

The robust, vigorous man who relished the thrill of polo and foxhunting as much as the challenge of high finance, was about to encounter a hurdle he had not expected. In 1936, at the height of his success, he had a serious heart attack at age fifty. It would change everything.

First, the doctors insisted he abandon his hard-charging equine sports. He could still ride, but for pleasure only. Friends and family convened a meeting to ask, "How are we going to get this bundle of energy to slow down?" A cousin, Hill Carter, an Ashland cardiologist, suggested a more sedentary horse activity: Thoroughbred breeding.

Why not? Chris's brain clicked, recalling his early fantasies of horse racing, visions that Cousin Bernard had sown with tales of Bullfield's glories. With the advent of cheap radios, Movietone newsreels and re-legalized betting, the drama of racing was thrilling more Americans than ever before. Many of his associates, the biggest names on Wall Street, owned fine stables of Thoroughbreds. It made sense, but where? No sooner had he asked the question than he knew the perfect place—back in Virginia, next to Bullfield, deep in the happiest memories of his childhood.

Granddaddy in a rare moment of relaxation.

31

Hard-charging Chris Chenery encountered a hurdle he had not expected. In 1936 he had a heart attack at age fifty.

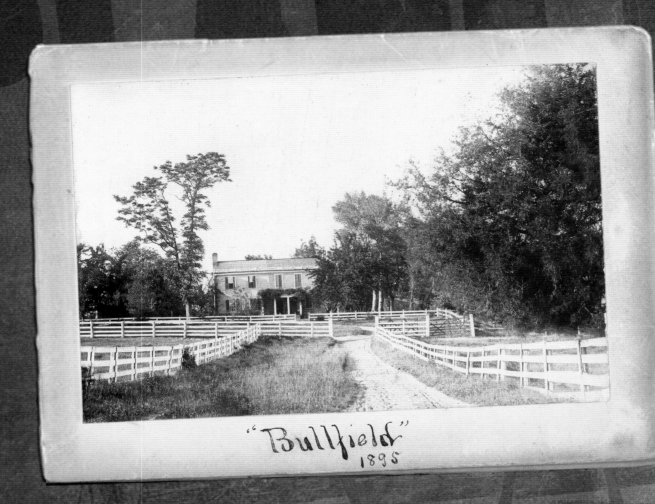

"Bullfield"
1895

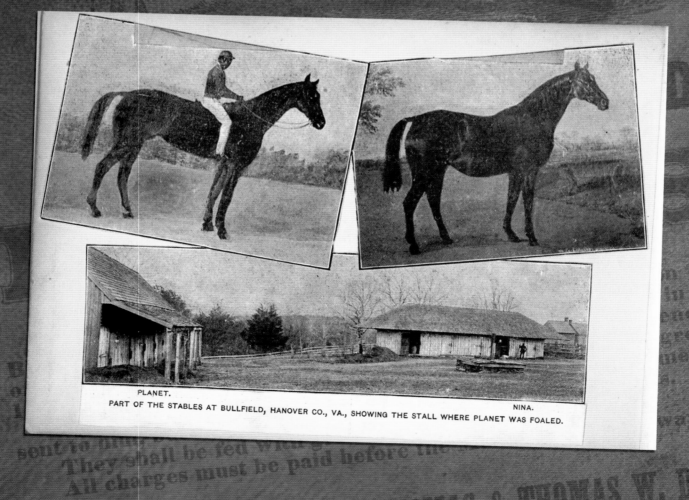

PLANET. NINA.
PART OF THE STABLES AT BULLFIELD, HANOVER CO., VA., SHOWING THE STALL WHERE PLANET WAS FOALED.

BULLFIELD
THE MECCA OF VIRGINIA TURFMEN

Author's note: We knew little about Bernard Doswell and Bullfield until we met his granddaughter Sarah Wright, a cousin of Hardenia Ferguson and thereby a distant cousin of ours. Sarah, an Ashland historian, wrote a detailed history of the Doswell family, its farm and its famous racehorses called "The Doswell Dynasty." Her home in Ashland was adjacent to the home my grandfather grew up in and she remembered playing with my aunt and uncle as a child. To our surprise, the more we learned about Bullfield, the more similarities we discovered to The Meadow.

Bullfield gained renown as one of the most successful racing and breeding farms of the nineteenth century. Its Thoroughbreds distinguished themselves on racetracks from New York to New Orleans, long before the epicenter of horseracing and breeding shifted to Kentucky. Bullfield became known as the "Red Stable" because so many of its winners were chestnuts and its jockeys wore solid orange silks.

The incongruously named Bullfield was founded by Bernard's grandfather Thomas Doswell in 1824, who later operated it in partnership with Bernard's father, Thomas Walker Doswell. Their names became synonymous with the finest bloodstock in America, as well as for the excellence of their Southern hospitality. So important was racing to the family that the portrait of Thomas Doswell shows his hand on the Turf Register, while his wife's portrait shows her hand on the Bible.

The farm's own racetrack originally was laid out in 1820 as a mile-long oval with markers to delineate each furlong. In 1882, *Frank Leslie's Illustrated Newspaper,* the *Time Magazine* of its day, featured the Bullfield track, describing it as one of the finest training centers in the country.

A treed circumference of rising ground around the track served as a natural grandstand. Here, scores of Major Thomas W. Doswell's gentlemen friends gathered each spring to watch the young colts run during Bullfield's much anticipated "Field Day." Afterwards, in keeping with Major Doswell's fabled hospitality, a sumptuous dinner would be served, complete with mint juleps presented in sterling silver goblets with silver straws.

The Red Stable's most famous son was Planet, a chestnut stallion born in 1855 who earned the nickname "the great red fox." He won twenty-seven of thirty-one races and became the top money winner with nearly $70,000 in purses, a record that stood for twenty years. In those days the horses raced in three-and four-mile heats, sometimes running as much as twelve miles in one afternoon. The versatile Planet was also an accomplished trotter who could do a mile in three minutes.

The Civil War and its aftermath curtailed racing in the South and diminished what would have been Planet's best years at stud (1861-1868). During the war, many of the Bullfield horses were hidden in the woods to protect them from Yankee marauders.

Despite the handicap of war, Planet managed to sire impressive offspring who made turf history of their own. His blood figures in the pedigrees of Kingman, winner of the 1891 Kentucky Derby; Bowling Brook, winner of the 1895 Belmont Stakes; the great filly Regret, who won the Kentucky Derby in 1915; Exterminator, winner of the 1918 Kentucky Derby; and (on the female side) Fleet Nasrullah, successful son of the legendary Nasrullah, the grandsire of Secretariat.

Planet's eminence was such that Major Doswell commissioned the renowned equine artist Edward Troye to paint a portrait of the horse with his black jockey Jesse in the saddle. During a raid on Bullfield, the portrait was cut from its

◄ Bullfield Stable would be an early influence on young, horse-crazy Christopher Chenery. Shown in this montage is the famous Troye portrait of Planet with Jesse, his jockey; Planet's dam, Nina; and a view of the stables.

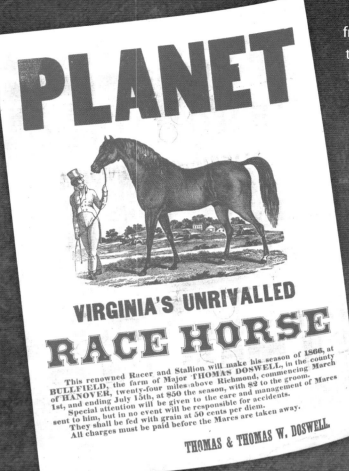

PLANET

VIRGINIA'S UNRIVALLED

RACE HORSE

This renowned Racer and Stallion will make his season of 1866, at BULLFIELD, the farm of Major THOMAS DOSWELL, in the county of HANOVER, twenty-four miles above Richmond, commencing March 1st, and ending July 15th, at $50 the season, with $2 to the groom. Special attention will be given to the care and management of Mares sent to him, but in no event will be responsible for accidents. They shall be fed with grain at 50 cents per diem. All charges must be paid before the Mares are taken away.

THOMAS & THOMAS W. DOSWELL.

frame by Yankee soldiers. It was later found in a ditch and returned to the Doswells by someone who recognized the orange silks worn by Jesse.

Planet's dam, Nina, pronounced with a long "i," was famous in her own right. The best racing daughter of the great sire Boston, she gave Bullfield Stable fifteen outstanding foals, including Exchequer and Ecliptic. She was one of the reasons that writers referred to Bullfield as "a nursery of Virginia racehorses." When the revered old mare died at the age of thirty-two in 1879, her obituary appeared in the newspaper.

The stable's fame was such that in 1882 the *New York Sportsman*, displaying then-popular nostalgia for "the Old South," hailed Bullfield as "the Mecca of Virginia's Turfmen" and lauded Major Thomas W. Doswell as "a Virginia gentleman."

The African-American jockeys and trainers of Bullfield contributed significantly to the success of the "Red Stable." There was Jesse, who rode Planet to many victories and was immortalized in the Troye painting. George rode Bushwhacker, "the iron horse" in three four-mile heats at Pimlico in 1877-78. Most notably, there was "Daddy Phil" Thompson and Morris Goodwin. Phil Thompson, who was born a free man, worked for Major Doswell at Bullfield for fifty-seven years, from 1825 to 1882. He began as a jockey, then became known as "one of the best colored trainers of his day." Morris Goodwin was born at Bullfield. He worked as a

Planet, a chestnut stallion born in 1855, was called the "great red fox." In the era that he raced, horses ran heats of three to four miles, sometimes running as much as twelve miles in one afternoon.

trainer, jockey and coachman and was very well regarded in racing circles. Racing was one of the few arenas where a black man could achieve respect, if not equality.

Bernard Doswell was born in 1860, just before the outbreak of the Civil War and before Planet was retired to stud at Bullfield. After his mother sold Bullfield in 1901, Bernard remained on a portion of the land called Hildene. He ran a small stable himself, aspiring to but never achieving the glory enjoyed by his father and grandfather during "the golden age of Virginia horse racing."

Despite achieving a measure of respect for his training skills, Bernard became something of a black sheep within the family. He was known to be fond of drink, and townspeople would chuckle about how his horse knew his way around the town of Ashland, stopping at the trees where Bernard had stashed his not-so-secret bottles of liquor.

Bernard may have felt he could not possibly live up to the legacy of his father and grandfather. In their day, a pantheon of champions sprang from Bullfield. In addition to Planet and Bushwhacker, there was Nina's son Algerine, who won the Belmont Stakes in 1876, along with Sarah Washington, Fanny Washington, Eolus, Eole, Knight of Ellerslie and Heimdal. Many of the champions were bred by Richard Hancock of Ellerslie near Charlottesville, and trained by the Doswells in a partnership that dated back to 1871. Richard's son, Arthur B. Hancock, would later found Claiborne Farm in Kentucky.

Bernard did enjoy success with the stable's last great racer, Morello, which he bought from the Hancock farm at Ellerslie. He purchased him for $100 in 1892 and the colt reportedly won $98,000 in his first season.

Bernard's greatest contribution to the "Sport of Kings" may have been to kindle a spark in the heart of Chris Chenery, a

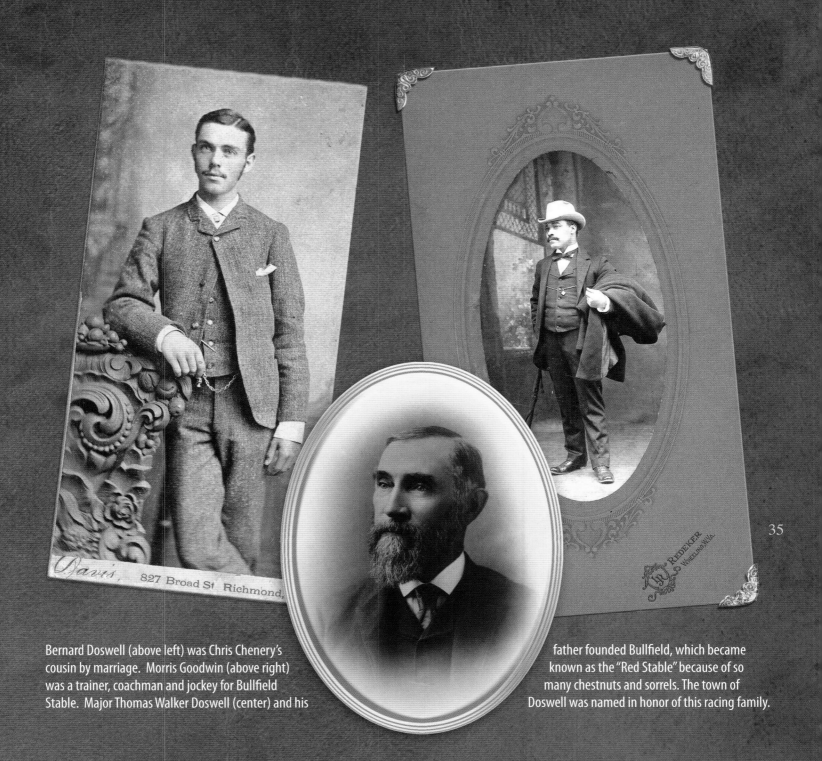

35

Bernard Doswell (above left) was Chris Chenery's cousin by marriage. Morris Goodwin (above right) was a trainer, coachman and jockey for Bullfield Stable. Major Thomas Walker Doswell (center) and his father founded Bullfield, which became known as the "Red Stable" because of so many chestnuts and sorrels. The town of Doswell was named in honor of this racing family.

35

horse-crazy young boy who would walk seven miles from Ashland to help exercise his cousin's Thoroughbreds. Decades later, my grandfather's farm would produce its own pantheon of champions.

Indeed, history would repeat itself in ways both subtle and dramatic. Chris Chenery would name his first foundation mare Hildene. It was a prescient move, for she would be his Nina. She and other remarkable mares to follow would produce their own nursery of Virginia racehorses for The Meadow that would later be known as an empire built on broodmares. And, like Major Doswell, my grandfather would be lauded by sportswriters as a Virginia gentleman.

As The Meadow underwent its transformation into a Thoroughbred farm, the design of the stable buildings and fences would resemble those at Bullfield. The grand tradition of Major Doswell's Field Day would be revived when Chris and Helen Chenery began hosting the famous Camptown Races for community enjoyment.

And, echoing the hoofbeats of Planet, the "great red fox" of Bullfield, a mighty red stallion would carry Meadow Stable's colors into immortality.

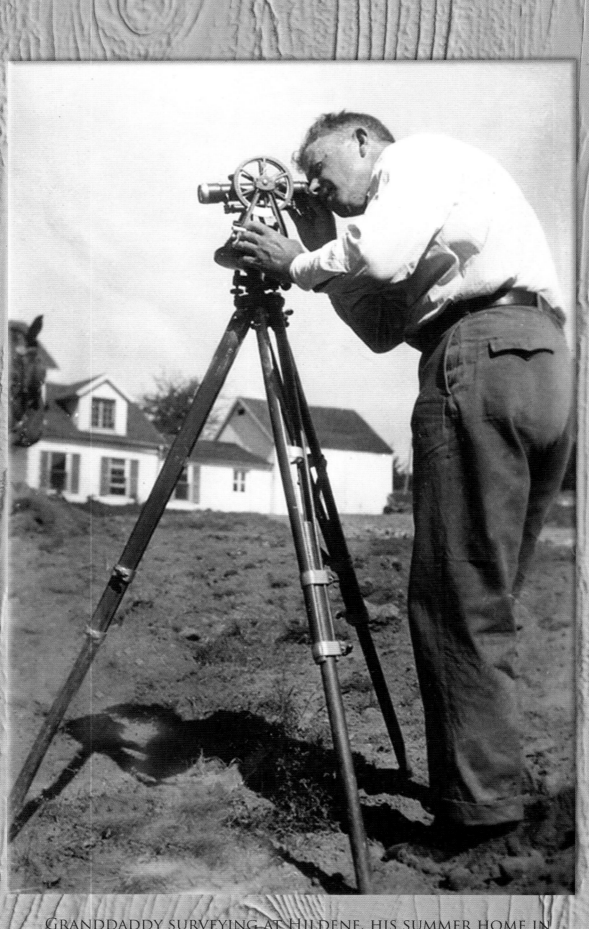

GRANDDADDY SURVEYING AT HILDENE, HIS SUMMER HOME IN
COLEBROOK, CONNECTICUT. HE LOVED TO BUILD, CHANGE,
REMODEL AND RESTORE.

Operation Rat Hole

Acquiring The Meadow allowed my grandfather to indulge in his greatest passion, horses. The world he created there became a haven for Thoroughbreds as well as for people. In time, the land and the workers would produce the most perfect horse ever seen.

But the first time Mother saw The Meadow in 1936, she was appalled. They'd driven down from New York to tour the Madeira School, the Virginia boarding school that my Aunt Miggie (Margaret) was attending. Granddaddy wanted to give Mother, his only New York-born child, a thorough dose of Southern life. Mom acquiesced because the school allowed students to bring their horses. Granddaddy hadn't seen The Meadow since Cousin Emily had sold

Mom (standing third from left) was captain of the riding team at the Madeira School, circa 1939.

it in 1912, and he wanted to show it to his wife and daughter. Thirteen-year-old Penny viewed the detour as just one of her father's tedious schemes. She had no idea that the day's events would renew not only her father's life, but three decades later, hers as well.

For two hours on that spring day, the long black Cadillac swept smoothly through piney forests, over sudden hills and onto bridges spanning muddy rivers. The car flashed past landscapes offering Mother impressions of unpainted shacks, rusted cars and raggedy children, signs of Depression-era poverty she rarely saw growing up in Westchester, N.Y.

At long last, Granddaddy signaled to Maudin, the chauffeur, to swing left onto a dirt road. They crossed a narrow bridge and climbed a slight hill, stopping at a gas pump in front of a small store. Grandfather stared in wordless surprise at the sign, "Hart's Corners." Maudin then steered the big limousine left onto a dirt road that led past tall trees to a weathered three-story house that loomed starkly over a bare yard. A spotted dog barked as the car pulled up to the gray porch. Maudin opened the door for Grandfather, but when Mom scooted over to follow, he growled, "You and Helen stay in the car. I'll be right back."

37

The Harts' dog with the old office in the background.

In disbelief, Mom surveyed the place her father had described to her as the glory of his youth, the place he spent his happiest days. Surely this couldn't be it? Soon she noticed a girl about twelve and a boy about seven standing silently in the corner of the yard, watching them. Just then, Grandfather exited the house, almost tripping down the bare steps in haste. When he saw the children, he stopped short and pulled a five-dollar bill from his wallet, handing it awkwardly to the girl. She took it with a surprised look, and Granddaddy jumped into the car. Asked why he had given the girl the money, Granddaddy said curtly, "For candy." His severe look made Mom stifle other questions. Shortly he swore, "Damn. They should never have let it go."

Back on the road, Maudin took the Cadillac further up the hill before entering a road on the right. At the end was another unpainted house, smaller, in a pretty clearing of trees. This was Over Yonder, Cousin Deenie's home, and she had invited them for tea.

A recent widow, Deenie Ferguson was a lively woman of sixty in a black dress, with white hair swept up in a bun and, curiously, a glove on just one hand. She lived on land that had been parceled out from original Meadow acreage in 1842. She had farmed actively until she mangled her gloved hand on farm equipment. Her passion now was family history.

As Deenie welcomed them, Mom noticed her uniquely Central Virginia pronunciation of Cheenery, rather than Chenery. She also added an "ie" sound to "ar" that turned 'garden' into "gie-arden." Granddaddy had taken pains to lose his Virginia accent, but in Deenie's presence his vowels softened and lengthened again. Mom wanted to ask why none of the houses she saw had any paint, but remembering that the Depression was still going, she kept quiet.

That day Deenie fussed over my grandfather as a mother might over a long-lost son. He responded warmly, but Grandmother viewed her charm with suspicion. Her fears were confirmed when Deenie pointed down toward The Meadow and cooed, "Don't the old elms arch prettily over the old homeplace? Isn't it a shame it ever left the family?" Grandmother wanted to roll her eyes, but Grandfather agreed emphatically. Before nightfall, he had offered to buy back the Harts' 400 acres. Typhoid had recently been found in the well, so the Harts welcomed the deal. Grandmother could only shake her head. "Operation Rat Hole," as she saw it, had begun.

With adequate money and The Meadow now his, my project-loving grandfather was like a child set loose in a toy store. He had so many ideas he didn't know where to begin. He wanted to bring the

Decades later the Harts still remain close to The Meadow. The son, Robert Hart, now of Smithfield, became a photographer and shot identification photos of Meadow foals for the Jockey Club during the 1970s. He courteously shared his portfolio with Mother. The daughter, Catherine Hart Bushee, remembers her time at The Meadow with great fondness, both for the beauty of the land and the pleasure of playing in the breezy upstairs hall. She also recalled the stone troughs in the basement where the milk was kept cool. Her daughter, Cathette Plumer, is involved in horses in the Richmond area.

Thoroughbreds he had at Boulder Brook down right away for riding. But first, he needed to build stalls and barns, erect miles of fencing, establish a source of clean water, obtain hay and hire workers.

Making the water drinkable was a challenge tailor-made for an engineer/utilities magnate. He devised a pumping system that pulled water from the spring, filtered it, then piped it all over the farm to houses and horses. Granddaddy would no more risk giving raw river water to the horses than he would to the people.

Next he had to enrich and revitalize the soil depleted by years of continuous tilling. Many folks believed that Thoroughbreds grew best on Kentucky bluegrass with its limestone-enriched soil. But Granddaddy knew that The Meadow's fall-line geology offered mineral-rich soil, and that great champions had thrived on local grasses at Bullfield. Always thorough, he consulted farmers and scholars alike to learn about acidity, alkalinity, grasses, grains, rainfall and fertilizers. Eventually, he seeded his horse pastures with the most nutritious forage he could find and planted other fields with timothy and hay to supplement their feed.

While he was renovating the land on the main level, Granddaddy also attacked a much bigger challenge: clearing the Cove and rebuilding the dike. First built by slave labor in the 1820s, the dike had kept the North Anna River back from the marshy acres of the Cove until it burst during the Civil War. After seventy years of neglect, an impenetrable tangle of vines had overrun the Cove. As an engineer, Chris relished the cyclic battle against seeping water, a contest the river and time always won. As a weapon in the fight, Granddaddy bought the biggest McCormick earth mover he could, a behemoth that remained in use in

Granddaddy surveyed the Cove and rebuilt the dikes, which had first been constructed by enslaved workers.

39

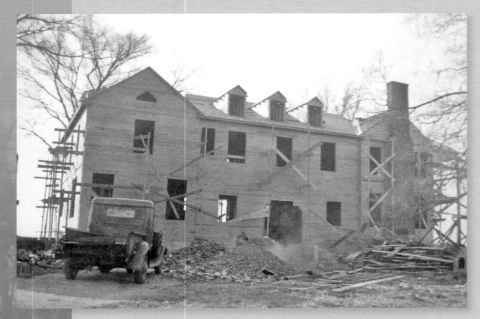

The old Morris house under renovation in 1937. Granddaddy added the ell on the left. The rest dated from 1808 (middle section) and 1851 (right wing.)

the 1960s, according to Mom. He used it to add to the dike's height and length until it measured forty-seven feet high, fifty feet thick and a mile long.

In the midst of the renovations, old legends about the Cove resurfaced, including stories that an escaped slave or a crazy relative hid among the brambles for years. But no proof of the claims ever emerged.

Clearing the undergrowth and rebuilding the dike were only the first steps. Granddaddy had to drain the swampland as well. He dug a series of eight-foot-wide ditches with a complex system of sluice gates and locks and a massive pumping system to remove the water. Even so, it took seven years to dry out the land. Eventually, most of the Cove became arable, with hay growing on one section and broodmares and foals grazing on another.

With the land renovations underway, Granddaddy turned his attention to the graying old house. The structure needed a careful facelift and modernizing, including electricity and indoor plumbing. An architect friend and neighbor in Pelham Manor, Charlie Hart, had little work during the Depression, so Granddaddy gave him the task of updating the manor while retaining its historic character. Together the friends settled on a blueprint that added a wing with a modern kitchen below and two bedrooms above. The original L-shaped house became a "U" with the flat bottom facing the Cove on the north and the opening facing Route 30 on the south. They added a modern circular drive to the new north entrance, and replaced the old driveway on the south with a lawn lined with boxwood hedges to screen out the road. Inside that space Grandmother planted a rose garden as a reminder of her hometown, Portland, Oregon, the "City of Roses."

A portico framed the new front door, with sidelights, an elliptical fanlight, fluted columns and a faux balcony on the roof. It was a discreet nod to the classic columned porches of antebellum mansions.

True to character, my grandfather valued functionality over grandeur, although he enjoyed comfort as much as anyone. As a result, the new façade was asymmetrical and the window heights didn't quite match. Visually the house suggested gentility without harmony—somewhat like its owner.

Granddaddy adored The Meadow and he was never happier than when he was riding on its fields. But it couldn't ease his restlessness or calm his hard-charging nature. My grandfather saved for himself the pleasure of designing the look and layout of the farm buildings. He knew just what he wanted: simple white

barns sided with thick clapboard, topped by vented cupolas, all trimmed in primary blue.

The yearling barn was typical. It had an office and a tack/grain room that book-ended a single row of stalls shaded by a long covered porch with square columns. Rear windows ventilated each stall and Dutch doors encouraged the horses to socialize with people and each other. In front, a shady walking ring with a water spigot to one side, allowed the grooms to walk and water the horses in comfort. Tall trees shaded the entire area. Granddaddy's barns created serene environments in which to house contented horses.

If he was going to raise the best Thoroughbreds he could, clearly the comfort and safety of the horses had to come first. This vision touched every aspect of the farm. He designed pastures and paddocks with durable four-board white fences. He built a three-eighths-mile indoor training track for exercising during inclement weather, as well as a mile-long outdoor track with a viewing tower that allowed accurate timing of workouts. He deepened existing ponds and added new ones. He built a pleasant home for his manager with offices both at the training center and near the main house. Within two years most of the essential structures were in place. The Meadow had become an attractive, well-equipped horse farm.

But symbolically it was much more than that.

The act of restoring The Meadow salved some of the painful feelings of loss that Jimmy and Ida Chenery,

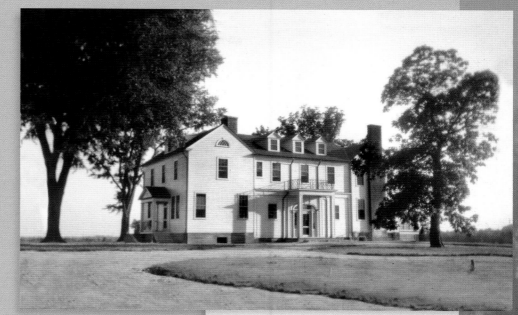

The finished house with new front entrance and circular drive, 1937.

The south lawn was lined with boxwood hedges to screen out the road (Route 30).

This 1937 photo shows the back of a barn still under construction.

41

despite themselves, had instilled in their children. The social revolution that began with the Civil War (and which renewed itself in the Civil Rights Movement) had eviscerated the culture and identity of the white Southern gentry. Without money or position, who were they? As a result, in the 1880s a myth emerged that the antebellum South was somehow kinder and nobler than its post-war image.

Granddaddy knew this was false, but grew up longing for the storied past anyway. That was why seeing The Meadow in its dilapidated state so disturbed him. Being able to reinvest it with graciousness, to

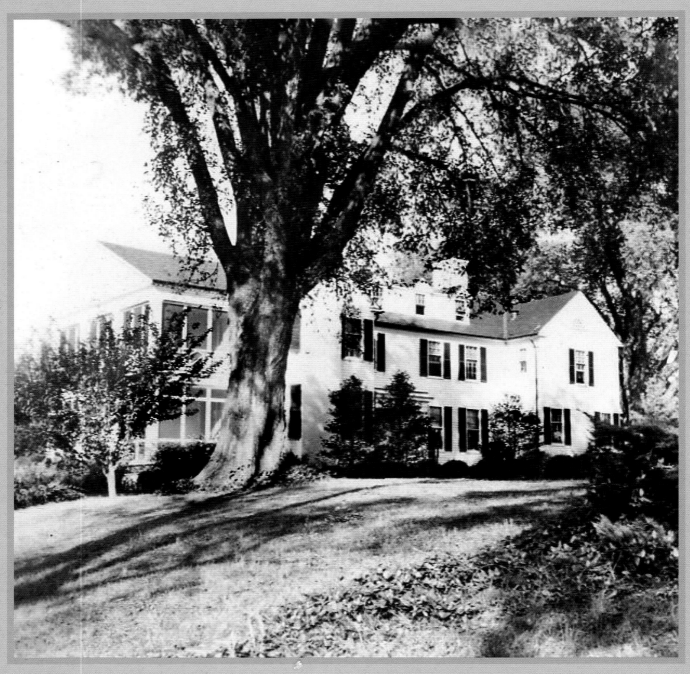

A view of The Meadow house from the edge of the family graveyard in 1947.

replant the fields in rich grasses, to stock it with fine horses—all this restored order and harmony to his sense of the world. Furthermore, as one of the largest employers in the area, he was in a position to offer jobs to the grandsons and granddaughters of former enslaved workers. For him, if not for his workers, it brought the traumas of the previous century to a close. It allowed him to look forward, to embark on the next adventure, to breed talented horses who might one day compete on the same storied tracks— Saratoga, Belmont—that had inflamed his imagination as a boy.

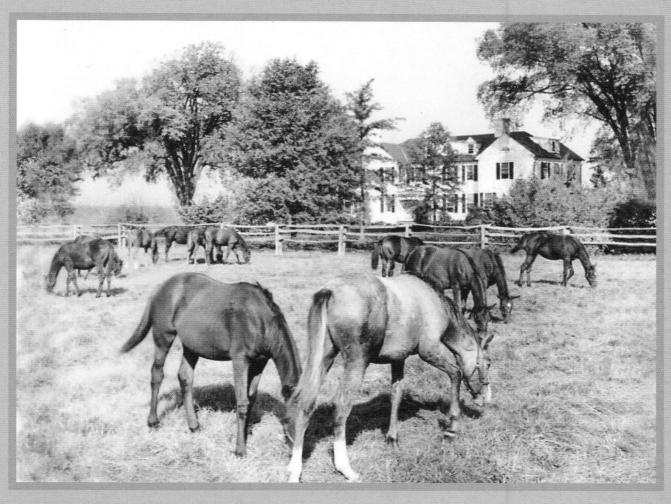

Meadow yearlings grazing by the house, circa 1947.

43

Friendship: The Hancocks and the Chenerys

As a young Confederate soldier from Alabama, Richard J. Hancock was sent to Charlottesville, Virginia in 1864 to recuperate from serious wounds. There he wooed and won Thomasia, daughter of a wealthy local farmer, Overton Harris. Richard and Thomasia soon inherited Ellerslie, a farm named for the Scottish estate of Sir William Wallace (aka "Braveheart"). When Hancock set about transforming his land into a horse farm, he sought the guidance of Major Thomas Doswell of the famous Bullfield Stable. Soon the Doswells and the Hancocks were partners, and Ellerslie became a reputable source of well-bred yearlings and the stud services of champion stallions. When Major Doswell retired in the late 1880s, he sold his orange racing silks and his stock in Ellerslie to the Hancocks.

By the turn of the twentieth century, Richard's son, Arthur B. Hancock, Sr., had brought renown to Ellerslie by breeding the best stallions and mares he could find and selling the resulting yearlings at Saratoga. In 1910, Arthur's wife, Nancy Clay, inherited a farm in Kentucky, which they named Claiborne and converted to a Thoroughbred operation.

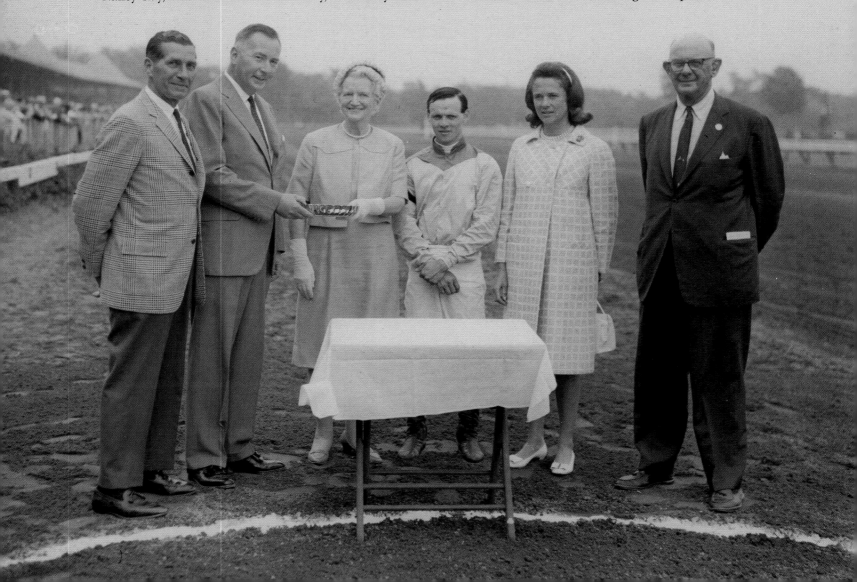

By the late 1930s, A. B. Sr. had gone into partnership with his son A. B. Jr., who was known to all as "Bull." In 1946, Bull sold Ellerslie and focused on Claiborne Farm instead. Over time, he met and surpassed his father's reputation as the most eminent Thoroughbred breeder in the nation.

My grandfather counted the Hancocks as good friends and business associates. Both men gave Granddaddy solid breeding advice as he began to launch The Meadow as a Thoroughbred farm, and Granddaddy returned the favor. He stood two of his top stallions (Hill Prince and Sir Gaylord) at Claiborne for stud services and helped to establish the reputation of the Hancocks' Princequillo by breeding to the English stallion early in his stud career.

Bull Hancock shared his private box at Churchill Downs with The Meadow team for the 1972 Kentucky Derby. Left to right: Penny Tweedy, Bull Hancock, Lucien Laurin and Jack Tweedy.

Although Granddaddy discounted the wisdom of his choice by noting that Princequillo was cheap and handy at nearby Ellerslie, it was in fact a key move for both farms. Not only did Princequillo sire Granddaddy's first Horse of the Year, Hill Prince, which made the Hancocks' stallion's reputation, but he also gave Grandfather his invaluable mare, Somethingroyal. Her many winning offspring included her greatest son, Secretariat.

In the 1960s, when she was learning the ropes of horse racing, Mother would consider herself grateful for the support and advice of Bull and later, his son Seth. She then repaid their kindness by asking Seth to syndicate Secretariat and Riva Ridge and stand them at Claiborne as studs. I once joked to Dell Hancock, Seth's sister, that Secretariat had built our family cabin in the mountains. She responded, "Secretariat has built quite a few things around here, too."

Long after these two families began a relationship that profoundly affected Thoroughbred breeding in the twentieth century, we discovered an ancestral link that made us distant cousins. Arthur. B. Hancock Sr., James H. Chenery and Ida B. Taylor all descended from the same Overton and Harris families of Hanover County. Furthermore, A.B. and Nancy Hancock picked the name Claiborne for their farm in Paris, Kentucky, after Sir William Claiborne, another common ancestor of both the Hancocks and the Chenerys. Sir William was the colonial leader who earned the enmity of Marylanders for trying to annex the Chesapeake Bay to Virginia. Fortunately his descendants seem to have united the horse racing world in support of their Thoroughbred bloodlines.

My grandmother, Helen B. Chenery, presenting a trophy at Saratoga. Left to right: Trainer Jim Maloney, William Haggin Perry, Grandmother, jockey Eddie Belmonte, Mrs. Perry and A. B. "Bull" Hancock, Jr.

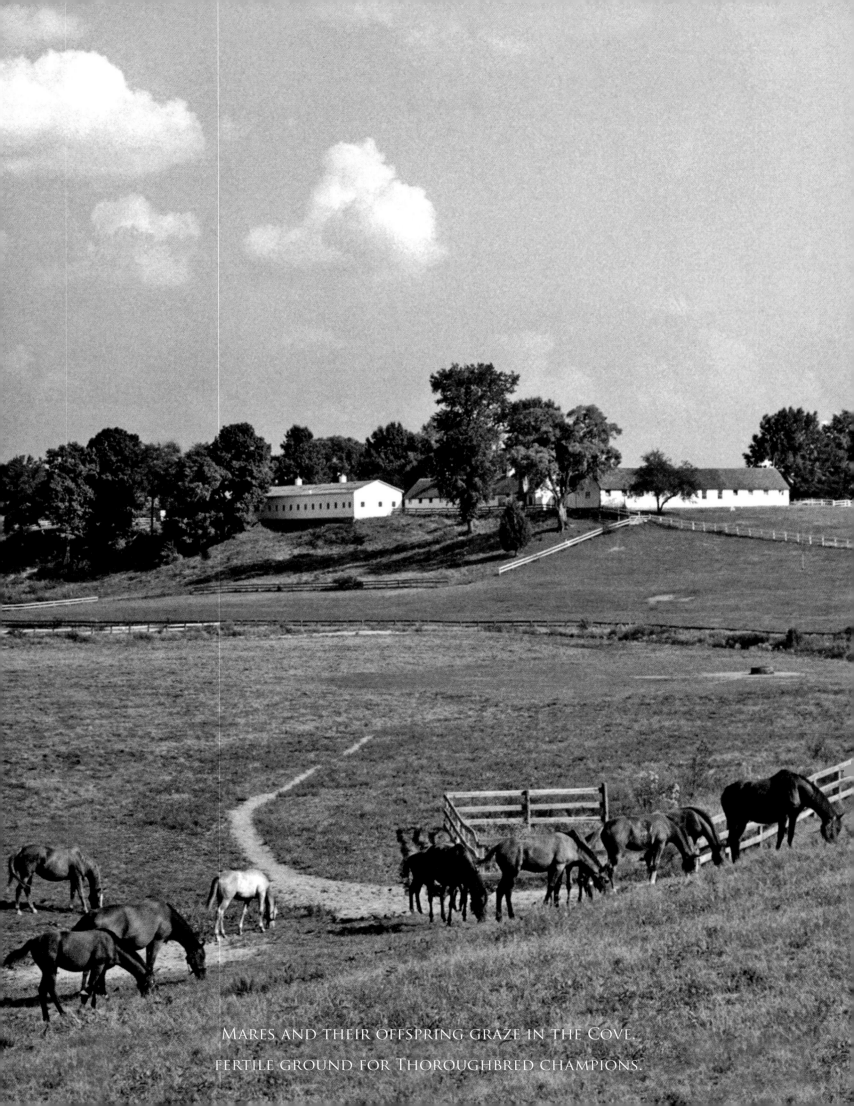

Mares and their offspring graze in the Cove,
fertile ground for Thoroughbred champions.

The Empire Built on Broodmares

As a man accustomed to shaping his own destiny, Chris Chenery molded The Meadow to fit his vision of a first-class Thoroughbred horse farm. In doing so, he also recast the destiny of horse racing in America and of his own family in ways no one could anticipate.

By 1939, Granddaddy had finished the physical renovation of The Meadow. Selecting horse stock to fill the new barns and pastures was next. For advice, he headed to the summer racing meet at Saratoga Springs, New York, where Thoroughbred owners had been gathering for sales, races, gossip and parties since the 1880s. Through business connections, Granddaddy already knew a number of Jockey Club members, including auto mogul Walter P. Chrysler, Jr., who owned North Wales Stud in Warrenton, Virginia. Chrysler introduced him to Arthur B. Hancock, fellow Virginian and breeder extraordinaire, who at that time owned two farms: Ellerslie near Charlottesville, Virginia, and the renowned Claiborne Farm near Paris, Kentucky.

The two tall, educated horse lovers bonded instantly. With Hancock's guidance, Granddaddy plunged into the study of Thoroughbred bloodlines, searching for fillies whose pedigrees were impressive but unfashionable at the moment. As he liked to say, "The price does not represent a horse's worth, only what some damned fool thinks he is worth." He was developing a good eye for a mare, a talent that would pay huge dividends in years to come.

At a dispersal sale that year, a yearling filly caught his eye. Sired by the 1926 Derby winner Bubbling Over, she sold for only $750. Granddaddy named her Hildene, after Cousin Bernard Doswell's farm at Bullfield. Perhaps the name embodied some of the magic of Bullfield Stable's illustrious past. This mare became what breeders called a "blue hen," showing little ability on the track but foaling talented

Hildene was a "blue hen," a producer of many winners.

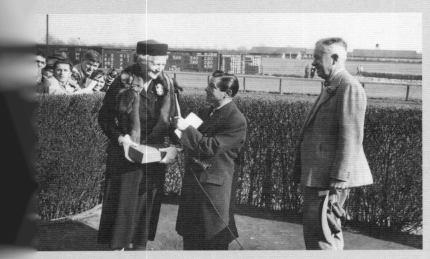

The Chenerys were thrilled to receive the trophy for Hill Prince's Jockey Club Gold Cup victory in 1950.

offspring that would eventually win millions, an astronomical return on the investment. Though she went blind after her first foal, Hildene would give Meadow Stable five outright stakes winners and her daughters foaled seven more, establishing a racing dynasty.

Through Hildene and the Hancocks, Granddaddy got his first big star, Hill Prince, in 1949, just ten years after he had begun breeding Thoroughbreds. Arthur's son Bull had recently acquired a bay stallion from England named Princequillo, who displayed impressive stamina by winning the two-mile Jockey Club Gold Cup. The champion was relatively unknown in the U.S. and his low stud fee of $250, as well as his staying power, appealed to my frugal grandfather. Thus he sent Hildene over to nearby Ellerslie to be bred to Princequillo during his first year at stud.

As a foal, Hill Prince wore a bell around his neck so his blind mother could tell where he was. The Meadow grooms said the mischievous bay colt would steal silently away from Hildene in the pasture. The mare, not hearing his bell, would whinny frantically until the foal came scampering back to her side.

Hill Prince also stole away from his rivals on the track, winning the title of Horse of the Year in 1950. He won that honor with a second in the Kentucky Derby and triumphs in the Preakness, the Wood Memorial, and most spectacularly the Jockey Club

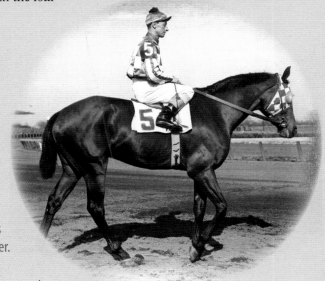

Hill Prince, son of Hildene and Princequillo, became The Meadow's first Kentucky Derby contender.

Hill Prince winning the Wood Memorial in 1950.

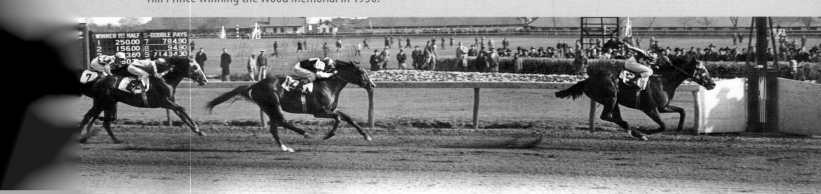

Gold Cup. In that upset he trounced Noor, a horse who had earlier bested Citation, the Triple Crown winner of 1948. As the 1949 Champion Two-Year-Old Colt, the 1950 Champion Three-Year Old Colt and 1951 Champion Handicap Horse, Hill Prince entered the National Racing Hall of Fame. He is still ranked 75th among the top 100 U.S. racehorses of the twentieth century, with career earnings of $422,140. His laurels brought his mother the title of Broodmare of the Year in 1950 and recognition as one of the top mares of the twentieth century.

Although the press dubbed the Meadow horse "the crown prince" for his many victories, my grandfather longed for the one prize that eluded him, the Kentucky Derby. Hill Prince had entered the race highly favored. Usually his come-from-behind style kept fans on the edge of their seats until his "roaring stretch drive" catapulted him across the finish line first. Sportswriters compared him to the great Triple Crown winner Whirlaway. Piloted by famed jockey Eddie Arcaro, Hill Prince seemed destined to wear the roses at Churchill Downs.

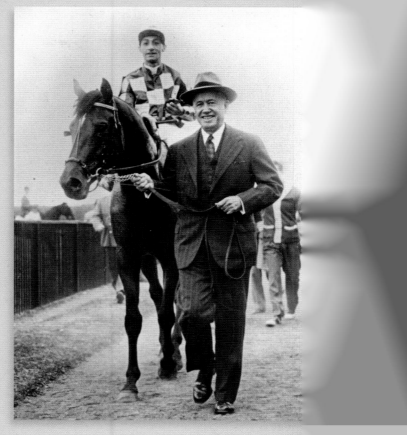

Chris Chenery leads Hill Prince with Eddie Arcaro up to the winner's circle at Belmont Park for the Jockey Club Gold Cup in 1950.

Granddaddy had filled rail cars with friends and relatives from Virginia and Chicago hoping to share his good fortune with them. Even my parents came to watch their first Derby.

The Kentucky Derby is called "the most exciting two minutes in sports" for a reason. There are no guarantees. Hill Prince finished second by a length to Middleground, who had had been second to him in the Wood Memorial. Granddaddy accepted the loss with his typical aplomb. Mother, pregnant with her first child, burst out crying with disappointment. He reprimanded her, "Don't ever do that again! Don't embarrass the horse!" It was a lesson in sportsmanship she would never forget.

Hill Prince avenged himself by scorching past the Derby victor in the Preakness Stakes, second leg of the Triple Crown. But the Preakness is not the Derby. Then, as now, the Kentucky Derby is the Holy Grail for every Thoroughbred owner, trainer, jockey and groom in the land. Losing the Derby began a disappointing pattern for my grandfather, whose horses won nearly every other big stakes race in the country.

Hill Prince received a hero's welcome when he came home to The Meadow in March, 1951 to rest after a leg injury. An excited crowd of Ashlanders braved the cold and damp waiting at the Doswell train depot for their native son to disembark. The local papers pronounced him "jaunty and self-possessed," as he paraded down the ramp. Camera bulbs flashed as Hill Prince posed with groom Bill Street holding his lead and trainer Casey Hayes patting his nose. "He's 99 percent recovered," Hayes said of his champion.

Hill Prince stood at stud at Claiborne Farm in Kentucky, much to the consternation of many Virginians.

After one more winning season at the track, Hill Prince was retired to stud at Claiborne in 1952, rather than at The Meadow. Loyalty to the Hancocks may have prompted Granddaddy's choice, a factor my mother would remember when she had a similar decision to make in 1973. But the notion of sending Virginia's star stallion to Kentucky sparked outrage from Virginia horse lovers and questions from the press. Granddaddy evidently felt the need to justify his stance, so he penned a fictional interview with Hill Prince for the *New York Herald Tribune*. Keeping it light, he described Hill Prince's new duties in the breeding shed: "You merely plant the seed, old boy—the mare grows the crop. Don't you remember the summary report of Caesar's visit to Egypt's Queen? 'He ploughed her and she cropped.' "

Granddaddy noted that since many Kentucky mares would visit the stallion, it was unfair to make them travel to Virginia with young foals at their sides. As a Virginia Gentleman, Hill Prince had to agree that "the convenience of the ladies, bless them, comes first, and if that means my living at Claiborne in Kentucky, why Claiborne let it be, and I'll try to learn to eat their bluegrass and drink their limey water."

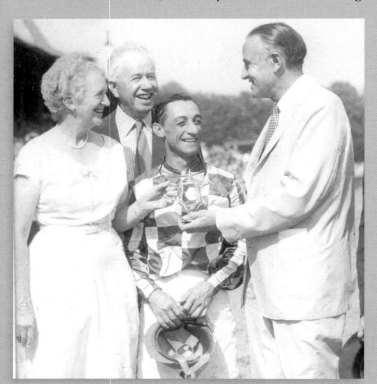

Standing Hill Prince at The Meadow would have boosted its breeding status, but perhaps Granddaddy felt they weren't ready to handle thirty or more visiting mares. In just ten short years, The Meadow had entered the big leagues of Thoroughbred racing. Though a full-blown passion, the stable was nevertheless only a part-time pursuit for Granddaddy. His primary duties remained in Manhattan at 90 Broad Street, running Federal Water Service and later Southern Natural Gas, and dueling with the U.S.

Grandmother loved receiving trophies from New York Governor Averell Harriman, shown here with Granddad and jockey Eddie Arcaro.

Supreme Court over corporate regulations. He developed other enterprises as well, including the Offshore Company, and served on many other boards. It was a tribute to his energy and hard work that he could make simultaneous successes of all of these endeavors.

In 1956, Hildene gave Meadow Stable another Derby contender in First Landing, named for the 350th anniversary of the Jamestown landing in 1957. Sired by Turn-To of Claiborne Farm, he matured into a strapping bay colt. Despite the moniker "Lazy Bones" during his early training, he won ten of eleven races in his first year on the track, becoming Champion Two-Year-Old of 1958. Horsemen spoke of First Landing in the same breath as Citation and Native Dancer, calling him one of the best two-year-olds to grace the track since World War II.

Yet his three-year-old campaign in 1959 paled against his brilliant debut. Although favored by many to win the Derby, like Hill Prince, he finished only third. While Hill Prince had gone on to win his Preakness, First Landing faded to an ignoble ninth in his. The press blamed these failures on an overly ambitious schedule, which may have been true. The next year, he redeemed himself as a handicap horse with triumphs in the Santa Anita Maturity, the Laurel Maturity and the Monmouth Handicap, among

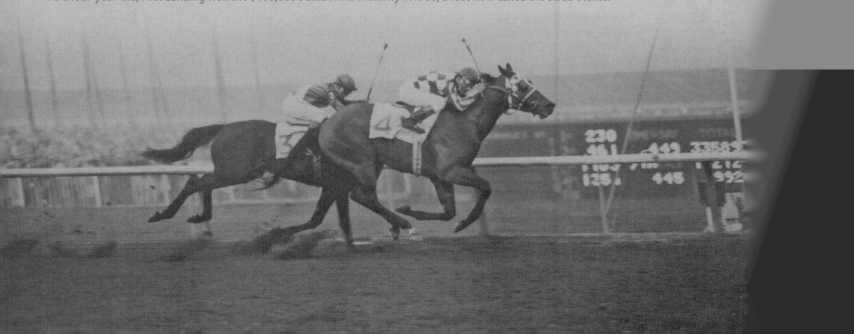

As a four-year-old, First Landing won the $100,000 Santa Anita Maturity in 1960, a race now called the Strub Stakes.

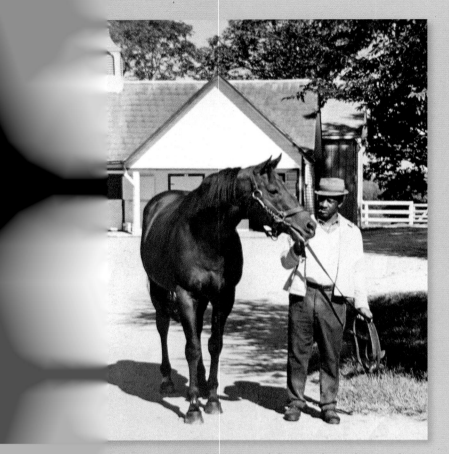

Groom Howard Gregory with First Landing, whose stud barn at The Meadow was called "First Landing's Motel."

others. First Landing surpassed Hill Prince's lifetime earnings with an astonishing $779,577.

Nevertheless, Granddaddy lamented his second Derby loss. Reflecting on First Landing's career, he remarked ruefully, "The Derby is the one that the people know. You can be a four-year-old champion all day."

By the time he retired the big muscular bay in 1961, Granddaddy had enough confidence in his farm's reputation to stand his stallion at The Meadow. To accommodate the bevy of mares seeking First Landing's attention, he built a new barn which the grooms instantly tagged "First Landing's Motel." Howard Gregory, the head stud groom, praised the stallion's manners. "First Landing was always real nice and quiet," he said. "He was the nicest one I ever had."

In 1959, The Meadow witnessed the birth of two more champions, Cicada and Sir Gaylord. A little bay filly, Cicada would outdo all the boys of The Meadow in her day. She was the daughter of two homebreds, Bryan G. by the famed Blenheim, and Satsuma, out of the venerable Hildene. My mother, who would soon compete against males herself, described Cicada as "small and feminine." Foaled in May, late for a Thoroughbred, the filly was only twenty-one months old when she began her racing career in February 1961. But what she lacked in age and size, she made up for in attitude and ability. "She was a very stout-hearted, determined filly," said Penny.

Willie Shoemaker, Cicada's jockey, put it more bluntly. "Cicada was a little bitty filly. In fact, she looked like a muskrat. But what a tough little bitch she was." Shoemaker may been thinking of the no-holds-barred duel when Cicada and a bruiser of a colt named Ridan raced head to head in the 1962 Florida Derby. Cicada sprang out of the gate and sprinted to a four-length lead. Ridan, who stood a full hand (four inches) taller, caught up with her on the outside and muscled her over to the rail, where he kept her pinned all the way down the stretch. Yet she matched the husky colt stride for stride, gamely battling down to the finish line. She lost by a nose, but proved she could hold her own against the big boys.

Cicada and her stakes-winning stablemate, Sir Gaylord, nearly gave my grandfather a double shot at the 1962 Kentucky Derby. Sired by Turn-to, Sir Gaylord was foaled by another great "blue hen" of The Meadow,

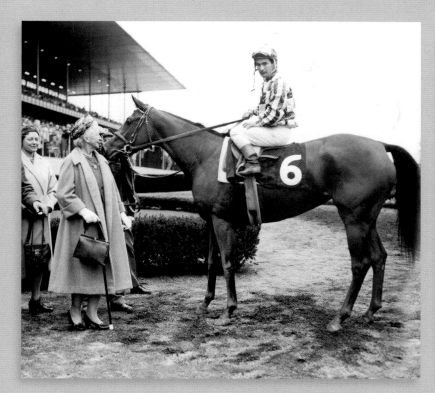

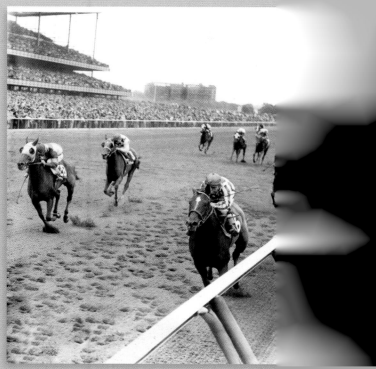

Cicada, shown here winning the Beldame Stakes in 1962, held the record as the nation's top money winning filly for nine years.

Somethingroyal. Her dam was Imperatrice, a stakes winner for whom Granddaddy paid a whopping $30,000 in 1946, far more than he did for Hildene. Imperatrice proved her worth, however, by foaling such stakes winners as Yemen (by Bryan G), Imperial Hill (by Hill Prince), and Speedwell (by Bold Ruler). But her most notable success lay in her daughters' offspring, especially Somethingroyal's sons Sir Gaylord—and Secretariat. Today, breeding scholars consider Imperatrice among the most influential mares of the twentieth century.

Her grandson, Sir Gaylord, like many of The Meadow horses, tasted success early as a two-year-old. He won four races in a row, then hit a slump. Roaring back as a three-year-old, he began Derby week of 1962 as the bettors' favorite over Ridan, Cicada's old nemesis.

Though fans clamored for Cicada to run for the roses as well, Granddaddy decided to enter her instead in the Kentucky Oaks, the fillies' derby, held the day before. He reasoned that as much as he admired Cicada, winning the Derby would not increase her value as a potential

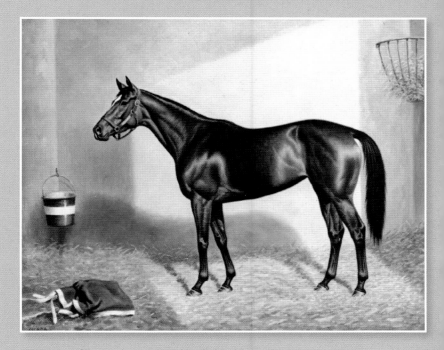

Champion filly Cicada as painted by Richard Stone Reeves.

broodmare the way it would increase a colt's future stud fee. That decision placed my seventy-six-year-old grandfather's last hope for a Derby win squarely on Sir Gaylord's shoulders. It also meant that Granddaddy would go to Churchill Downs as the first breeder in history to field favorites in both the Derby and the Oaks in the same year.

Imperatrice, looking out of her stall at The Meadow. The great foundation mare lived to the ripe old age of thirty-four.

But what a difference a day makes. On Thursday, the eve of the Oaks, it poured rain. Sir Gaylord took to the track for his final blowout anyway. And final it would be. The Derby favorite bobbled slightly in mid-stride. Writer David Alexander, who was standing near Casey Hayes, described the moment:

"I looked at his face when Sir Gaylord took a wrong step, and I thought of a photograph I had seen in some magazine of a Frenchman weeping while Hitler's legions entered Paris. The Frenchman's face was unforgettable, and Casey's face was just as memorable at that stricken moment."

Churchill Downs "Speedwell" W. Shoemaker, up May 5, 1962

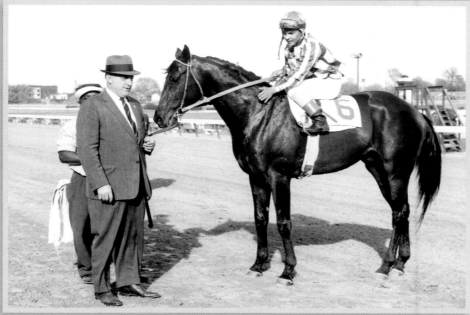

Sir Gaylord won this prep race for the 1962 Kentucky Derby. Sadly it would be his last race and the end of my grandfather's Derby dreams. Sir Gaylord would fracture his sesamoid less than a week later and never race again.

Sir Gaylord had fractured his sesamoid, a bone in his ankle. To Casey fell the unenviable task of meeting Granddaddy's train that afternoon in Louisville with the news that his colt could not race in the Derby and might never race again. Sadly, the same thing had happened to Sir Gaylord's sire, Turn-to, the week before his Derby race. Granddaddy took the crushing news with characteristic stoicism, telling his trainer, "Casey, I am very sorry for you."

In the hurried conference that followed, Hayes suggested they salvage the situation by running Cicada in the Derby instead of the Oaks. But Granddaddy refused. Her feed and water had already been withheld a day in advance in preparation for Friday's contest. If they scratched her from the Oaks race to run her Saturday in the Derby, Cicada would not have food or water for forty-eight hours. "I won't do that to the filly," he said, clearly aware that his last chance to win the Kentucky Derby had just evaporated in the foggy rain at

◄ All dressed up on Derby Day, 1962, the Meadow team won a minor stakes race with Speedwell, instead of the Kentucky Derby with Sir Gaylord. Among a bevy of unknown beauties, Mom receives the trophy while Dad, Elizabeth, Casey, and Granddad look on.

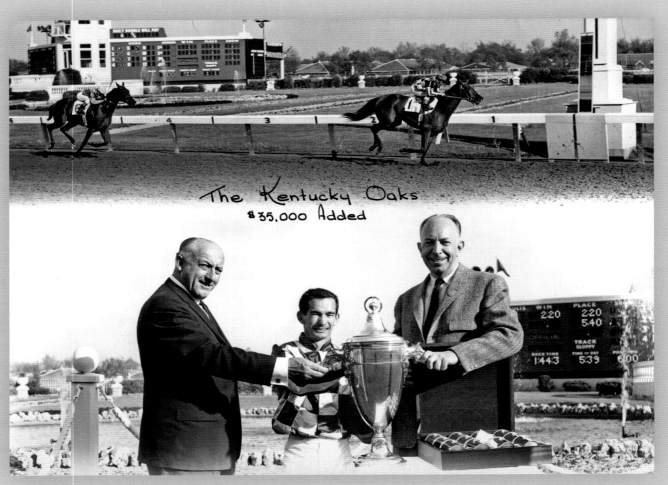

The Kentucky Oaks
$35,000 Added

Cicada's easy victory in the Kentucky Oaks, a race for fillies, was a bright spot for Meadow Stable during Derby Week 1962 in contrast to Sir Gaylord's career-ending injury.

Casey Hayes holding Sir Gaylord and Cicada nose to nose at The Meadow. Together the champions produced stakes winner Cicada's Pride.

Churchill Downs. Composed as always, he went to Barn 41 to see Sir Gaylord, telling reporters he was sorry to disappoint the colt's many fans.

Cicada won the Kentucky Oaks the next afternoon, skimming over the slop with ease. The Meadow's "Iron Maiden" became the top money-winning filly in the nation, pocketing $783,674 in track earnings, and holding that title for the next decade. She won twenty-three out of forty-three starts and never finished out of the money. She became the first filly to win champion titles at two, three and four years of age. Like Hill Prince, she was inducted into the Racing Hall of Fame as one of the top racehorses of the twentieth century. Her success, coming purely from Meadow horses, validated Granddaddy's decades of careful breeding. In Cicada, his emphasis on matching horses known for stamina with those blessed with speed produced a sound horse with the best attributes of both.

Sir Gaylord retired to stud after his injury in Kentucky. As a stallion, he brought my grandfather international recognition, especially through his sons, Sir Ivor and Habitat, top English sires.

When Cicada entered the broodmare barn at age five, Granddaddy, the eternal optimist, declared, "I am looking forward to breeding and racing Cicada's foals." Immediately bred to Sir Gaylord, she bore a stakes winner, Cicada's Pride. But her racing prowess did not easily translate to the breeding shed. The track's "iron maiden" often came up barren.

Ironically, Cicada's breeding troubles would later give The Meadow its greatest triumph. Under a foal sharing arrangement between Meadow Stud and Mrs. Henry Carnegie Phipps, owner of Bold Ruler,

Sir Gaylord and Cicada together, painted by Menasco.

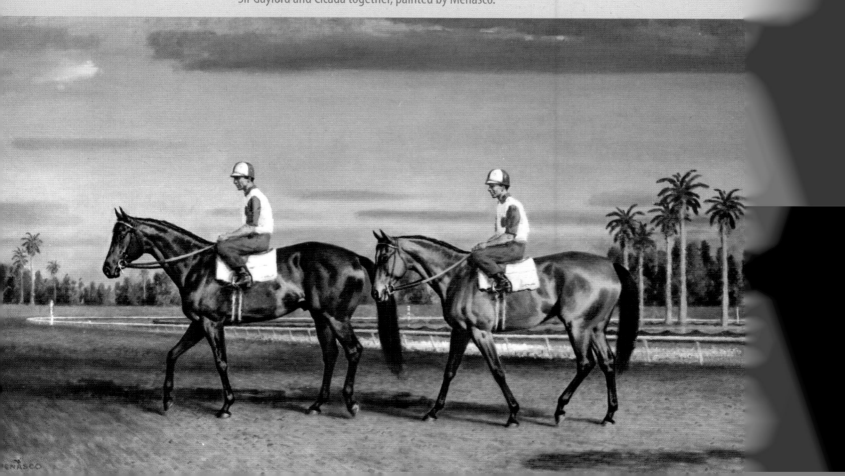

Howard Gentry and Grand-
daddy's cousin and agent,
Admiral Lundsford Hunter
(Deenie's brother) admire the
evidence of The Meadow's
success in the trophy room.

58

Granddad bred two Meadow mares to Bold Ruler each year and he and Ogden Phipps would flip a coin to determine who got first pick of the foals. When we lost the coin toss in 1969, we automatically got first pick in 1970. Cicada's infertility that year guaranteed us the only Bold Ruler foal in 1970, a lovely big chestnut out of Somethingroyal, who would go on to greatness. My family had no way of knowing then that the stars had aligned in a way that would impact our lives and the history of horse racing forever.

Despite his lost hopes for the Derby, Granddaddy had accomplished much with the Thoroughbred farm that the experts had said could not succeed in Caroline County, Virginia. In just twenty-four years, The Meadow had produced thirty-one winners, among them sixteen stakes winners, winning a remarkable one-fourth of all races entered and earning a total of $4,340,292 purse money. Meanwhile the farm made a yearly profit. By 1962, The Meadow had grown to 4,000 acres with stables for over 200 horses.

The stable had also earned the respect of the old New York racing families, like the Whitneys, the Vanderbilts, the Phippses and the Guggenheims. Granddaddy joined the exclusive Jockey Club in 1957 and bought box seats at

Cicada with her foal Cicada's Pride by Sir Gaylord. 1966.

Saratoga and Belmont Park. Silver plates and bowls filled the glass cabinets that lined the trophy room in the old stone basement at The Meadow. Yet Granddaddy's proudest moment may have been when Virginia sportswriters dubbed him "the Virginia Gentleman" for his unfailing graciousness in both victory and defeat.

The man who built a utilities empire during the Depression had constructed a pastoral kingdom as well, "an empire built on broodmares," far from the bluegrass path. In the tradition of Bullfield, the famed Red Stable of the Doswells, my grandfather had created his own "nursery of Virginia racehorses" at his ancestral home.

Within a decade, The Meadow would give Granddaddy his Kentucky Derby winner . . . and much more than he had ever dreamed.

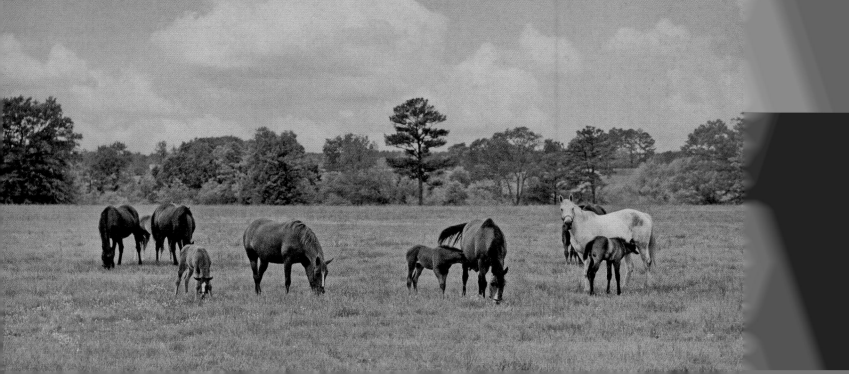

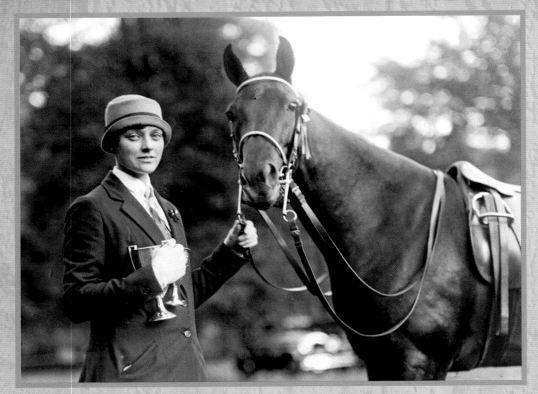

Elizabeth Ham was the sort of person about whom we all said, "Thank God for Elizabeth!" Circa 1928.

The Meadow Team

Granddaddy wanted to know every aspect of what went on at The Meadow. But not even a whirlwind of energy like him could manage that, so he hand-picked a management team that he called first thing every morning. Either he had a list of tasks for them or a dozen new ideas that had occurred to him overnight, or both. One of this team's top qualities was forbearance. In time, it became loyalty as well.

Elizabeth Ham, Executive Assistant. First on Granddaddy's team was his longtime executive assistant, Elizabeth. Conscientious and well-organized, she managed his personal and business affairs wherever they took him. For The Meadow, she kept meticulous records in her small neat hand documenting horses' births, deaths, races, wins, purses, purchases, sales and progeny.

A 1928 business graduate of Mount Holyoke, Elizabeth appreciated her boss's financial wizardry and the challenges of his work. She also loved horses and rode almost as well as he did. Later, Elizabeth taught Mother the ropes when she took over The Meadow in 1968. She also attended every race in Riva Ridge's and Secretariat's careers. Grandfather's esteem for her was so great that at his death, she inherited one-sixteenth of his estate. Elizabeth remained an unofficial member of the family until her death in 2000.

Howard Gentry, Farm Manager. Once again, Granddaddy turned to Bull Hancock for a recommendation on the important position of farm manager. Bull suggested the Gentry brothers, who had grown up at Ellerslie in Charlottesville and knew how to meet the Hancocks' high standards. Bryan Gentry managed The Meadow for five years; then Howard took over from 1946 until his retirement in 1976. Howard's horse knowledge and management skills soon earned respect and ample latitude from my grandfather in decision-making.

Howard lived with his wife, Alice, in a white clapboard bungalow above one of the ponds at The Meadow. They knew everyone in the area and everyone knew them. Howard was an even-keeled character known for teasing and story-telling in his thick country accent.

Howard ran The Meadow for thirty years, adding humor and conscientiousness to his great talent with horses. Photo circa 1970.

Alice was kindness itself. Later when Howard's nephew Bobby Gentry joined The Meadow to manage the farm's agricultural operations, he and his wife, Joyce, became Meadow fixtures and beloved residents as well.

Casey Hayes, Horse Trainer. Granddaddy had an ambivalent relationship with his trainer J. H. (Casey) Hayes. He conditioned the Meadow horses at tracks from New York to Florida from the late 1940s until 1969. A former riding instructor at Boulder Brook Club in New York, Casey knew horses but not racing. He learned quickly that my grandfather oversaw things closely via a phone call every morning with a list of what to do. Granddad respected the expertise Casey acquired but over time, it was Casey's willingness to let Mr. Chenery call the shots that ensured his longevity with Meadow Stud.

Dr. Olive Britt, Veterinarian. The first woman veterinarian to have an equine practice in central Virginia, Dr. Britt came to work at The Meadow in the mid-1960s. She stayed for fifteen years, living on

Casey Hayes on the right, with Mother and her siblings, Miggie and Hollis, accepting the trophy from Mrs. Henry Carnegie Phipps for the Alabama Stakes, 1968.

61

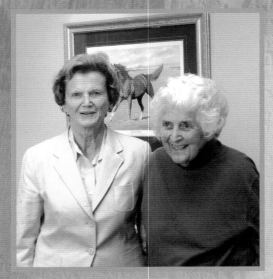

Mom with Dr. Olive Britt (right), the veterinarian at The Meadow.

ten acres of land that the Chenerys gave her. Her daily routine began by meeting Howard Gentry at 7:00 a.m. to determine the priorities for that day. Dr. Britt provided routine care to the Thoroughbreds and often observed young horses at the training track to detect any problems.

She attended Secretariat as a colt, giving him shots, worming medicine and physical examinations. When he started his training on the exercise track, she would watch him run. She took similiar care of Riva Ridge.

Mom initially resisted having Dr. Britt as veterinarian for The Meadow, while Dr. Britt thought Penny didn't know "doodley-squat" about racehorses. But both women developed great respect for each other and a friendly rapport. Mom said she learned a lot about soundness from Dr. Britt. Unquestionably, Dr. Britt, who had a devoted following of horse owners in Virginia, helped to make important decisions about the horses of The Meadow.

Other Staff: Many of the Meadow workers came from a web of local families who remained with the farm for decades. For example, yearlings began their initial training under the skilled hands of Bob Bailes and later his son

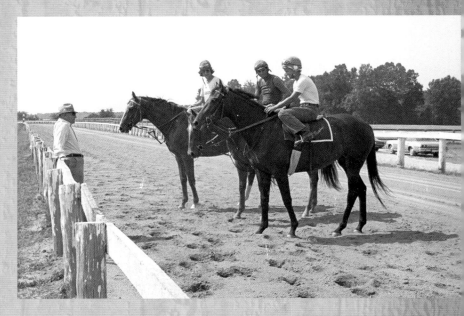

Bob Bailes, leaning against the fence, broke and trained the yearlings slowly and gently, which paid off in good-natured race horses.

Meredith (Mert) Bailes. Brothers Harry and Bill Street drove the horse vans, took care of maintenance and served as grooms. Later their sons, Tom and George, helped out as well.

Many of the grooms came from local African-American families whose ancestors had lived at The Meadow as enslaved workers owned by the Morrises. For a variety of reasons, many of them stayed on after Emancipation. For example, George Washington Tillman had been born at The Meadow before Emancipation and lived long enough to

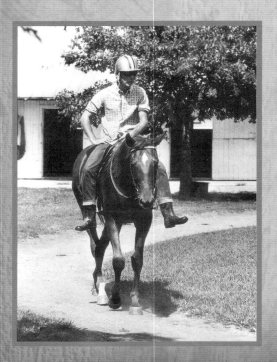

Mert Bailes, the first man to ride Secretariat, riding Hope For All, by Secretariat out of Hopespringseternal, 1976.

62

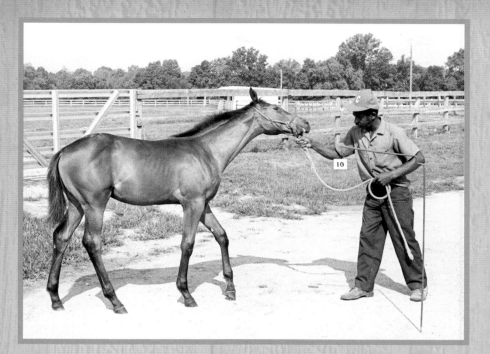

Lewis Tillman, Jr., who cared for the young Secretariat, holding a 1977 Meadow foal for his Jockey Club registration picture.

return to it in its new incarnation as horse farm. Many of his children and grandchildren became the staff that gave The Meadow horses their excellent care. Over time, the older ones passed generations of knowledge about horses and farming to their sons and nephews.

Early on the much-loved Aunt Sadie Morris kept The Meadow household running according to Grandmother's precise specifications. Later various nieces and daughters took over for her, among them three sisters: Magnolia, Pearl and Iola. Maude and Harriet Tillman and Eloise Morris Romaine also worked in the house. Most of these folks lived in what was then called Duval Town, now Dawn, a community established by free blacks after the Civil War. To make it easier for them to get to the farm, Granddaddy would send a truck to pick up the workers every morning and return them at night.

Each worker, no matter his or her rank, had a stake in the success of Meadow race horses. Chris Chenery never forgot what it was to be poor and he understood that each person contributed to the success of the whole. So when a horse won a big purse, he gave each of his employees a week's pay as a bonus. In a concrete way, this made the entire farm staff regard the horses' successes as their own.

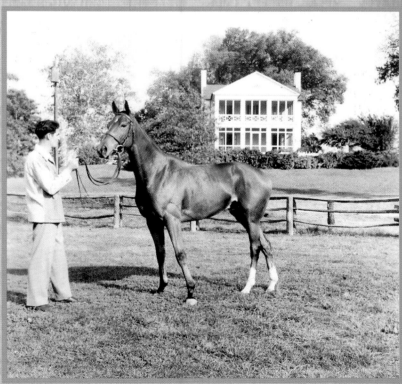

Bill Street holding Mangohick, Granddaddy's first stakes winner, in 1947.

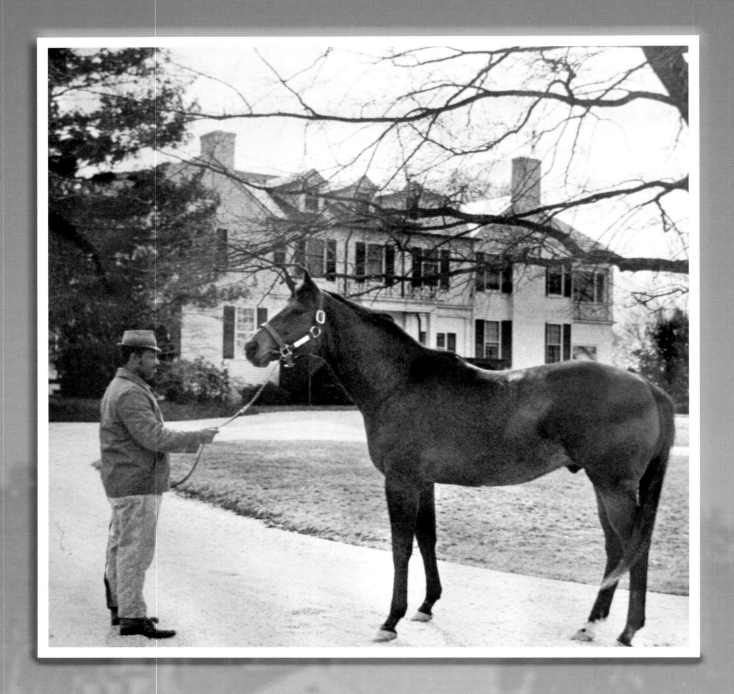

THE BOOK TEAM INTERVIEWED MOST OF THE FORMER GROOMS OF
THE MEADOW OVER THE COURSE OF SEVERAL YEARS.

*Author's Note: The team, assisted by Virginia State University, videotaped oral histories of
some of the African-American grooms for a project sponsored by the Virginia Foundation for the
Humanities, the State Fair of Virginia and the Secretariat Foundation. The interviews with Howard
Gregory, Alvin Mines, Charlie Ross and Wesley Tillman are on file at the Library of Virginia and
Virginia State University.*

A Good Hand on a Horse

They grew up working with their hands in the rural Caroline County of the post-Depression years. Local jobs were scarce and mostly limited to cutting pulpwood for the local sawmill, working for the railroad, in a mechanic shop or as a farm laborer. But the calloused hands of the men who became the grooms of Meadow Stable would touch some of the greatest Thoroughbreds in racing . . .and leave their own indelible imprint on the history of The Meadow.

Their names did not appear in the headlines or record books, but Lewis Tillman, Sr., Lewis Tillman, Jr., Bannie Mines, Alvin Mines, Charlie Ross, Wesley Tillman, Garfield Tillman, Raymond "Peter Blue" Goodall, Howard Gregory and others from the close-knit web of local families most assuredly contributed to the success of Meadow Stable. Personally selected for their jobs, these dedicated men would be entrusted with the daily care of the valuable broodmares and their foals, helping with the early training of skittish colts and fillies, transporting finely tuned racehorses and handling powerful stallions in the breeding shed.

Wesley Tillman came to work at The Meadow as a youngster. In 1946, at age twelve, he began helping in the hay fields with his grandfather, Samuel Tillman, during the summer.

"My grandfather said, 'If you're big enough to walk all the way down here to the farm, you're big enough to work.' So he gave me a pitchfork and I started throwing hay on the wagon. That was my first job," Tillman said. He earned two dollars a day.

By age eighteen, Wesley was helping his uncle, Lewis Tillman, Sr., who was in charge of the broodmare barn. They would turn the horses out in the morning after feeding and get them back up in the evening. In the meantime, they would clean out the stalls and put in fresh bedding. When the

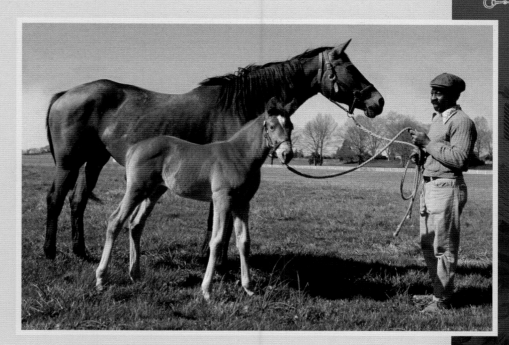

Lewis Tillman, Jr. was in charge of the broodmares and foals at The Meadow for many years. Here he holds Somethingroyal with her filly Quaint Idea by Reviewer. 1976.

65

◄ Howard Gregory holds Sir Gaylord, who had been a Kentucky Derby hopeful, in front of the main house.

mares and foals came back up from the Cove in the evening, the men would feed them and put them in their stalls for the night. Wesley also pulled night watch duty when mares were getting ready to foal.

His next job was "up the hill" to the yearling barn. "That's when I started breaking horses," Tillman said. "You had to be real gentle with any horse and take your time with them. If you groomed them right, they would even get to like you so you could get them to cooperate with you."

The next stop for young horses was the training center located across Route 30 where they would begin to learn the fundamentals of racing. The grooms would saddle up the horses for the exercise riders for

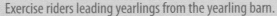

Exercise riders leading yearlings from the yearling barn.

the day's work on The Meadow track. Afterward, the grooms would wash the horses, brush them down and put them on the hot walker (a mechanical walking machine) for a while. Lastly, they would lead them back to the barn and turn them out into the fields until feeding time. Between their grooming duties, the men would cut grass, fix fences, paint barns or do other chores around the farm.

Tillman, along with other grooms, sometimes traveled with the horses when they were shipped out as two-year-olds to the training stables in Florida, New York or Delaware. As the men would see, it was a different world outside the rolling green fields of The Meadow.

"Everybody was treated equally at the farm," Tillman said. "I didn't see any racism. We were all like a big family."

Wesley Tillman holding champion Cicada, who was the nation's top money-winning filly in the 1960s.

But on the road, in those days of segregation, "coloreds" were not allowed in many restaurants or hotels. "I had to stay in the back of the van with the horses from here to New York," Tillman explained. When the crew stopped for lunch, the white driver, Bill Street, would bring Tillman his meal, which he ate in the van as the racehorses munched their hay and occasionally sneezed on his food. If the grooms did take a break from the van,

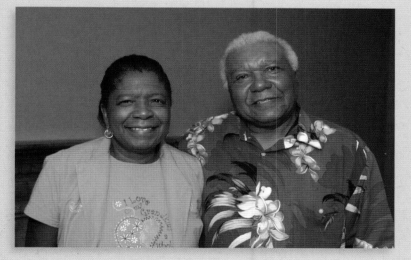

Wesley Tillman with his wife, Mary Arlene, in 2008 after taping the oral history project about the grooms of The Meadow.

they had to go to the back door of the restaurant to get a sandwich or eat in the kitchen with the cooks. Mostly they shrugged it off as part of their job.

At the racetrack, the Meadow grooms would stay with the horses for as many as three or four weeks. "We had our bunks right at the end of the barn, so if anything happened, like if the horses would get down in the stall or start kicking, we'd be right there with them," Tillman said. After new grooms were hired and the horses were settled in, the Meadow grooms would return to Virginia to start working with the next crop of young hopefuls.

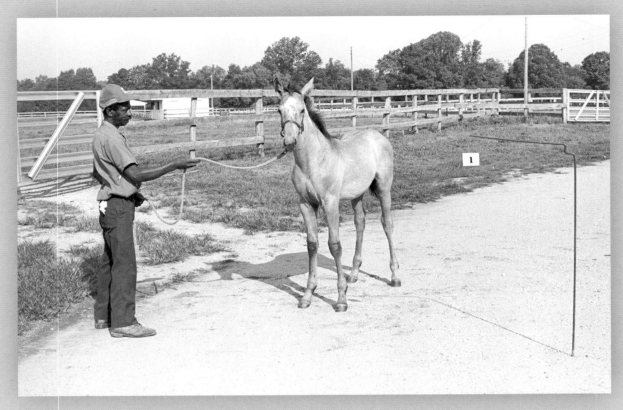

Lewis Tillman, Jr. holds a colt for his Jockey Club identification photo.

Alvin Mines first came to The Meadow at the age eight or nine, tagging along with his grandfather, Lewis Tillman, Sr., who was affectionately called "the Mayor of Duval Town." He remembers playing in the fields with the other grandchildren until the horses' feeding time when his grandfather would call the mares and foals up from their pasture in the Cove.

Alvin Mines first came to The Meadow at the age of eight or nine with his grandfather, Lewis Tillman, Sr.

"Man, the horses used to come running up, maybe about fifteen of them with their colts and the foals," Mines recalled. "I remember we were grabbing round my grandfather's leg because we thought the horses would run us over. He said, 'Don't worry, the horse is not going to bother you.' And sure enough, they'd come up and they'd just circle around you and go on."

Mines began working at Barn 33, also known as "First Landing's Motel" around 1974. There, with groom Clarence Fells, he helped with the visiting mares who were to be serviced by the Meadow stallions. Often the mares had foals at their sides, who did not want to leave their mothers for even a few minutes. "I had to hold the foals and then you were in a rassling match!" Mines said.

68

Next he worked at the broodmare barn with his uncle, Lewis Tillman, Jr. Later he went across the road to work at the racetrack/training center, with his brother-in-law, Raymond Goodall. Goodall was the chief groom for Riva Ridge. He taught the short and stocky Alvin how to handle the tall, high-headed Thoroughbreds who often did not want to have a halter or bridle put on them. It seemed that farm manager Howard Gentry liked to test the young groom by giving him the tallest horse in the barn to lead. Mines recalled being jerked off the ground more than once.

The grooms who had a special way with horses were highly respected at the farm. This was particularly true of Howard Gregory, who worked at The Meadow for nearly thirty-two years. He was known as "the stud man."

He began as a farm worker, making twenty-five dollars a week in the 1940s.

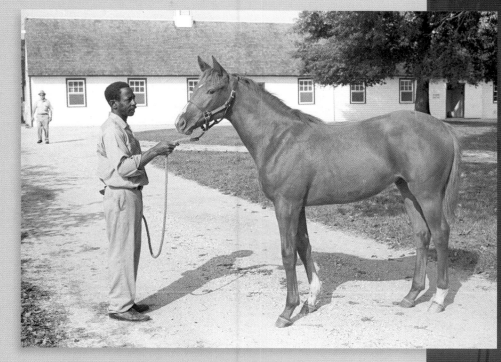

Lewis Tillman, Jr. holds a yearling as Howard Gentry looks on from the barn.

69

Gregory had no prior experience with horses, other than some farm mules. He simply learned by doing, mostly under the watchful eye of Howard Gentry, who supervised all the breeding.

He had been working at the training track for several years when Gentry offered him the job taking care of the stallions, along with a raise. "He told me I had a good hand on a horse and no fear," Gregory recalled. "I had five young children to take care of, so I took the job. I did not know what I was getting into!"

He took charge of six stallions, each of which had his own paddock. Breeding time was around 2:00 p.m. each day in the breeding shed. Some days there would be four or five mares to be serviced.

"I had three horses that died in there," Gregory noted. "One was Third Brother, a full brother to Hill Prince. He just

Howard Gregory worked at The Meadow for thirty-two years and was in charge of the stallions, an often dangerous job.

dropped dead after breeding the mare." Another time, a stallion fell over dead, nearly crushing Howard Gregory and Howard Gentry against the wall.

One stallion, named Tillman in honor of Lewis Tillman, did little to flatter his namesake. He was especially rank and ill-tempered. "That horse looked to kill you!" Gregory said, adding that the horse would charge at any groom who entered his paddock. Gregory was the only one who could handle him. "I had many people come watch me," he said of those who came to learn his techniques.

Charlie Ross was the groom who led Secretariat around with his first rider in the saddle.

His favorite stallion was First Landing. "He was very, very mannerable," Gregory noted. "When I would take him around to breed, you'd never hear him squeal or make a whimper or nothing."

Despite the inherent dangers of his job, Gregory said, "I would turn back the hands of time" to do it all over again.

Charlie Ross also came to The Meadow in the early years. He would earn the distinction of being the last Virginia groom to take care of Secretariat before the colt was shipped down to Lucien Laurin's training stable in Florida in January 1972. Though track groom Eddie Sweat and exercise rider Charlie Davis were more closely affiliated with "Big Red" during his meteoric racing career, it was Charlie Ross, along with trainer Meredith "Mert" Bailes, who helped start Secretariat under saddle.

Meredith "Mert" Bailes shown hot-walking a horse in training.

Ross had been working at the farm more than twenty years when Secretariat was transferred over to the training center and became one of his charges. Ross held the colt while Bailes first "backed" him, laying himself over the colt's back to get him accustomed to human weight. Ross was the groom who led Secretariat around with his first rider, Bailes, in the saddle.

"Yeah, he sat up on the saddle in the stall and I turned Secretariat around in the stall, waiting until he got used to that. Then the next move we would take him out in the big round shed and we'd walk him around in there until he'd get used to that," Ross recalled. He added that Secretariat did not act up or buck like some of the other horses did in those circumstances.

Typically taciturn, Ross admits he was a part of history. Then a flash of pride breaks through and he says, "They called me 'The Man'," for his way with horses. He agreed that the early care a young horse receives can influence him for life.

Alvin Mines put it best. He said, "I think the horses, once they got the feel of the grooms that were working with them, there was something that grew up in them, you know. They go to someone else's hands when they leave here, but I think the horses always know who had the first hand on them."

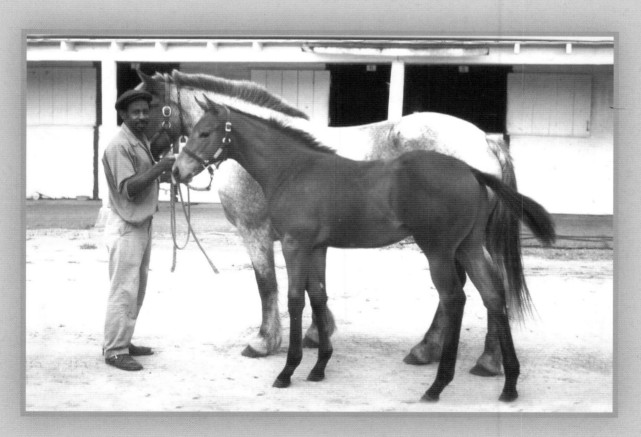

The capable hands of the grooms of Meadow Stable touched some of the most famous horses in racing and left their own indelible imprint on the farm's history. Shown here is Bannie Mines holding a nurse mare and an orphan foal.

A Granddaughter's Memories of The Meadow

For all The Meadow's eminence as a Thoroughbred farm, I, as a child from Colorado, simply saw it as a place of magic. Its heady smells, rich gardens and huge trees were worlds apart from the dusty fields and delicate wildflowers of my beloved high plains and mountains. Nor were Granddaddy's magnificent horses anything like the swaybacked old mare I rode at home. The Meadow offered adventure, mystery, history and elegance. It was also the place where my formidable grandfather—the demanding patriarch, tycoon, and horseman extraordinaire—was at his happiest and most affectionate.

I can still see him high astride Granite, his big gray hunter, looming impossibly tall above a child of three. He taught us to ride from our earliest days. At first a groom would lead me or one of my siblings in circles around a shady walking circle atop a crabby Shetland pony. Later Granddaddy let us ride gentle old mares, but he would not subject his best mounts to our callow hands. Nor did my sister Sarah or I ever earn the honor of galloping freely over pastures

Grandfather in a characteristic pose astride Granite.

with Granddaddy. In the 1950s, we were too young, and in the 1960s, he was too old. It would have been a memorable ride.

Elizabeth Ham described Granddaddy as "a bold rider who rode bold places." He loved to jump the eight-foot-wide ditches that drained the Cove, a scary endeavor that became an unofficial test of horsemanship for friends and family. Grandmother,

My brother Chris with the crabby Shetland pony who grudgingly taught the Chenery grandchildren to ride.

Granddaddy made sure we got to know horses at an early age. Here I am as a toddler greeting a gentle friend.

My grandparents walk across the south lawn of The Meadow, accompanied by Admiral Lunsford Hunter, a cousin and Granddad's business agent.

73

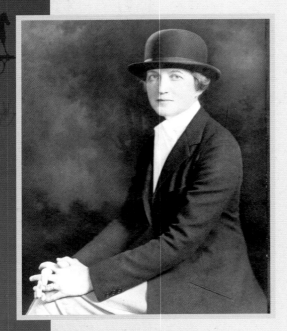

Helen Bates Chenery, my grandmother, posing in her riding attire.

who was never at ease on horseback, fell and broke her collarbone attempting such a jump. After that, she quit riding. Thereafter Granddaddy took Elizabeth, who loved riding as much as her boss did, on his daily gallops.

A favorite memory of mine was following Mom and Granddaddy after dinner down the hill to visit the broodmare barn. The sweet smells of baled alfalfa in the hayloft and boxwood from the garden floated on the soft evening air, so much richer than the dry breezes of the West. Friendly whuffles and nickers from mares hoping for treats greeted us as we entered the pungent duskiness of the barn. Granddaddy showed me how to offer a chunk of carrot (never sugar or candy) with a flat palm to avoid getting nipped. I thrilled as the mamas gobbled up my offerings with the merest brush of nimble lips. And if a foal were brave enough to stick out a nose, its soft nuzzle and liquid eyes enraptured me.

Some mornings, Granddaddy and Mom would go to the track early to watch the horses in training work out. Occasionally we kids joined them, under one condition: no whining. We'd get up, dress and leave the house before breakfast. We'd cross Route 30 to the training center with its mile-long track of sandy loam just as the sun cleared the piney bluff to the east and the mists began to fade. At trackside, we'd clamber up a vertical wooden ladder to a tall white lookout tower.

From what seemed to me a vast height, we watched trios of young horses sprint down the manicured track. The sound of their thudding hooves lay down a steady backbeat to the raucous birdsong of dawn. Mom, Granddaddy, Elizabeth, Howard Gentry and Bob Bailes would peer through binoculars and talk of fractions of seconds and the running style of each horse, while making cryptic notations in their stud booklets.

I remember watching the early morning gallops from the lookout tower at the training center.

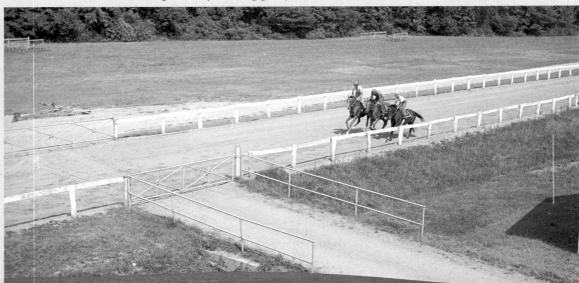

While a new set of horses galloped, the grooms would wash and cool the previous ones by walking them around an oval path within the quadrangle formed by the training office, barns and the three-eighths-mile indoor track, talking to them softly as they went.

Next, we'd stand by as the grooms brought out yearling after antsy yearling for what seemed like interminable inspections, while the adults analyzed their every feature. I would admire the sleek animals for a time, but then start prancing with impatience and hunger. Mother would snap, "Katie, be still! Not much longer now." Finally we'd return to the house for that long-awaited breakfast, which, like all the meals, we ate in the formal dining room.

View of the indoor training track. Inset: Elizabeth Ham produced our all-important yearly stud books. These listed each stallion, mare, yearling and foal, along with each horse in training or at the track. The books also included breeding plans for the following year.

MEADOW STUD, INC.
Stud and Racing Stable
DOSWELL, VIRGINIA
.
1961

At least once per visit, Granddaddy offered us the great joy of driving the back roads of the farm in his blue Chrysler convertible with the top down. We'd stand bracing our legs against the back seat, with the wind tossing our hair as the car jostled over narrow farm roads lined with fragrant pink hedges. On those rare occasions Granddaddy didn't mind if we giggled or yelled. He loved showing off The Meadow, and we loved his open-air tour.

When he had business in Ashland or Richmond, Mom would take us down to the ponds to swim. These were large by Colorado standards, perhaps five acres all together, amazing to children from the dry high plains. The lakes in Colorado were clear mountain ponds so cold that they made your bones ache. A swimmable pond, even if it was

Swimming in one of the farm ponds gave us a break from the muggy Virginia summer. Here are my cousin Lee, my sister Sarah and Mom.

75

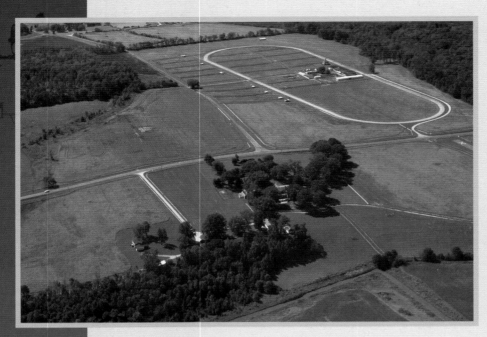

Aerial view of The Meadow showing the house, the training center and the track. The ponds were just beyond the upper fields in the photo.

murky, made a great treat in the muggy Virginia heat.

A white latticed open shed offered shade and a wooden pier allowed us to jump shrieking into the tepid water, stuffed into stiff and faded orange life jackets. We even got to paddle the farm canoe out to a tiny island where snakes were rumored to lurk.

Sometimes the Street children or the Zimmerman kids would join us. Though their fathers worked for my grandfather, such distinctions held no sway at the ponds where Mom was just another mother with young children to entertain. But in retrospect, I never saw any of the children of the African-American workers in those ponds.

On hot afternoons, I lolled in the garden under the canopy of a huge weeping willow, whose branches enclosed my imaginary playhouse. Beside it ran a low brick wall that circled the family cemetery, which contained three dozen unmarked graves. This fascinated me. Who lay under that grassy mantle? And why were they buried in the garden and without headstones? Because no one seemed to know, these questions tugged at me. Once when Grandmother was weeding around the wall, a gardener remarked that there would be "a great getting-up" from those graves one day.

At every turn, The Meadow seemed to breathe history. There was the basement room full of Meadow Stable's trophies, from the earliest, won by Hornbeam in 1948 to those won in 1962 by Cicada, our best filly. On the wall, scores of framed black and white pictures showed my grandparents celebrating the wins of races with intriguing names like the Sapling Stakes or the Grey Flight, won by horses with mysterious monikers like Third Brother and Rappahannock.

Upstairs, Granddaddy loved to show us a dark nick in the old polished wood of the third floor banister. Family lore said it came from Yankee weapons during the Civil War. I would finger the notch, about an inch long and half an inch deep, trying to imagine a swordfight on that narrow landing. Because of the nick, Granddaddy refused to replace the upper banister when he remodeled the house.

My brother Chris and I loved to play on this tractor. Once Chris got it out of gear and it started rolling down the hill, which terrified me until an adult leaped on and stopped it.

When not enjoying the horses or the Meadow grounds, I mainly remember struggling to behave. Naturally hyperactive and inquisitive, I found it a challenge to adhere to the strict standards of decorum in the house. Grandmother liked formal meals, and she ran a tight ship. Cocktail hour was especially trying for

The living room in the house displayed family portraits and equine art.

us youngsters, as the adults believed that children were to be seen and not heard.

Around five-thirty each evening, we would assemble in the living room, hair combed, faces shiny, hands clean, to be presented to the adults. Then we were mercifully released to play quietly in the sunroom next door while the grownups nursed their bourbons.

The living room, which had been two separate parlors in Dr. Morris's day, had high ceilings, tall windows and yellow patterned walls, making a cheerful gallery for equine art. The south wall featured a full-length portrait of Granddaddy in his hunting clothes. On the other walls hung old English racing or hunting prints, the Franklin Voss portrait of Hill Prince, and later the Menasco portrait of Cicada and Sir Gaylord parading at Hialeah.

The adjacent sunroom had once been a sleeping porch, but now the screens gave way to big square picture windows looking west. I loved to prop my elbows on the deep polished sills and watch the mares and babies graze in their big pasture by the river. During cocktail hour, we kids played quietly on the cork floor. But if we got noisy, the grownups would banish us to the maids' workroom, which flanked the kitchen.

Here the maids washed and ironed clothes and linens. For most of my childhood, four sisters with the melodic names of Iola, Magnolia, Pearl and Eloise, worked at the house. Their roots at The Meadow ran deeper than mine because their grandfather, George Washington Tillman, was born at The Meadow as an enslaved person before the Civil War.

I loved this view from the sunroom, looking down on the pasture with the foaling shed in the distance.

77

The Chenery grandchildren sitting on the back steps of the house: Clockwise from left rear, my brother Chris, Teresa Chenery, Lee Carmichael, Holly Chenery, Sarah Tweedy and me, circa 1959.

78

My relatives considered me a spirited girl who, like a colt, "required a firm hand," but these ladies always welcomed me with warmth and patience. Their workroom, with its comforting aroma of hot rolls drifting in from the kitchen and the scent of crisp linen rising from their steam irons, became my refuge whenever my misbehavior triggered land mines in the rest of the house. When I was older and aware of the fact that it was their job, not their choice, to care for me, I began to appreciate their kindness even more.

At exactly seven o'clock, a maid announced dinner and we trooped across the hall to the large formal dining room. This room had high ceilings, a simple Federal-style mantel and wallpaper of stripes and vines in the Williamsburg fashion. Its tall southern windows opened onto Grandmother's beloved rose garden and French doors gave onto a shallow balcony in front.

Iola Fells and I shared a laugh as we reminisced about The Meadow in 2007.

Besides an enormous dining table, the room had an antique cherry breakfront with glass-paned doors that we did not dare open. Inside, bewitching little ceramic and jade figurines of animals and fairies sat alongside Chinese vases and Great-Aunt Mary Taylor Tompkins' silver tea service. Many of these treasures were heirlooms and, of course, absolutely untouchable.

Behaving at dinner especially bedeviled my younger brother Christopher and me. Grandmother would indicate our places and we'd stand behind our chairs until Granddaddy or Dad would say grace; then we'd sit down for a meal whose starched formality was exceeded only by the deliciousness of the food. Grandmother would step on an electric buzzer discreetly hidden under the carpet, which rang audibly in the kitchen. Magnolia and Pearl

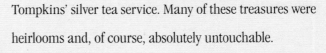

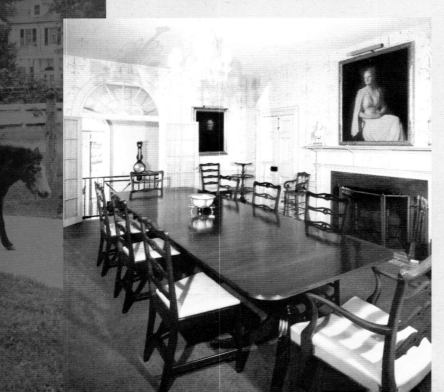

We children tried valiantly to be on our best behavior at the formal meals served in Grandmother's dining room.

would then appear in their light gray uniforms and ruffled white aprons carrying a platter laden with Iola's good Southern cooking. They would pause beside each person, lift an ornate silver cover and offer the dish. We were expected to serve ourselves, but if the heavy silver spoon or spatula proved tricky, the maids would assist, sometimes with a discreet wink.

The serving ritual took forever. While waiting for Grandmother to pick up her fork, thus signaling that we could begin, I occupied myself by studying the ornate woven designs of the white linen napkins or the spidery initials etched on each of the half-dozen silver utensils at my plate. I admired the fine grooves in the pretty little curls of butter resting on chilled saucers and coveted the tiny silver scoops for salt or pepper that rested in quarter-sized glass cups of brilliant blue on filigreed silver stands.

Once the meal began, I was in heaven. For a girl whose mother hated to cook, Meadow meals were a revelation. They introduced me to spoon bread, popovers, salads with avocados and grapefruit, fresh peaches and cream, and of course, grits. I relaxed as food and conversation distracted the adults from scrutinizing my behavior. Yet over the mantel, a life-sized portrait of Grandmother draped in a blue chiffon evening gown seemed to fix an unnerving gaze on me. It was enough to keep any child on her p's and q's.

Granddaddy and Grandmother often entertained on a large scale at The Meadow in the 1940s and 1950s, hosting elaborate parties for family, old friends, local dignitaries, fellow Thoroughbred owners and breeders. Reminiscent of the spring "Field Days" of Major Doswell at Bullfield, these events often included short horse races and yearling inspections, followed by elaborate buffets at the house. The success of such gatherings later led Granddaddy to host the Camptown Races as a charity event at The Meadow. (See Camptown sidebar, pages 82-85.)

Grandmother's blue-and-white checked linen table-cloths covered long tables adorned with huge bouquets from her own garden. Great platters of ham and roast beef, salads and spoon bread, fresh vegetables and desserts vied for space alongside her famous version of Army Navy Punch, whose potency surprised more than one normally demure lady. These events took so much planning that, as Elizabeth Ham noted in the Mount Holyoke alumnae magazine, she spent the month of November, 1947 in Virginia organizing one of the Chenery barbeques.

Granddaddy also put on barbeques for the workers and their families every year in June. At these events, black

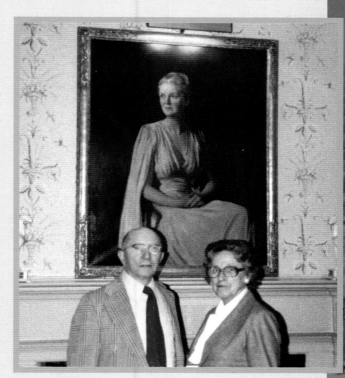

Howard and Alice Gentry standing before Grandmother's portrait in the dining room at The Meadow.

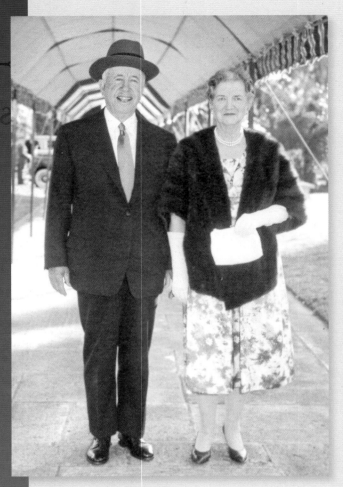

families mingled freely with white families, an unusual practice for the time and place. It seemed natural, however, because the workforce itself was mixed. Most of the grooms and farm workers were black, while most of the exercise riders and managers were white. From all accounts, they worked well together, despite the pervasive segregation of the era. The Meadow paid good wages and offered other benefits. Former workers recalled how Granddaddy gave them half a hog at Christmas and shared beef with them when Meadow steers were slaughtered. They appreciated how he would send a snow plow to their neighborhoods to clear the roads in the winter and would provide a bush-hog so workers could cut grass and brush on their own properties in the summer. One worker remembers getting a raise so his daughter could go to college; another said that he got a raise so his wife could quit her job out of town and move to the farm with him. Granddaddy also provided his workers with low-cost loans for home improvements.

My grandparents, all dressed up to enjoy a day of racing at Belmont Park.

80

Everyone at The Meadow seemed to share a heartfelt sense of place. As Meadow veterinarian Dr. Olive Britt said, "The Meadow was absolutely the most wonderful place in the world. We all felt like we were part of something special. Black and white — we were all friends. There was a sense of family here."

The Meadow evoked a heartfelt sense of place, inspiring some to call it a "Camelot" in Caroline County.

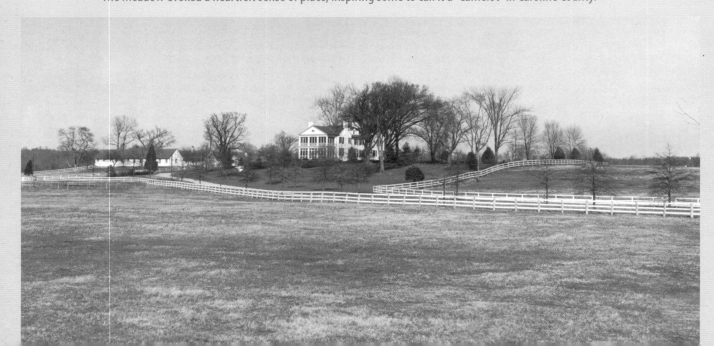

But like any utopia, it could not last forever. Unbeknownst to any of us, my indomitable grandfather, the "bold rider who went bold places," was about to encounter his final hurdle, an obstacle far more formidable than the wide ditches of the Cove—one that not even he could leap. It would be up to my mother, Penny Chenery, to pick up the reins to pursue his lifelong dream of breeding the perfect racehorse.

Although Grandfather loved The Meadow most, he enjoyed three other homes as well: Pelham Manor and Saratoga Springs in New York, and Palm Beach, Florida. But his office at 90 Broad Street, New York City, was his center of operations. From there he ran the Federal Water Service Corporation and later Southern Natural Gas. He also developed the Offshore Company.

He believed deeply in the biblical adage that much is expected of those to whom much is given. Not only did he share his wealth with his extended family, but he served on numerous corporate boards and contributed both time and money to his various alma maters and churches, among many other organizations. For my grandmother's sake, he generously supported the building of Lincoln Center in New York, despite his relative ignorance of the fine arts. A classic story about him goes like this: a friend, seeing him in New York City in top hat and tails, asked if he were heading to the opera. To this he replied, "No, we're going to hear Maria Callas!" It was a story he often told and always found amusing.

He made his most notable civic contribution to racing, however. In the mid-1950s, the Jockey Club appointed a committee comprised of John W. Hanes, Harry Guggenheim and Chris Chenery to clean up the "disgraceful" state of New York racing. After thirteen months' study, they proposed a revolutionary idea: create a non-profit organization called the Greater New York Racing Authority to run the industry and funnel all profits to the state. They obtained the necessary legislation and raised the funds to improve tracks at Belmont and Saratoga and to rebuild Aqueduct. However, when New York banks balked at financing the project, despite the backing of moguls like Vanderbilt, Whitney, Phipps, Kleberg, and John W. Galbreath, my grandfather borrowed thirty million dollars on his own credit to get the ball rolling. John Schiff wrote to Mom at Granddaddy's death, saying that "without him, the finances to establish NYRA never could have been arranged."

81

THE CAMPTOWN RACES

AT THE MEADOW 1953-1958

"Camptown Races"

The Camptown ladies sing this song
Doo-dah! Doo-dah!
The Camptown racetrack's five miles long
Oh! de-doo-dah day!

Goin' to run all night
Goin' to run all day
I bet my money on a bob-tailed nag
Somebody bet on the gray

(*Camptown Races* written by Stephen Foster, published by F. D. Benten, Baltimore, 1850.)

82

When my civic-minded Grandfather offered to host the first Camptown Races at The Meadow in 1953, he did so not only as a charitable gesture, but as a nod to the racing history of the region. Having grown up near Racecourse Avenue in Ashland, he heard stories of the famous racetrack located there prior to the Civil War. But an even greater influence likely was Major Thomas Walker Doswell's celebrated "Field Day" races at nearby Bullfield Stables in the 1880s, which young Chris learned of from his older cousin Bernard Doswell.

In the 1940s, the Chenerys hosted spring races at The Meadow, which were precursors to the Camptown Races.

Like that earlier Virginia gentleman, Major Doswell, Chris Chenery hosted spring races in the early 1940s when The Meadow was just getting on its feet as a Thoroughbred farm. He would invite friends from the vicinity as well as from New York and Kentucky to watch his two-year-old colts and fillies run at The Meadow track. Favored guests later were invited back to the main house for a lavish buffet served on a table said to be over sixteen feet long.

The idea for the Camptown Races originated with local horseman, T. Edward Gilman of Eagle Point Farm, who wanted to raise money for the Ashland War Memorial. Dick

Gillis, the mayor of Ashland and civic booster ex-
traordinaire, reportedly suggested the name "Camp-
town Races" after the popular folk song by Stephen
Foster.

Billed as "a country race meet," the inaugural
Camptown Races were held on Saturday, June 6, 1953.
The event attracted a crowd of about 3,000 spectators.
Subscribers paid $100 each for a five-year parking
spot at the meet. Admission for the general public was
one dollar. The race card featured a farmer's race
with "bona fide work horses," a ladies' race, a Quarter
Horse race, two Thoroughbred races, a hunter's race
for horses that had been foxhunted, and a mule race.
Each winner received a silver trophy. The event was a
resounding success from the start.

"THE CAMP TOWN RACES"

A Country Race Meet
to be run at

THE MEADOW

ESTATE OF MR. AND MRS. CHRISTOPHER T. CHENERY
Doswell, Virginia

SATURDAY, MAY 8, 1954
2:00 P. M.

BENEFIT
ASHLAND WAR MEMORIAL ASSOCIATION
ADMISSION $1.00

Sumpter Priddy of Ashland served as the announcer of the first Camptown Races and many
thereafter. He remembered that the ladies wore dresses and heels and the gentlemen wore coats and
ties. "Mr. Chenery always wore a bow tie," Sumpter said. "He was the epitome of punctuality and
dress."

People brought picnic baskets and blankets to spread out on the grassy fields. Any drinking was
done discreetly, with a nip or two
from silver flasks tucked away in
vest pockets. Spectators lined the
rails as buglers called the horses to
post. Local beauty queens present-
ed trophies and the local papers
snapped the winners' photos.

Later on, the date for the
races was changed to the second
Saturday in May. *The Richmond
Times-Dispatch* described the
scene: "The Chenery estate, The
Meadow, provided a perfect set-

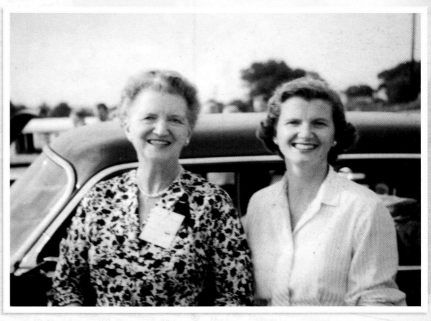

My grandmother, Helen Chenery, and my mother enjoying the Camptown Races,
circa 1955.

ting for the afternoon's sport and between the races spectators could get a view of the broodmare pastures where mares and foals were galloping around in a herd, kicking up their heels." The paper went on to say that Mr. and Mrs. Chenery were "pepped up" over the good race that Prince Hill, a full brother to Hill Prince, had recently run at Belmont. Indeed, The Meadow was still basking in the limelight from Hill Prince's fame as Horse of the Year in 1950.

In addition to hosting the event, the Meadow staff served on the all-volunteer race committee. Howard Gentry was paddock superintendent and Admiral Lunsford L. Hunter served as one of the racing stewards. The stable also ran some of its own second-string horses in the races.

By the sixth annual meet in 1958, racehorses and race fans were coming to the Camptown Races from well beyond central Virginia. "With the largest number of entries we have ever had and the largest subscriber list, we hope to make more money than ever for the Ashland War Memorial," Ed Gilman, racing secretary, told the newspaper. Other local chari-

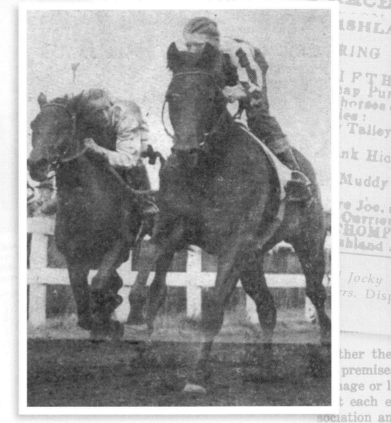

Littlepage, ridden by jockey Andrew Elam, driving down the homestretch in the three-eighths mile race at Camptown. The horse was trained by Ed Gilman, who originated the idea for the Camptown Races.

ties also benefited from race proceeds.

In fact, according to Donna Gilman Dennehy, who has kept her father's archives of the races, the Camptown Races spawned the Varina Races and the Goochland Races, creating Virginia's own Triple Crown.

At the Camptown Races, left to right: James R. Lewis, general chairman of the races; Christopher T. Chenery, Leslie Combs II of Lexington, KY; Richard S. Reynolds, Jr., president of Reynolds Metals Co.; T. Edward Gilman, race secretary; and Edmund T. DeJarnette, member of the Steering Committee.

But the Camptown Races at The Meadow became victims of their own success. As the event grew in popularity, so did the crowds, swelling from 3,000 to over 35,000. And as the crowds increased, so did the hazards to the safety of The Meadow and its Thoroughbreds. After a valuable colt stepped on a broken bottle and severed a tendon, Howard Gentry urged Granddaddy to discontinue hosting the Camptown Races. Ever the gentleman, Granddaddy gave the organizers a contribution matching the race proceeds and politely asked them to find another location.

The next year, the Camptown Races moved to Mannheim Farm in Ashland, which could accommodate thousands of cars and buses. The event continued there until 1976, when an injured jockey filed a lawsuit, forcing the tradition to come to an end. In 1987, the Camptown Races were revived briefly at Graymont Park with the backing of the Hanover Association of Businesses. Later Graymont Park was sold, providing an endowment to perpetuate the funding of community charities that was so important to the original founders of the Camptown Races in 1953.

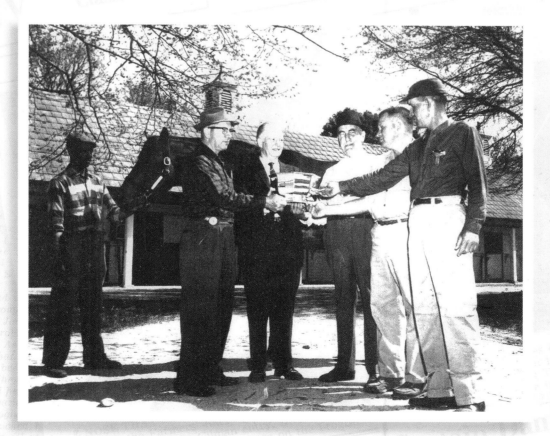

Edmund T. DeJarnette, (second from left) receives the Christopher T. Chenery Challenge Cup from Meadow Stable officials, Howard Gentry, left, Adm. Lunsford Hunter, Leon Zimmerman and Robert Bailes. Groom Howard Gregory holds First Landing in background.

MY HORSE-CRAZY MOTHER POSING IN A NEW RIDING OUTFIT, AGE EIGHT.

Penny Earns Her Spurs

My mother was supposed to be a boy. Granddaddy wanted a son in his own image: a robust, practical child who preferred motion to rest and the outdoors to anywhere else. Instead, his first child, Hollis, born in 1918, was bookish, brilliant and frail like his grandfather. Unfairly, my grandfather picked on Hollis while Grandmother defended him. They battled over their son all their lives, no matter how accomplished he later became.

Chris Chenery and his daughters, Miggie (left) and Penny (right).

The second child, Margaret (Miggie), arriving in 1919, didn't meet her father's expectations either. Like him, she was smart, energetic and competitive. Like her mother, she was lovely, creative and sensitive. But she had a stubborn streak and refused to kow-tow to Grandfather as he felt a daughter should. Sparks soon flew between them as well.

That left child number three, my mother, or "Daught Two," as her dad teasingly called her. Helen, called Penny, born in 1922, was both willing and able to fulfill his notion of filial duty. Watching her siblings fight with their dad, she learned early how to go along to get along.

Bright, athletic and practical, she followed her father like a puppy. If he stood around and kicked dirt with farmers, she did too. If he jumped fences on his horse, she jumped with hers. If he wanted her to dress nicely and be feminine, she did that too. The one place she couldn't go was to the races, as the New York tracks didn't admit children. It would have helped her later if they did.

Like her father, she loved horses. When she needed solace, she cleaned tack or groomed her horse. She liked dogs too, finding them more companionable than people. When an animal died in a novel she was reading, she found it so heartbreaking that she swore off fiction for years.

Mom describes her childhood as sheltered. With a demanding father, a mother entirely occupied in pleasing her husband and two highly competitive siblings, Penny often felt alone. She had

My mother relaxing in her riding clothes, her favorite outfit.

Penny, age fourteen.

Penny, Miggie and Hollis, about 1938.

school friends, of course, but they had to pass a strict test. My grandparents insisted on knowing not only her friends' parents and their employment, but also their religion. As a result, she knew mainly people like her, upper-middle class white Protestants in Westchester County, New York.

Penny, center, with friends in Washington, D.C. in 1937.

When she was thirteen, her parents sent her to the Madeira School, a boarding school in Northern Virginia, as her father said, "to expose her to Southern manners." She took her horse with her and captained the equestrian team. But she always felt like an outsider.

In 1939, she followed the footsteps of her sister, cousins, mother and aunt to Smith College in Northampton, Massachusetts. Soon she discovered boys at nearby Amherst College and her grades dropped. But when Granddaddy threatened to cut off her allowance, her good marks returned. She majored in American Studies, more out of convenience than passion, but what she really learned was how to balance work and play. More importantly, Smith taught her confidence, independent thinking and critical inquiry. These qualities served her well later in racing, an industry that had never taken women seriously.

Mom showed her mettle in her first job in 1943 when factories were working around the clock to prepare for D-Day. She served as assistant to the head of a naval construction company. When a supplier's delivery delays threatened to jeopardize an important deadline, she called the supplier's CEO, explained the problem and got immediate assurances that they would speed up their shipments. Her boss found this move astonishing, but to a utility tycoon's daughter and a Smithie, it was the only logical thing to do.

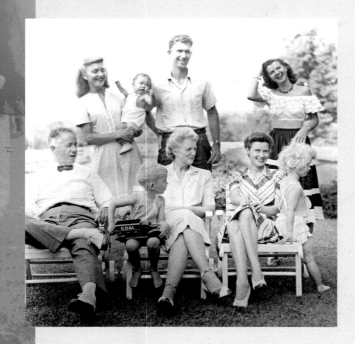

The Chenery family relaxing at Hildene, their summer house in Colebrook, Connecticut, in 1948. Back row from left, Miggie with Lee, Hollis and Penny; front row, Granddaddy, Kip Carmichael, Grandmother and Louise Chenery with Holly.

Penny in the Red Cross in Germany, 1946.

Her next job widened her horizons considerably. Hollis, who was serving in Italy, suggested she come to Europe with the Red Cross. She got her parents' reluctant permission on Hollis's say-so, but had to wait until she turned twenty-three. Victory had been declared in Europe by the time she got there, so the Red Cross girls' mission was to boost the troops' morale as they returned from the front. The girls dispensed coffee, donuts and smiles. For the first time Mom met people of different races, religions and social classes as peers. It opened her eyes. Once returning to her barracks from a date, she remarked ingenuously, "Gee, I had a good time. And he didn't even go to college!" To this a roommate responded wryly, "Look at Chenery—discovering humanity."

Her Red Cross stint prepared her for much later when she would appreciate and interact with horse racing fans of all stripes. Her friend Martha Gerry, the very shy owner of Forego, once asked Mom how she could talk so easily to strangers. Mom shrugged and said, "They are just people who love horses too."

By the time my mother came home in 1947, she was twenty-five and still single despite several offers of marriage. One day my grandfather sat her down and said bluntly, "Penny, if the Bolsheviks [Communists] take over this country, they will shoot you of all people first because you have no skills to contribute to society." After that daunting assessment, he told her to find the best job she could and he would pay her the equivalent salary to go to graduate school. Reasoning that someday she might inherit some money, she chose to get an MBA from Columbia University. Her class contained 800 men and only twenty women.

She studied hard. Nevertheless, by 1948, Mom admits to parking her car near the law school library in hopes of crossing paths with an attractive young law student she'd met named Jack Tweedy. He had trained with the 10th Mountain Division Ski Troops in Colorado during the war, but he actually served in Myanmar (Burma) with the OSS (the forerunner of the CIA). He had wrangled on his uncle's ranch in West Texas, so to him, riding was work, not fun. Mom liked him anyway, but didn't accept his proposal until my grandparents gave him the nod. Dad was charming and forthright. Even more important to my grandmother, he belonged, with his old New York roots and both St. Paul's School and Princeton University in his resume. In the spring of 1949, when Mom was three months shy of graduation, Dad wired her from Denver where they hoped to settle: "Have job and apartment. Plan wedding."

Penny as a bride in 1949.

This put her in a quandary: should she finish her degree? Her professors predicted that she could pass her exams without much more study. My grandparents, however, pooh-poohed the idea. "What do you need that degree for now that you are getting married?" What indeed? The message was loud and clear, and her entire generation of women heard it—no matter how smart and capable they were, no matter what they did during the war, the only acceptable role for them now was to be a wife and mother. So Mom quit school—and always regretted it.

After an elegant wedding that Mom remembers as mostly Grandmother's show, the couple moved to Denver in June, 1949. With Dad working at a respected law firm, Grant, Shafroth and Toll, they had ready access to a group of compatible peers from among old Denver families and new Ivy League transplants. Penny's job description was clear: support her husband's career, host nice dinners for his clients, have babies, manage an attractive home, and try to be content. She was game, but it was like swimming upstream for this woman of high energy and unfulfilled ambition.

For one thing, despite her top-notch education, Mom didn't know how to cook or clean. Second, as her own mother had been essentially an orphan, neither Grandmother nor Mom knew much about raising children. Third, domestic matters bored her to tears. She loved us children, certainly, and managed to glean the basics of motherhood from the other moms.

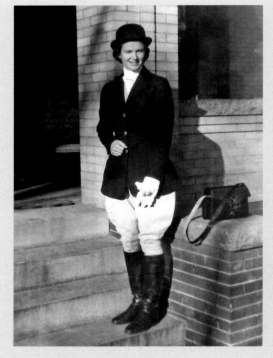

Penny in hunting attire, Denver, 1950.

But the talents her new job required were not her strengths and she knew it. We knew it too. Before my older sister and I had hit puberty, we could tell that Mom needed other outlets, preferably challenging ones beyond the home. As my younger brothers Christopher and John arrived in 1955 and 1960, that insight became even more obvious.

Yet we had a lot of fun together enjoying Colorado's magnificent mountains. Our favorite times came at Vail, where Dad, as one of the

Penny, born and raised in the East, came to love the West.

My father, Jack Tweedy with my brother, Chris, 1958.

resort's founders, took us camping when it was still just a sheep field. In 1962, we built a small house right by the original gondola. Mom hadn't skied much before marriage, but she took to it with spirit, developing a stylish parallel form that took her anywhere she wanted to go. She drove us up to Vail every weekend, winter and summer, no matter the weather. No one handled those snowy mountain passes as fearlessly as our parents. On the worst trips, she would lead us in singing old cowboy songs, Broadway tunes and her mother's turn-of-the century favorites. I was never afraid with her at the wheel.

Penny and her children: Sarah, Chris, and Kate, 1957, in Denver.

Mom's sense of humor came in handy when Dad tried to impose decorum during family dinners. Often we'd conspire with Mom to crack him up. Many meals that began with formal manners ended in hilarity with puns, anecdotes and good-humored barbs flying round the table. I remember Dad hiding his chortles behind his napkin while the rest of us gasped with hysterical laughter.

Despite truly loving Mom, Dad was little prepared for her complex nature. Like her father, Dad was a straightforward, logical problem-solver who had avoided emotion. He didn't see why she couldn't get with the program to become a happy housewife. As a result, they clashed over money, decision-making and power. The more Mom struggled to fit the wife/mother mold, the more she felt like a failure.

But the times were changing, and as other women began expressing similar frustrations, Mom began to see things in a different light. She never viewed herself as a feminist, and certainly not as a radical, but she quietly read *The Feminine Mystique* by Betty Friedan, Smith, Class of 1942—and identified with its revolutionary ideas.

By 1967, Granddaddy, then eighty-one, had lost his mental sharpness and his hands shook constantly. His eyes didn't focus well and he neglected things that he had cared deeply about, such as The Meadow. Howard Gentry repeatedly asked Elizabeth Ham

Our family Christmas card, 1961: Chris, Dad, Kate, John, Mom and Sarah.

Dutiful Penny with her parents in
Palm Beach, Florida, early 1960s.

to settle matters that Granddaddy would have previously handled instantly. Though retired, he kept going to his office, mostly to nap. Everyone noticed these changes, but no one wanted to admit that the great man might be losing his grip. Grandmother and Elizabeth agreed privately not to let him go anywhere alone, just in case.

One October day, Casey Hayes, the trainer, called Granddaddy to come see his horses at Belmont where they were stabled. Elizabeth happened to be at a hair appointment, so Granddaddy went with Raymond, his chauffeur. There, a well-known track veterinarian convinced the old man to sell four of his best mares cheap, claiming that they were "dirty" (carrying infections). Although the mares were healthy, Casey, eyeing a ten percent commission, backed up the vet's opinion. At their urging, Granddaddy inked a wobbly 'CTC' on the sales contract then and there.

The next day, Grandmother made a frantic call to Mom in Denver. Granddaddy had been duped, she said, and was refusing to rescind the deal, declaring that Elizabeth had been stealing from him and that the farm account needed cash. Neither claim was true, and Grandmother begged Mom to fly east right away to talk some sense to the old man.

Mom had no more success with Granddaddy than Grandmother did. They debated taking the matter to court, but concluded that the public embarrassment Granddaddy would suffer wasn't worth it. Therefore they let the mares go, except for one saved on a technicality. However a deeper problem remained—who would take charge of Meadow Stable?

Before that question was settled, Mom got another phone call from New York just three weeks later. I remember vividly— it was the afternoon of Monday, November 20, my brother Chris's twelfth birthday. I was standing beside Mom as she took the call from Great-aunt Bannie who said that Grandmother had just died of a brain aneurysm. To my amazement, Mom didn't cry at the devastating news. Instead she stayed calm, made plans to go east and began packing. I remember wondering at her drawn face and her lack of tears.

Hollis scheduled the funeral for Wednesday, November 22, 1967, in Pelham Manor, too quickly for our family to get there from Denver. Therefore we did not get to say goodbye to Grandmother. Mom stayed

Our Christmas card, 1967, in Littleton, Colorado; clockwise
from left: Kate, Dad, Chris, John, Sarah and Mom.

east that Thanksgiving to keep her father company. Soon after Grandmother's death, Granddaddy began to decline rapidly, both physically and mentally. Three months later he entered New Rochelle Hospital with a urinary infection, never to leave again. He lingered there in declining consciousness for the next four and a half years.

Penny perfected her skiing at Vail, where we had a house from 1962 to 1984.

In the family meetings that followed to decide the fate of The Meadow, one thing became clear. Neither Hollis nor Miggie had any interest in running the stable. Hollis had a demanding career, having achieved international respect as a tenured professor of economics at Harvard. By 1970, he would become a vice president of the World Bank under Robert McNamara and a close associate of Henry Kissinger. Miggie also had her hands full. She owned and ran two successful businesses in Tucson, one in real estate investment and the other in editing. She and her daughter, Lee, loved living in Arizona and didn't want to move east.

Clearly Mom was the only candidate to take charge of the stable. This was what she'd been waiting for, unknowingly, all her life. She barely managed to hide the glee in her voice as she accepted the job. The only condition was that she had to get the stable back in the black within a few years.

As soon as she got home, she dove into the daunting process of educating herself about the horse racing industry. She ordered trade journals and tomes on horse conformation and breeding lines, and started reading every spare minute she had. The learning curve might be steep, but she relished the challenge. Finally, she had a real career!

Mom began her new life with a double burden of grief, mourning the actual loss of her mother and the emotional loss of her father. Besides, she no longer trusted the trainer, Casey, who disparagingly referred to her as "the daughter." Yet she needed him, at least until she knew her job better. In those early days, she had two key people to turn to: Elizabeth Ham and Bull Hancock, the master of Claiborne Farm.

Elizabeth provided continuity and confidence. She knew exactly how Granddaddy had always done things, and that was her default position on every issue. She admired her boss's daughter for showing many of the same strengths he had. Furthermore, Elizabeth both liked and trusted Howard Gentry, which eased Mother's mind about matters on the farm itself.

In contrast, Bull Hancock didn't know Mom well, but he respected her obvious aptitude for learning. Plus, as the third-generation Hancock to run the family business, he knew all about filial duty. He valued her willingness to try to fill Chris Chenery's shoes. He also remembered how my grandfather had supported

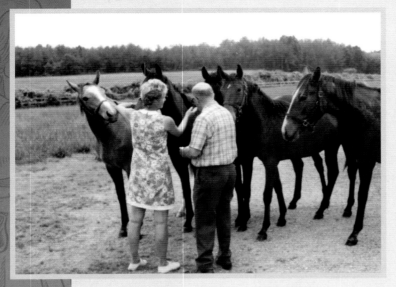

Mom and Howard Gentry check over Meadow yearlings, 1969.

his own early solo efforts by breeding to the then-unfashionable Princequillo before he became a sought-after sire. So Bull repaid the favor by advising my mother on breeding, sales and purchases.

It took a year and a half for Penny to gain the confidence to fire Casey. She remembers it as the day she developed a backbone. She still had a lot to learn, but now she felt firmly in control.

Bull helped her find her new trainer, Roger Laurin, a talented young man who managed strings of race horses for various owners. Roger and his wife came to The Meadow to meet Howard, Elizabeth and Mom in the fall of 1969. Right away he suggested culling unproductive mares and trimming the number of horse in training, which had not been done in recent years. Next he suggested paring the number of horses at the track to ones that were fit and showed promise. These actions improved the bottom line right away. In addition, a few stakes winners like Gay Matelda and Syrian Sea brought home purses.

But Mom knew she had really earned her spurs when she asked Bull to help her plan the breeding schedule for 1969. He responded, "I could tell you, but you're smart. You figure it out." Coming from Bull, that was a huge compliment.

Meanwhile back home in Colorado, we missed Mom. She had been commuting east one week out of every month for two years now. We knew she needed to travel, but it wore on us kids, on Dad, and especially on her. 1969 was a tough year for all of us. As the oldest child and a senior in high school, Sarah bore the brunt of Mom's absences, driving carpools and trying to keep the boys in line while getting ready for college. I was away at boarding school in Concord, Massachusetts, and Dad had to travel often for his work as well.

Sarah, Kate and Penny Tweedy with Syrian Sea, winner of the Nixie at Saratoga, August 8, 1968. Angel Cordero up.

On President's Day, 1969, I was skiing with friends at Stowe, Vermont, when I lost control and barreled into a tree. I broke five ribs, punctured a lung, lacerated my spleen and injured my left kidney. Already planning a trip east, Mom packed her stuff for Virginia and flew to Burlington, where I was in the ICU at the University of Vermont Medical Center. The seriousness of my injuries hadn't been made clear to her and the first sight of me full of tubes and bandages rocked her. It took two weeks before I could be moved to Colorado and two months before I went back to school. Meanwhile, Mom had to conduct her Meadow business long-distance. It was a tough time for us both. How does one nurse an injured teen while running a racing stable? Mom used every minute efficiently and was very organized. I watched and took note.

All this time pressure was mounting from her siblings to turn a profit at the stable. At a meeting in 1970, Hollis finally pushed for an end to what he saw as Penny's experiment in racing. He felt the money would do better in the stock market. Granddaddy had always made the farm support itself, but from 1966 through 1968 the bottom line had dipped into the red.

"But Dad's still alive," Mom argued, "and as long as he is, we owe it to him to keep the horses." It seemed Hollis's ongoing resentment of his father might trump Mom's continuing desire to carry on Granddaddy's legacy. Although Miggie sided with Hollis, the call of filial duty won the day.

From then on, however, Mom was on notice—deliver profits or hand over the horses. We could see her drive to succeed intensify in this most emotional of tasks. Quitting was not an option, no matter how uncertain she felt. In the back of her mind, she knew that some day all Granddaddy's years of careful breeding would pay off again. The question was, would it happen soon enough?

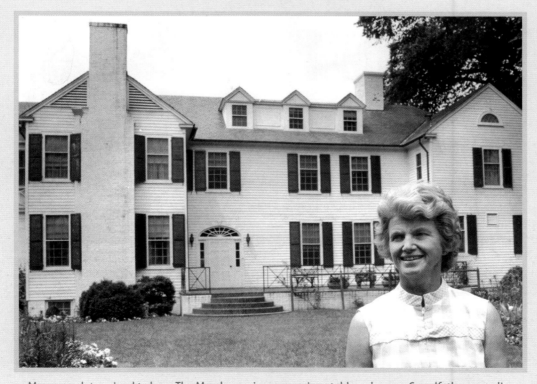

Mom was determined to keep The Meadow going as a racing stable as long as Grandfather was alive.

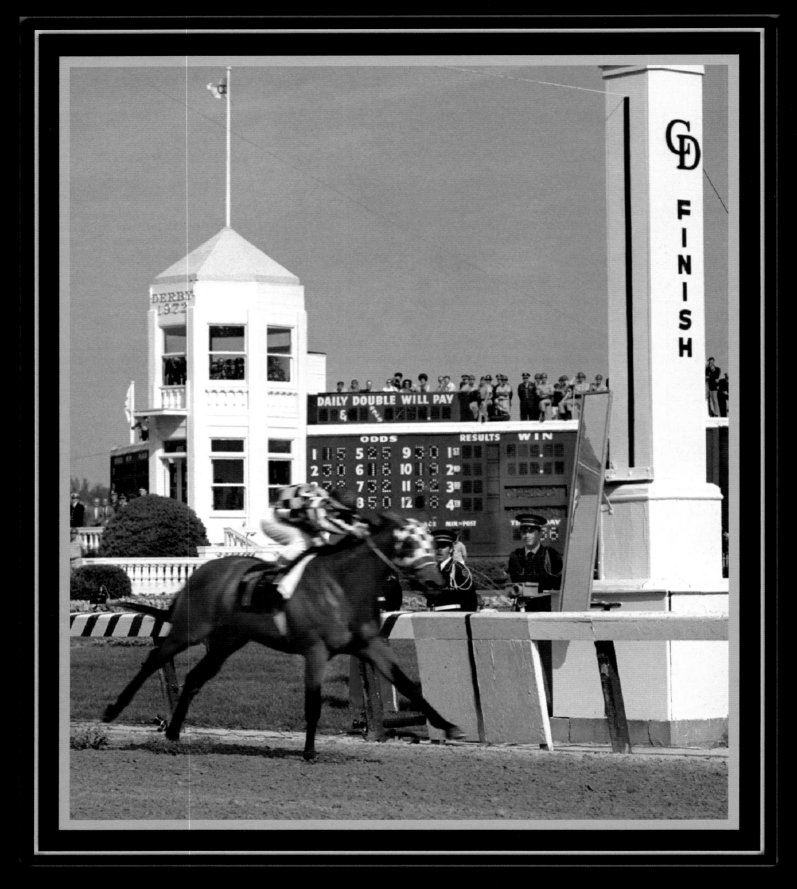

RIVA RIDGE WINS THE 1972 KENTUCKY DERBY

Riva Ridge to the Rescue

With Granddaddy's health failing and his racing stable operating in the red, The Meadow's future would depend on a scrawny bay colt born on April 13, 1969.

The colt's dam, Iberia, was a Meadow mare with great genes and a sour disposition. Her father, Heliopolis, led the sire lists in England, while her mother, War East, traced back to the mighty and semi-malevolent Man o' War. Iberia ran poorly, but she conveyed her bloodline's speed to her sons, especially Hydrologist, who won over $400,000 by 1969. Howard Gentry, farm manager, hoped that the new foal would inherit an extra dose of speed from his father, First Landing, The Meadow's leading stallion.

But the sickly homebred didn't look like the savior we needed. Skinny even by foal standards, the colt was a mess the first time Mom saw him, suffering from diarrhea and a fever of 102 degrees. Howard's horse journal entry said, "Colt looks poor and thin. You could run your fingers along his ribs and play a tune."

Antibiotics soon cut the fever and the foal's health improved over the summer. But not his looks. His appearance fell far short of the classic Thoroughbred ideal. He had floppy ears, a narrow chest and an odd bay color, pale instead of the preferred rich, reddish brown. His legs, however, were just fine. One horseman later described them as "very slender, like a deer's legs." By September of that year, Gentry's stable journal reflected the colt's improvement. He wrote: "good-looking, sound, travels well, a nice way of moving."

The colt's disposition, calm like his father's, impressed senior groom Howard Gregory. "He was so quiet, you could lead him around on a shoestring," Gregory said. "He didn't make no hell; he didn't press up against you or try to push you or get away from you or nothing."

Mom named the ungainly colt Riva Ridge, after a hard-won battle that the Army's 10th Mountain Division fought to secure a key summit in the Italian Apennine Range in World War II. My father had trained with that division and years later, he and friends from the 10th also founded Vail, the Colorado ski resort. Our favorite ski trail at Vail was Riva Ridge, a long sweeping run that descended 2,500 feet from the top of the hill to the village below. Little did we know how well the name suited the determined colt, whose strategic victories would affect The Meadow's future in surprising ways.

As he did with all of First Landing's foals, Gentry took particular charge of Riva, giving him extra attention. That summer, his diligence saved the foal's life—and those of several others.

On Saturday, August 19, 1969, Hurricane Camille struck Virginia, one of the few Category Five storms ever to cross the state. The afternoon before, Howard Gentry began to worry about the broodmares and foals pastured down in the Cove. The radio reported twenty inches of rain upriver in Scottsville. He asked

Howard Gregory to find men to help move the horses to higher ground. They gathered the mares and foals together and stabled them safely in the broodmare barn.

Early the next morning, the swollen North Anna River burst through the levee that Granddaddy had painstakingly rebuilt thirty years before. The water completely filled the Cove in about twenty minutes, creating a debris-and-snake-infested lake fifty

A group of Chenerys on the fence at The Meadow. (Left to right) Penny, Kate, Elizabeth (standing), John Fager, Peter Chenery, Janet Chenery and Miggie Carmichael.

feet deep. To Howard Gregory, the sound of the water roared "just like an airplane." The roiling waters rose so high they almost lapped the broodmare barn and the stud barn on the hill above the Cove. The foresight of Gentry, Gregory and other Meadow grooms had saved the mares and foals, including Riva Ridge. Three years later, the colt would rescue the farm in his own way.

In early 1971, Riva left The Meadow to winter in Hialeah, Florida. In May, he and three other Meadow horses in training were shipped to Belmont Park in New York to begin racing. There, trainer Roger Laurin saw potential in the colt. Mom did, too. She wrote about Riva in her notebook: "Will be a racehorse. Alert, quick to learn, most promising."

Penny and her sister Miggie at Saratoga, August, 1971 for the Flash Stakes, which launched Riva's career.

Just when Riva arrived in New York, trainer Roger Laurin gave Mom notice that he'd been offered the post of head trainer for the Phippses' Wheatley Stable. Frantic to find a new trainer, Mom asked Roger for a recommendation. He suggested his father, Lucien, who had just retired, as a temporary substitute. Once Lucien Laurin got to know the Meadow horses, he never mentioned retirement again.

Riva floundered in his first race of five-and-a-half furlongs (almost three-quarters of a mile). Mom recalled that "Riva didn't know whether to go forward or backward when the gate opened." Bumped around in the field, he finished well back of the other horses. Despite his deer-like speed, Riva was timid, which cost him two of his next four races. Lucien and Mom needed to find the key to Riva's confidence.

They discovered it at Saratoga, a legendary launching pad for many young Thoroughbreds. The key was putting the intuitive jockey Ron Turcotte on Riva for

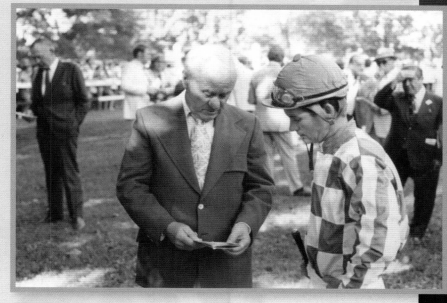

Lucien Laurin and Ron Turcotte conferring before a race at Saratoga, 1971.

the Flash Stakes on August 2, 1971. Riva won, so impressing Ronnie (as we called him) that he told Lucien this was the best two-year-old he had ever ridden. From a jockey whose mounts included champions like Northern Dancer, Tom Rolfe and Arts and Letters, it was high praise indeed.

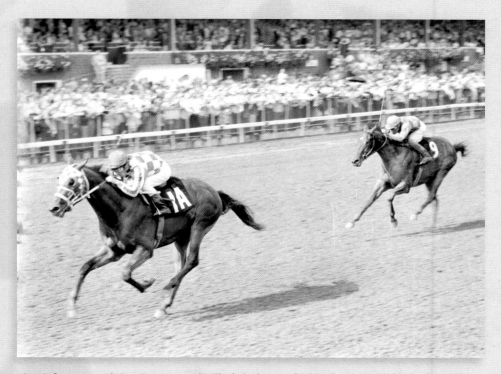

Riva's first win with Ron Turcotte in the Flash Stakes marked a turning point for the timid horse.

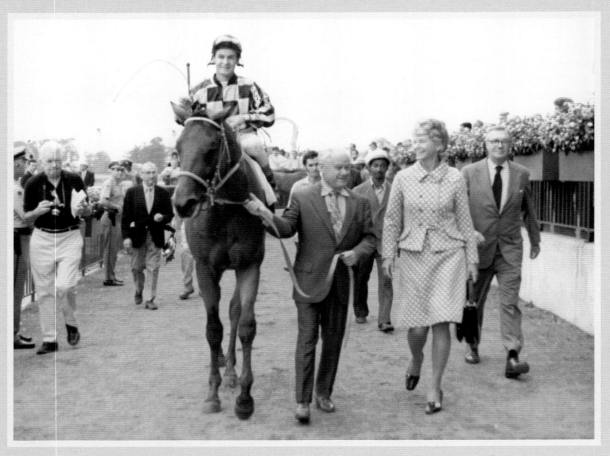

Riva's win in the Belmont Futurity in September, 1971 boosted Mom's hopes for a new champion.

Ron also perceived that Riva ran from the other horses, not with them, which he diagnosed as fear. He generously offered to school Riva to accustom the colt to the hurly-burly of close contact with other racehorses. Lucien agreed. Over the next four weeks, Ronnie and exercise rider Charlie Davis would work Riva in ever closer quarters with other horses, teaching him to run beside them, through them and around them, on the inside and outside. They tested his new-found confidence at the Belmont Futurity on September 18, 1971, where Riva came from behind to win handily. His performance encouraged Mom to tell the *Blood-Horse*, "Okay, this is it. Now we've got another one. We've got a good horse."

Riva sailed through his two-year-old campaign. He took the Champagne Stakes by seven lengths, the Laurel Futurity by eleven lengths and the Garden State Stakes by two-and-a-half lengths.

Riva winning the Belmont Futurity in fall 1971.

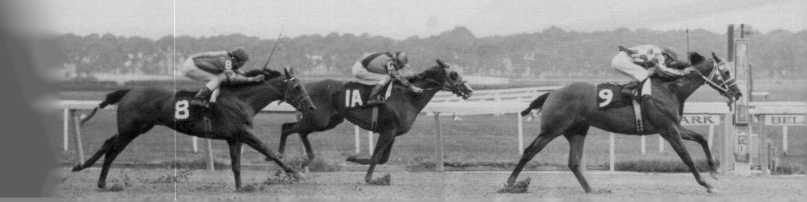

Left photo: Riva with Lucien Laurin at Laurel, 1971.

Below: Riva with Ronnie up, being ponied by Charlie Davis.

In his autobiography, Ron Turcotte reflected on Riva's wins that fall: "I was so proud of him, not only because I was right about my work for his benefit, but because he overcame his own fears and could run any way I wanted him to. This way he could be rated [reined in] and run longer distances to the best of his ability, of which he had plenty." The tall, ungainly colt fattened Meadow Stable's bank account by $503,263 and captured the 1971 Two-Year-Old Colt of the Year honors.

Yet his winnings contributed far more than money. Years later, Mom put it bluntly: "Riva saved the farm." His victories quelled calls from my uncle Hollis and my aunt Miggie to sell The Meadow and the horses. Had he not turned The Meadow's bottom line black, his stablemate, the strapping chestnut colt in training back in Virginia, might have never raced under our blue-and-white silks. And without The Meadow team of Mom, Lucien Laurin and Ron Turcotte, it's impossible to know if Secretariat would have run as spectacularly as he did.

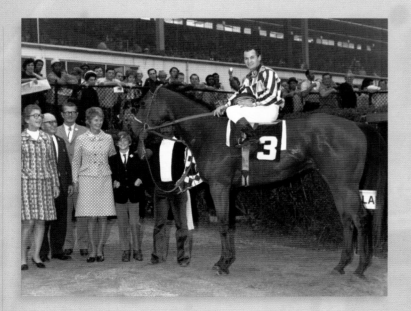

Riva won the Laurel Futurity by eleven lengths in 1971. Left to right: Miggie Carmichael, Howard Gentry, George Gardiner, Mom and John.

Mom observed, "I feel very strongly that Secretariat might not have bloomed for another trainer. The two horses were so different and each needed Lucien's ability—Secretariat because he needed so much work to keep him challenged, and Riva, because he needed coddling."

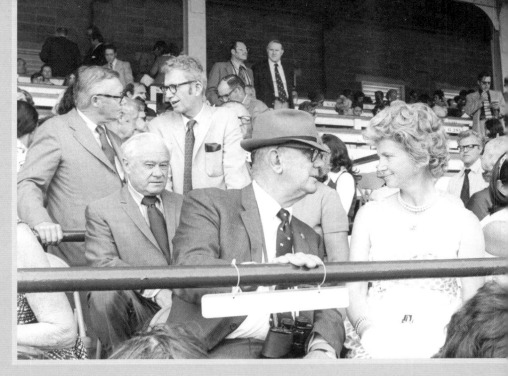

Penny and Arthur "Bull" Hancock compare notes at the 1972 Derby, while Jack Tweedy and Hollis Chenery confer behind Lucien Laurin.

Following his stellar two-year-old campaign, Riva Ridge reigned as Mother's Golden Boy. Once again, our Derby hopes rose, just as they had with Hill Prince, First Landing and Sir Gaylord. Riva enjoyed a well-deserved rest at Hialeah over the winter, while Mom and Lucien mapped out an unorthodox training strategy. Though in those days most Derby contenders raced six or seven times before the all-important first Saturday in May, they opted to enter Riva in only three contests, knowing he ran best when fresh and well-rested.

Riva gets an extra scoop of oats on his third birthday on April 13, 1972.

Riva Ridge in training in 1972, with exercise rider Jim Gaffney up. Jim said, "I guess the best way to describe Riva Ridge was that he was a nice moving, long, lanky, flop-eared horse with a nice smooth way of galloping and when you dropped him down on the rail to work out, he was all business."

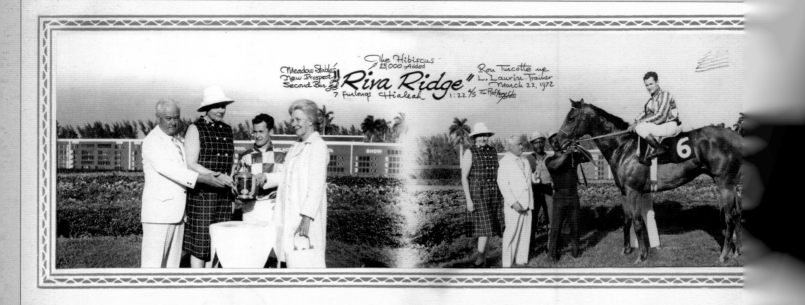

A portion of the win photo collage that racetracks give to the owners of winning horses. This one shows Lucien, Elizabeth and Ronnie in the winner's circle for the Hibiscus Stakes.

Keenly aware that Riva was The Meadow's best—and perhaps its last—shot at winning the Derby, my grandfather's lifelong dream, Lucien trained him carefully. On winter mornings in 1972, he waited until full light before sending Riva to the track so that other horses would not bump or spook him in the dark. By spring 1972, the gangly colt had grown sleek as a greyhound, standing sixteen hands, one-and-a-quarter inches tall. He had not lost his good disposition or his competitive spirit.

Ronnie found the three-year-old Riva relaxed, easy to handle and eager to run. In March, the *Daily Racing Form* reported that the colt was turning in sizzling fractions. At the normal "12-clip" or twelve seconds per furlong, a time of sixty seconds would be very respectable for five furlongs. Riva was ripping up the same ground in :57 1/5.

On March 22, Riva made his three-year-old debut by winning the Hibiscus Stakes in Florida, pumping up our Derby hopes. But with the next race, they nearly slipped away. Riva finished a weak fourth in the Everglades Stakes, undone by sloppy footing, a traffic jam and a slam into the rail. It was Ronnie's first loss on the colt.

Riva won his last prep race before the Derby, the Bluegrass Stakes, but Ronnie still didn't like the way he ran. He thought Riva's blinkers obscured the sight of other horses behind him. The day of the Kentucky Derby, May 6, 1972, Ronnie asked Lucien if he could enlarge the slits in the blinkers. "You should have seen the expression on his face!" Ronnie exclaimed. First Lucien refused on grounds that it was too late to make changes. But when Ronnie said, "I sure would hate to lose a Derby this way," Lucien relented.

"I knew he was the best horse in the race," Ronnie declared. "He was feeling good and had worked good over the track which was very fast. Everything was to his liking and I could smell the roses."

RIDGE, Bay C
 Meado

 Ron
urse $140,300
:01 4/5—1 1/4 M
(Derby Purse)

104

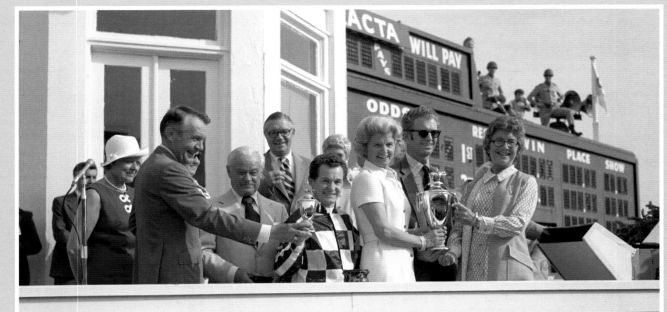

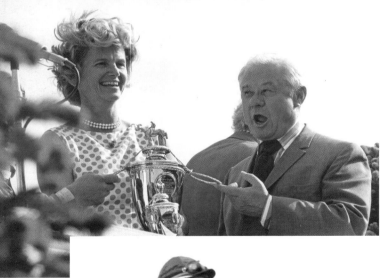

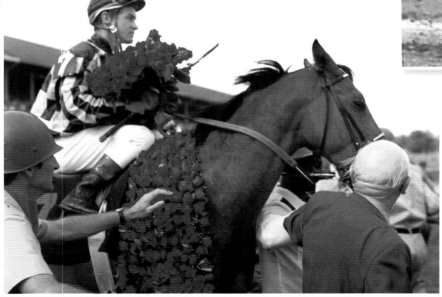

Scenes from the
Kentucky Derby 1972:
Riva's win saved
Meadow Stable
from the auction block.

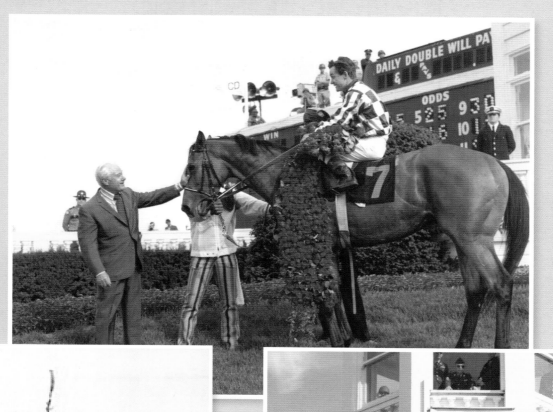

RIDGE, Bay

Mea

Re

Purse $140,300

2.01 4/5—1 1/4

cl. Derby Purs

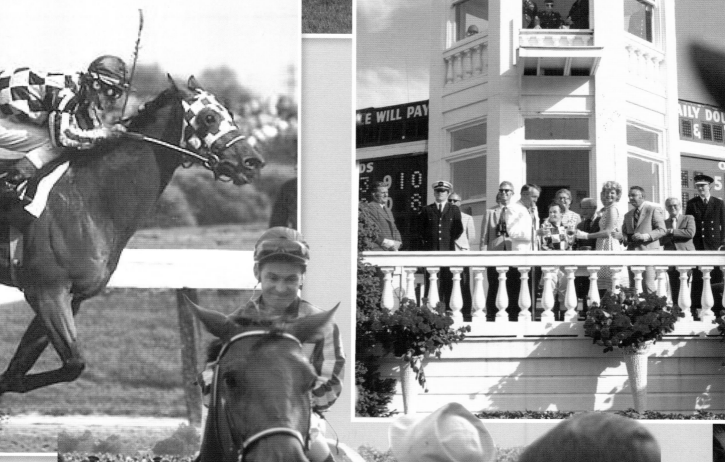

Evidently, so did Riva. He grabbed the lead out of the gate and, despite a bump at the start, recovered quickly with no trace of his old timidity. He disposed of Hold Your Peace easily and rebuffed his major challenger No Le Hace to win the Kentucky Derby by three-and-a-half lengths. A record crowd of 130,564 at Churchill Downs cheered as Riva Ridge became only the thirteenth horse in Derby history to win wire to wire. His time of 2:01⁴/₅, under a strong hold by Ronnie, was the seventh fastest ever recorded.

That day, the Kentucky sun shone brightly on Virginia's Meadow Stable as Granddaddy's Derby jinx finally lifted. Lucien had trained Riva to peak at the perfect time. Ron had kept Riva off the rail where the deeper soil of the "cuppy" track could have tired him, thus allowing him to sprint to the front where the field of fifteen couldn't block him. The last-minute tactic of widening the blinker slits had helped Riva keep his challengers in sight. For once, everything worked.

In the winner's circle, the red roses draped Riva's neck as Mom, wearing her lucky blue and white dress with Grandmother's racehorse pin on her lapel, accepted the ornate Derby urn on behalf of Meadow Stud.

Back in New Rochelle Hospital, my once-indomitable grandfather lay mute in his hospital bed, felled by Alzheimer's disease. His nurse watched the race on TV, then turned to him and exclaimed, "Mr. Chenery, Mr. Chenery! Your horse just won the Kentucky Derby!" He said nothing, but lifted a blue veiny hand which fluttered while a tear trickled down his withered cheek.

Riva's Derby win fulfilled the old horseman's lifelong ambition and united the Chenery family in support of The Meadow. It also gave the horse star status and thrust Meadow Stable and my mother into the national spotlight. With her blond bouffant hair, bright smile and enthusiasm for the sport, Penny Tweedy became the

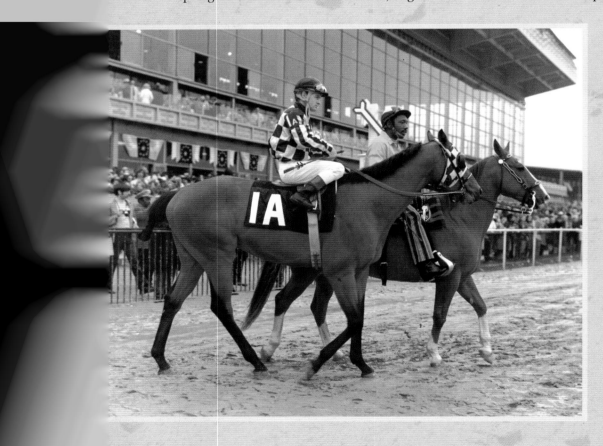

Had it not been for a muddy track at the Preakness, Riva might have won the Triple Crown before Secretariat did.

fresh new face in racing. The media and the public loved her class, pizzazz and accessibility.

Now The Meadow team had a new goal—the Triple Crown. Lucien aimed Riva for the Preakness Stakes, which my grandfather had proudly won with Hill Prince in 1950. But rain and a slick track drowned our Pimlico hopes. A long shot at 19-1, Bee Bee Bee took the Black-eyed Susans that day, as Riva finished fourth behind his rival, Key to the Mint. The Preakness loss took the shine off Mom's Golden Boy. She told the *Blood-Horse* years later, "After the Preakness, people stopped looking at us as the champion. We were just another contender."

Suddenly the mile-and-a-half Belmont Stakes loomed nearly as dauntingly as had the original alpine Riva Ridge. Winning the Belmont Stakes on the home turf of the Vanderbilts, the Phippses, the Guggenheims and yes, the Chenerys, offered Thoroughbred owners serious bragging rights, ones that had eluded the horses of Meadow Stable.

Once again, tremendous expectations rode on Riva Ridge's slender legs. On Belmont day, in the late afternoon of June 10, 1972, Lucien boosted Ron aboard Riva and they circled the paddock, waiting for the bugler to summon the horses to the race. Minutes later, the bell rang, the gates clanged open and Riva broke to the inside.

The prestigious Belmont Stakes trophy (below) seemed out of reach for Meadow Stable after Riva lost the Preakness. Bottom photo: Riva Ridge handily won the Belmont Stakes, sailing across the finish line seven lengths ahead of the field. Posting the third fastest time ever run in the Belmont, the Meadow colt ran faster than Triple Crown winners Count Fleet and Citation.

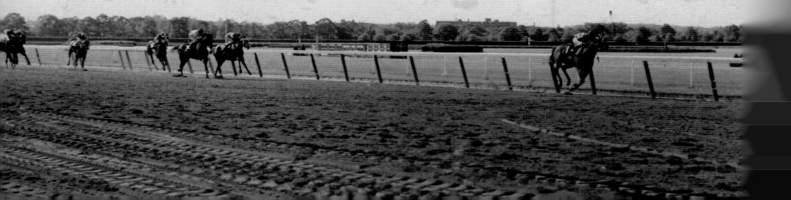

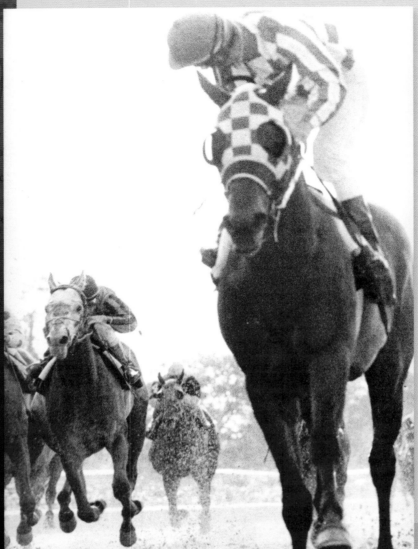

Ron took Riva to the lead right away. He planned to hold the pace at 48 seconds for the first half mile (an easy 12-clip) thus saving strength for the last quarter-mile. It worked like a charm. No one, not even Key to the Mint, mounted a serious challenge. Riva had plenty of juice left as they rounded the final turn, showing the tiring field a clean pair of heels as he sailed across the finish line seven lengths ahead. Posting the third fastest time ever run in the Belmont at 2:28, the Meadow colt ran faster than Triple Crown winners Count Fleet and Citation.

Top photo: Ron Turcotte glances back at the field as Riva gallops to victory in the 1972 Belmont Stakes.
Bottom photo: Mom leads her "Golden Boy" Riva to the winner's circle at Belmont.

108

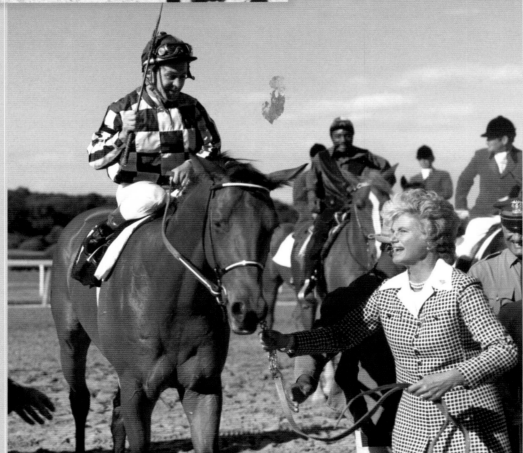

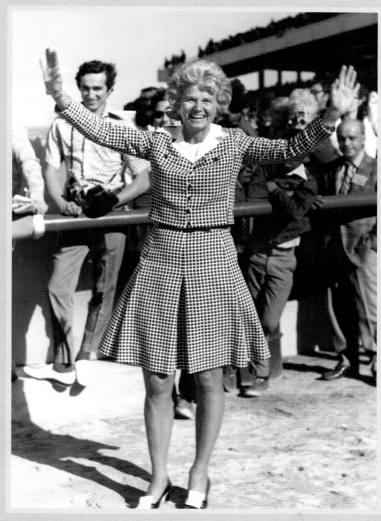

Mom was jubilant after Riva won the Belmont.

Champagne flowed at Meadow Stable. But, as Mom noted later, "A good horse arouses ambitions that obscure the lessons learned by experience." By that she meant that she and Lucien became over confident. Just three weeks after emerging from the crucible of the Triple Crown, Riva shipped to California for the Hollywood Derby. The tired colt won—barely. After that, he ran five more times as a three-year-old and came up empty each time. Like the goose that laid the golden egg, The Meadow's Golden Boy simply stopped delivering.

The horse that had earned the prestigious Eclipse Award as juvenile champion in 1971 and won two jewels of the Triple Crown in 1972, lost the award as a three-year-old. Instead, the Eclipse Award went to Key to the Mint, who failed to win a single Triple Crown race. Looking back at Riva's losing streak, Mom mused that having a good horse could make you forget the "hard work that got you there."

But Riva wasn't done yet. In 1973, recharged by a long winter's rest at The Meadow, he triumphed as a four-year-old handicap horse just like his sire, First Landing. Riva set a world record for a mile and

The Meadow Stable team happily accepts the Belmont trophy. Left to right: Miggie Carmichael, Hollis Chenery, Mom, Ron Turcotte, NYRA Chairman Alfred Vanderbilt and Lucien Laurin.

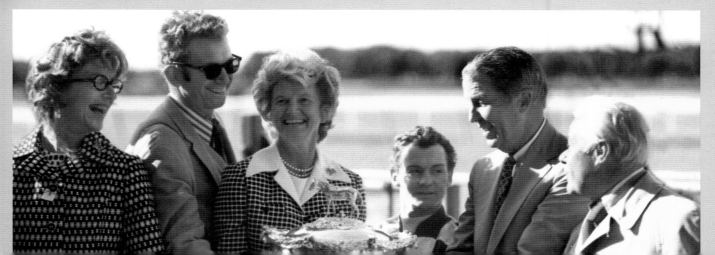

RIDGE, Bay C
........ Meado
............ Ron
urse $140,300
01 4/5—1 1/4 M
l. Derby Purse)

This young woman so loved Riva that she drove from the Midwest to visit him at The Meadow in the winter of 1973.

three-sixteenths in the Brooklyn Handicap; equaled the mile and
one-eighth track record in the Massachusetts Handicap;
and set a track record in the mile-
and-one-eighth Stuyvesant Handicap
at Aqueduct in New York. In so doing,
he reclaimed his title as champion, this
time as an older horse.

Yet despite his new records,
Riva's moment of glory had passed.

One of the keys to Riva becoming a better
racehorse may have been when jockey Ron
Turcotte convinced trainer Lucien Laurin
to cut larger slits in Riva's blinkers. Riva is
shown here with groom Eddie Sweat.

Only Mom and his groom, Eddie Sweat, seemed to remember what he had accomplished. Instead, the fans who used to chant "Viva Riva" outside his stall in Barn 5 at Belmont now congregated by the stall of the camera-friendly chestnut youngster next door. Secretariat, saved from the auction block by Riva's Derby victory, had made an unforgettable entrance on the racing scene. An everyday champion like Riva Ridge could not help being swept aside in the flood of publicity and adulation that engulfed his phenomenal stablemate.

Unbelievably, lightning had struck twice at Meadow Stable. But in the end, only one champion would be called "America's Super Horse."

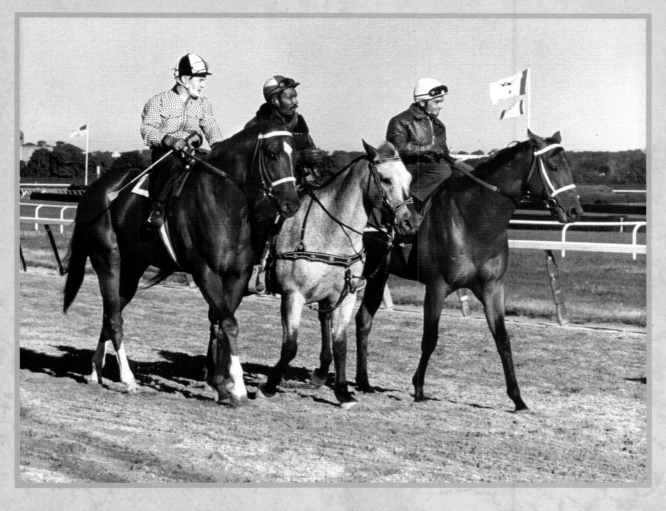

A rare photo of Secretariat, lead pony Billy Silver and Riva Ridge together on the track, with Ronnie, Charlie Davis and Jimmy Gaffney up.

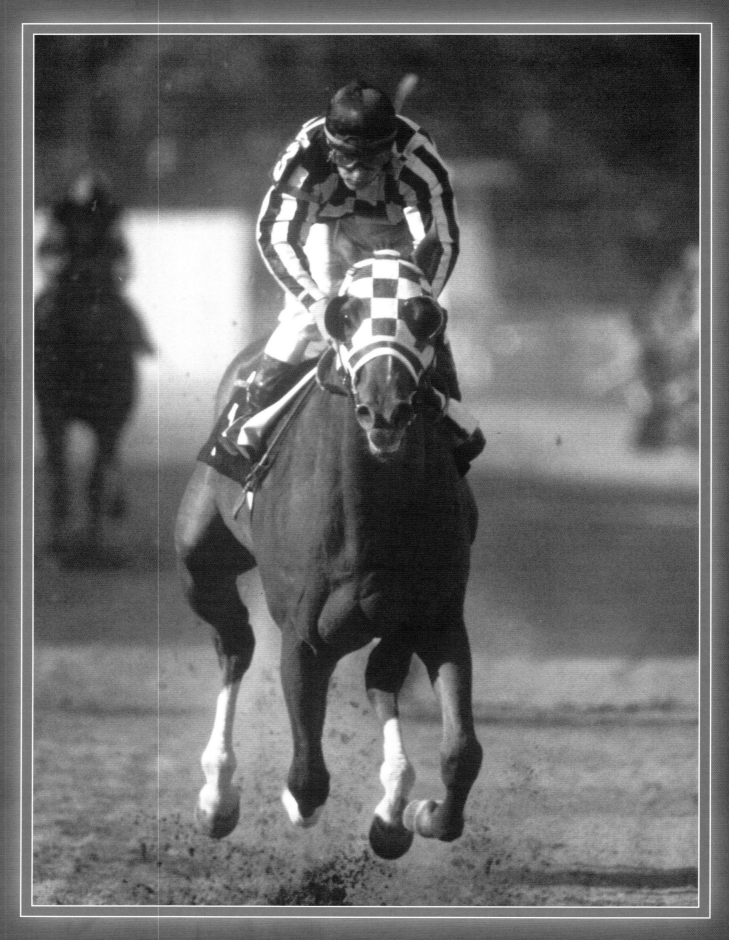

WHEN SECRETARIAT PASSED OTHER HORSES AT TOP SPEED, HE REMINDED
THE OTHER JOCKEYS OF THE RED BALL EXPRESS.

America's Super Horse

This chapter focuses on Secretariat from my family's point of view. For the definitive history of Secretariat's racing career, please read William Nack's wonderful book, Secretariat: The Making of a Champion. *Based on a tip from exercise rider Jimmy Gaffney, Nack was among the first sportswriters to pick up on Secretariat's genius. He followed the Thoroughbred closely from his earliest days at the track. Subsequent editions of the book add moving essays on Secretariat's retirement, his death, and his legacy. The 2010 Disney movie,* Secretariat, *is based on Nack's book.*

In the summer of 1972, while the nation anguished through the end of the war in Vietnam, anti-war protests at home, and the politics of the Nixon presidency, life was good for Mom and Meadow Stable.

Riva Ridge's wins in the Kentucky Derby and the Belmont Stakes had legitimized Mom's job in the eyes of her siblings and earned respect from the male-dominated racing industry. She had charmed the media with her classy good looks, enthusiasm and lively quips. Most of all, Mom had accomplished what Granddaddy had always wanted. A Meadow Stable horse had finally won the Derby after three near-misses in thirty-two years.

For my siblings and me, that summer proved to be more ambiguous. While we thrilled at Riva's wins and Mom's success, we didn't like the fallout. To end the four-year pattern of family separations, Dad took a job with a longtime client in New York. That meant leaving our beloved home in Littleton, Colorado, and relocating to Long Island. The move gave us more time together, but fostered a sense of dislocation as well.

I had just returned from a year of learning Spanish and teaching English in Ecuador, and my reaction to the change was to depart for college as soon as possible. But on the rainy drive home with friends from the summer term at Antioch College in Ohio, we ran into the back of a slow-moving truck on the Pennsylvania Turnpike. I broke my back. After three weeks in the hospital, I went home, confined to bed for several more weeks. Mom, who had hoped to make daily visits to the track unencumbered by other duties, suddenly found herself tending to a bedridden daughter. To relieve my boredom, I pasted news articles about our horses into scrapbooks. To our surprise, during that fall our two-year-old, Secretariat, began to produce more clippings than did our Derby champion Riva.

Despite the amazing good luck that he would ultimately bring to Mom, it was bad luck that gave us Secretariat in the first place. In 1968, when Mom was only a year into running the stable, she faced a dilemma. Mrs. Henry Carnegie Phipps, owner of Bold Ruler, the top sire in the nation, wanted bloodlines from Meadow Stud's excellent mares. Her son Ogden, who managed her horses, had established a foal-

The original foaling shed at The Meadow circa 1950. It was modified later and Secretariat was born there on March 30, 1970.

sharing arrangement with Granddad in which two Meadow mares would go to Bold Ruler each year and a coin toss would determine who got first pick of the resulting foals. Mom didn't like leaving such important matters to chance, but she went along with the deal in 1968. However, in 1969, she suggested that whoever lost the first year would automatically get first choice the next year.

When they tossed the coin in 1969, Mom lost. Ogden chose The Bride, a full sister to Secretariat, who didn't race but produced several stakes winners.

We got Rising River, who raced poorly and ended up as a sire in Europe. Mom's consolation was that in 1970, the last year of the deal, we automatically got first choice of the Bold Ruler foals. That fateful year Cicada turned up barren, but Somethingroyal took. Her 1970 foal would, in essence, be the last horse Granddaddy bred. Howard Gentry, a man known for coaxing mares through difficult births, gave the eighteen-year-old mare more attention than usual.

The foal arrived just past midnight on a cold, rainy March 30, 1970, in the small wood-frame foaling shed near the broodmare barn at The Meadow. Somethingroyal often foaled easily, but this time Howard Gentry had to ease a folded foreleg out of the birth canal. He and as-sistant Raymond Wood tugged

Somethingroyal, the dam of Secretariat.

and waited, following the mare's contractions. When the foal's broad hips finally popped out, Howard commented, "There's a whopper." Our veterinarian, Dr. Olive Britt, arrived shortly after and was amazed at how quickly the foal got to his feet and nursed.

"He was beautiful," Dr. Britt remembered, "well put together, correct; his legs were perfect. He had a beautiful head and was as red as fire." Mom's first thought when she saw the handsome colt was, "Wow!" Her second thought was, "He's too pretty to be good."

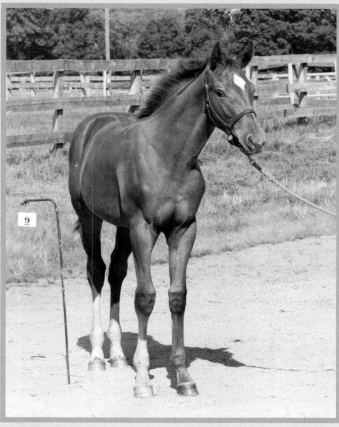

Secretariat at six months old, standing for his Jockey Club identification photo, 1970.

But the grooms who cared for the big chestnut foal felt that this might be the horse they had been waiting for. Howard Gregory, the head stud groom at The Meadow, worked closely with Lewis Tillman, Jr., the groom who shepherded Secretariat through his first twelve months. Gregory remembered that "Secretariat stood out; he was different. We knew he was something."

Secretariat showed his dominant personality early. By the time Mom first saw him he was "frisky, the boss of the herd. He didn't hang around his mother, who was an old lady by then. He was very much in command."

To his handlers he was mischievous but not mean. Dr. Britt noted that "Secretariat was sharp to be around. No one but the best groom could take care of him."

The first three names we submitted to the Jockey Club for the striking colt were all based on his lineage and his dominant personality: Scepter, Royal Line, and Something Special. They were all rejected. The next set included Games of Chance, Deo Volente (Latin for 'God Willing'), and Secretariat. The last was a name Elizabeth Ham liked because she had once worked for the League of Nations, which like its successor, the United Nations, was a secretariat, an organization run by a Secretary General. The word suggested leadership and power without referring to royalty. It was a name that fit its bearer well.

I first met Secretariat in the spring of 1971 on one of Mom's visits to The Meadow. He was the most striking yearling of his crop, outstanding in color and size, with something in his attitude that made you look twice, maybe three times. Mom had long since taught us that looks and speed do not necessarily correlate, and many a big handsome colt has turned into a big handsome nothing at the track. Mom certainly wasn't convinced yet of his promise, although she noted "Lovely!" next to his name in her stud book. She had her hopes for that fall pinned on a pair of two-year-olds—Riva Ridge and Upper Case— and like Granddaddy, she was too practical to be fooled by a youngster's good looks. Secretariat, who would leave The Meadow for further training with Lucien Laurin on January 20, 1972, would have to show her something more.

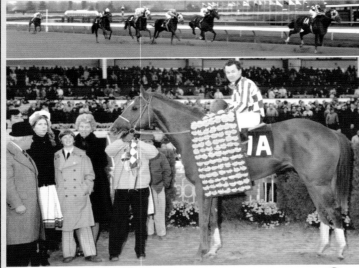

THE GARDEN STATE OF 1972
$298,665 Gross Value
"SECRETARIAT"
Garden State Park

Meadow Stable
Angle Light 2nd
Step Nicely 3rd 1 1/16 Mile

Ron Turcotte up
L. Laurin Trainer
November 18, 1972

1:44 2/5

116

And show her he did. Although he lost his first outing on July 4, 1972 at Aqueduct Racetrack in Queens, New York, after being bumped badly at the start, the colt then won race after race at the top northeastern tracks—Belmont, Saratoga, Laurel, Garden State and back at Aqueduct. Ridden by jockey Ron Turcotte, he set a pattern of breaking from the gate roughly, gearing up slowly, and closing like a freewheeling semi.

I was lucky enough to attend his last race as a two-year-old, the mile-and-sixteenth Garden State Stakes in New Jersey. Wearing an oversized skirt and a poncho over my back brace, I forgot any back pain as I watched Secretariat make his classic move, from last and slowest to first and fastest, proving he could run more than a mile with something to spare. That victory capped a year in which our beautiful red colt thrilled audiences, won nearly a half-million dollars and out-polled his stablemate Riva for Horse of the Year honors.

Under Mom's leadership, Meadow Stable concluded 1972 as its most successful year to date. Riva's

and Secretariat's winnings of over a million dollars put the stable solidly in the black and in the racing headlines. In December, we returned to Vail, the home of our hearts, for the holidays. I turned twenty as we celebrated what turned out to be our last Christmas together as an intact family.

What happened next changed everything.

On January 3, 1973, Granddaddy died in his sleep. Though he'd been mentally absent for five years, his actual death brought equal parts sorrow, relief and panic. Sorrow, that the man who had dominated and supported so many lives—and whose determination had fulfilled the dreams of

Lucien Laurin methodically conditioned Secretariat for his 1973 campaign. Pictured here on Billy Silver, Lucien leads Secretariat, ridden by exercise rider Charlie Davis, to the track as groom Eddie Sweat walks alongside.

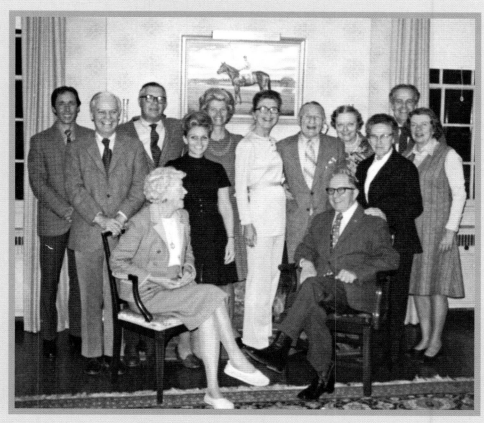

A rare gathering at The Meadow. Seated: Blanche Perrin and Howard Gentry. From left in back: Mert Bailes, John Fager (Meadow lawyer), Jack Tweedy, Shirley Bailes, Penny Tweedy, Miggie Carmichael, Al Homewood, Elizabeth Ham, Alice Gentry, Peter Chenery and Faeth Chenery.

so many others along with his own—was no longer among us. Relief, that our once-vigorous grandfather's long incapacitation was over. Panic, that nothing would ever be the same again.

For his burial we gathered at The Meadow during a bitter storm that brought a foot of snow to central Virginia. As a measure of respect, county snowplows waited by The Meadow's gate to escort mourners to the cemetery in Ashland. We laid Granddaddy to rest in the family plot beside his parents, his brothers, and his wife at Woodland Cemetery in a graveside service that included as many racing friends as could brave the storm. Lucien Laurin and Ron Turcotte, up from Florida, stood bareheaded in the blowing snow.

Mom, Hollis, Miggie and Elizabeth now had a tough call to make. Estate taxes then hovered at seventy percent. Granddaddy's worth, as valued at date of death, was inflated by the prices that Secretariat and Riva could command—a sum far higher than anyone had planned for. Even worse, the taxes would come due in just nine months. John Fager, Granddaddy's lawyer, advised that they either sell the farm and all of his assets, except Riva and Secretariat, or that they sell the two champions and keep all the rest. It was a brutal choice.

Since Riva's career had nose-dived following the Derby, they chose to keep him for a few months, thinking he might bounce back as a four-year-old, which he did. But there was no such hope for Secretariat. If he won the Triple Crown, his value would increase some, but if he didn't, it would plunge far more. The time to sell was now, in the spring, before he began to train for the Derby. It was heartbreaking for Mom.

If they sold Secretariat outright, the new owners might retire him right then, but if they syndicated him to investors as a sire, Mom could insist on racing him until the end of the year. Racing fans wanted to see him run in the Triple Crown classics, and Meadow Stable deserved to compete in them.

Mom turned to Seth Hancock for advice, just as Granddaddy had gone to Seth's grandfather thirty-seven years before. Consulting with bloodstock experts, they settled on $190,000 per share, which entitled each investor to one Secretariat stud service each year, to use or to sell. At that time, it was an outrageous price for a colt who might not even win as a three-year-old. Moreover, Bold Ruler's colts were known for early brilliance, not stamina or distance. Syndicating Secretariat was a huge risk for a woman who hated to gamble, and Mom knew her head would be on the chopping block if he failed to deliver.

It took a great deal of courage on Mom's part to entrust such an important matter to the young Hancock, who was only in his twenties and just taking the reins of Claiborne Farm after his father Bull's recent death. But both Mom and Seth demonstrated their ability to carry on their respective family traditions as the most expensive race horse syndication of its time came together.

By March, 1973, thirty-two investors had bet on Big Red's career, and the estate had raised $6.08 million of the $11 million we owed the IRS. Now the Meadow Stable team had to wait and see.

Mom watched carefully as Lucien and Ron methodically conditioned Secretariat at Belmont that spring. He had grown in size, ability and attitude. Ronnie felt he showed greater confidence and a stronger desire to win. The horse liked and needed hard workouts, and Lucien made sure he got them. Guarded optimism reigned in Lucien's barn. Mom shared their hopes but, ever the realist, she steeled herself for whatever might come.

Secretariat won his first outing in 1973 by four lengths on a sloppy track at Aqueduct, capturing the Bay Shore Stakes on St. Patrick's Day, which relieved everyone. One race at a time, Mom thought. Next he equaled the track record in the mile-long Gotham Stakes at Aqueduct on April 7, winning by three lengths. Each racing success upped the pressure on Mom.

Charlie Davis walked Secretariat back to his stall after a workout, 1973.

For Secretariat's final Derby prep, Lucien chose the mile-and-one-sixteenth Wood Memorial at Aqueduct, a race Granddaddy had won twice. Not this time, however. Eddie Sweat, Secretariat's groom, would later say that a mouth abscess bothered the colt. Ronnie noted that he tossed his head before the race as if in pain. Whatever the reason, Big Red finished a dull third.

You would have thought the sky had fallen. Some in the press dropped the six million dollar horse like a plummeting stock, while others acknowledged that even champions have bad days. The syndicate politely asked Seth Hancock if Mom planned on losing many more races. The Meadow team

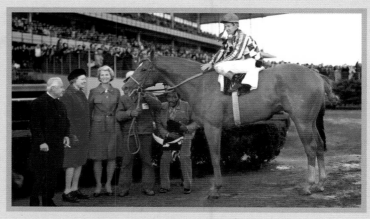

Secretariat won his first outing in 1973, capturing the Bayshore Stakes on March 17 at Aqueduct. Left to right: Lucien Laurin, Elizabeth Ham, Mom, Eddie Sweat, Charlie Davis and Ron Turcotte up.

SEVENTH RACE

Aqueduct

APRIL 21, 1973

1 1/8 MILES. (1.47 1/5) 49th Running **THE WOOD MEMORIAL** Purse $100,000 Added. 3-year-olds. By subscription of $200 each, which shall accompany the nomination; $500 to pass the entry box; $500 to start, with $100,000 added. The added money and all fees to be divided 60% to the winner, 22% to second, 12% to third and 6% to fourth. Weight 126 lbs. Starters to be named at the closing time of entries. Trophies will be presented to the winning owner, trainer and jockey. Closed with 27 nominations.

Value of race $144,900, value to winner $68,940, second $25,278, third $13,788, fourth $6,894. Mutual pool $448,023, OTB pool $126,822.

Last Raced		Horse	Eqt.	A.	Wt	PP	St	1/4	1/2	3/4	Str	Fin	Jockey	Odds $1
31Mar73	$9FG^3$	Angle Light		3	126	8	1	1^1	$1^{1\frac12}$	$1^{1\frac12}$	$1^{1\frac12}$	1^{hd}	Vasquez J	c-.30
31Mar73	$8SA^1$	Sham	b	3	126	2	2	$2^{1\frac12}$	2^2	2^2	2^2	2^4	Velasquez J	2.60
7Apr73	$7Aqu^1$	Secretariat	b	3	126	6	7	7^2	$6^{1\frac12}$	5^3	4^{hd}	$3\frac12$	Turcotte R	c-.30
29Mar73	$7Aqu^1$	Step Nicely	b	3	126	7	4	5^{hd}	$4\frac12$	$4^{1\frac12}$	5^6	$4\frac14$	Cordero A Jr	15.80
14Apr73	$6Aqu^1$	Champagne Charlie		3	126	3	5	$3^{1\frac12}$	$3^{1\frac12}$	$3\frac12$	3^2	5^6	Venezia M	13.00
7Apr73	$7Aqu^3$	Flush		3	126	1	6	8	8	8	6^4	6^7	Ussery R	b-38.20
31Mar73	$9FG^1$	Leo's Pisces		3	126	5	3	$4\frac12$	7^6	6^{hd}	7^1	7^3	Baltazar C	37.90
31Mar73	$8Aqu^5$	Expropriate	b	3	126	4	8	6^1	$5\frac12$	7^5	8	8	Adams L	b-38.20

b-Coupled: Flush and Expropriate; c-Angle Light and Secretariat.

Time, :24⅗, :48⅕, 1:12⅕, 1:36⅗, 1:49⅘ (Wind in backstretch). Track fast.

$2 Mutuel Prices:

3-(K)-ANGLE LIGHT (c-entry)	2.60	2.10	—
1-(C)-SHAM		2.10	—
3-(H)-SECRETARIAT	2.60	2.10	—

B. c, by Quadrangle—Pilot Light by Jet Action. Trainer Laurin L. Bred by Noonan & Runnymede Farm (Ky).

IN GATE AT 4:54 OFF AT 4:54 EST Start Good Won Driving

ANGLE LIGHT saved ground after quickly sprinting clear made the pace under good handling, settled into the stretch with a clear lead and responded gamely to last over SHAM. the latter prompted the pace throughout and finished strongly, narrowly missing. SECRETARIAT, unhurried early, commenced to rally while racing outside horses on the backstretch, continued wide into the stretch, lugged in slightly nearing the final furlong and failed to seriously menace the top pair. STEP NICELY, in close quarters between horses on the first turn, raced within easy striking to the upper stretch but lacked the needed late response. CHAMPAGNE CHARLIE, well placed early, made a run along the rail at the far turn, eased to the outside nearing the stretch but weakened during the drive. FLUSH was without speed. LEO'S PISCES was through early. EXPROPRIATE, hustled along after breaking slowly, lacked room along the rail midway of the first turn and was finished after going a half.

Owners— 1, Whittaker E; 2, Sommer S; 3, Meadow Stable; 4, Hobeau Farm; 5, Wimpfheimer J D; 6, Buckland Farm; 7, Taub J; 8, Buckland Farm.

Trainers— 1, Laurin L; 2, Martin F; 3, Laurin L; 4, Jerkens H A; 5, Sedlacek W; 6, Campo J P; 7, Paley H; 8, Campo J P.

Scratched—Knightly Dawn (14Apr73^6Aqu4); Beautiful Music (21Mar73^6SA1); Settecento (14Apr73^6Aqu2).

A copy of the Wood Memorial chart documenting Secretariat's surprising loss.

scratched their heads and worried—until the abscess broke a few days later. When Big Red recovered his frisky spirits, confidence revived among the Meadow team. For Mom, the silver lining in her colt's defeat was to lower her expectations from the impossible height they had hit.

Derby week, normally hectic and stressful for owners, might have gone easier for Mom because she'd done it with Riva the year before. But this time, she carried the burden of the syndicate owners' expectations as well as those of her family. Deep inside, she believed that if Secretariat felt good on Derby day, he could win.

May 5, 1973, dawned sunny and warm at Churchill Downs, where 134,476 spectators had gathered. The infield resembled a rock festival with boisterous fans in long hair and tie-dyes, while in the box seats the big-hats-and-blazers crowd dominated. Because The Meadow entourage included so many relatives and friends, Mom only took my brother John to the Derby. My sister Sarah and I would watch it on TV, like millions of others.

We heard, "Secretariat is last" shortly after the starting gate clanged open, but then the camera tracked only the leaders. The seconds ticked by. I shouted at the TV in frustration, "Where is Secretariat?" Suddenly, along the backstretch, we caught a glimpse of a nose with blue-and-white blinkers as he surged into fifth place. We lost him again when the announcer refocused on the soon-to-be-irrelevant leaders. Finally he spied

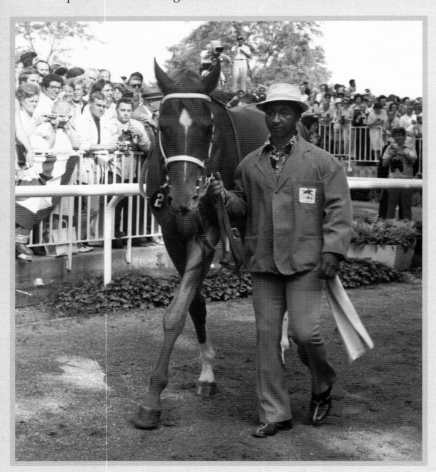

Big Red storming to the front. His voice rose in excitement as our boy snatched the lead on the turn and pulled ahead. Sham chased him valiantly, but couldn't match him. When the cheering and stomping ended, we learned that Secretariat had run the fastest Derby ever in 1:59 $^{2}/_{5}$, and remarkably, he ran each furlong faster than the last. Sham had clocked the second fastest time. Nearly forty years later, those records would still stand.

The Derby confirmed what many of us secretly believed: Secretariat was the fastest and most powerful horse in the last half-century.

Groom Eddie Sweat enjoyed an especially close bond with Secretariat. Here he walks him in the paddock at Belmont Park, 1973.

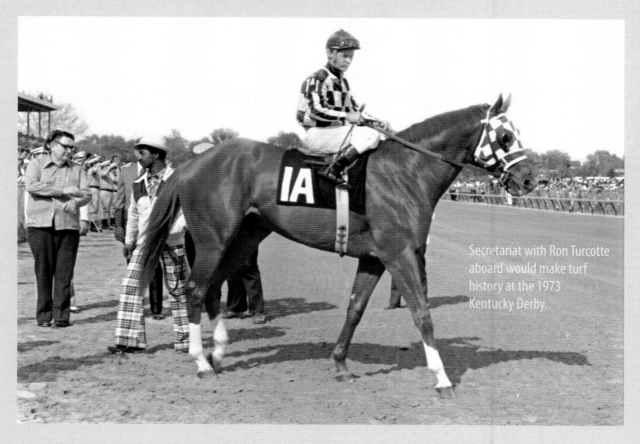

Secretariat with Ron Turcotte aboard would make turf history at the 1973 Kentucky Derby.

Yet it was his astonishing move in the Preakness that really converted non-believers. Once again Sarah and I had to watch it on TV. This time Secretariat surprised us. After a slow start, the field of six entered the first turn off the pace. Ronnie urged the big horse forward with a slight hand gesture. But Secretariat responded by accelerating dramatically, passing two horses in a few bounds. It was more than Ronnie expected, but the intuitive jockey let him set his own pace. The result was one of the most thrilling sights in all of racing.

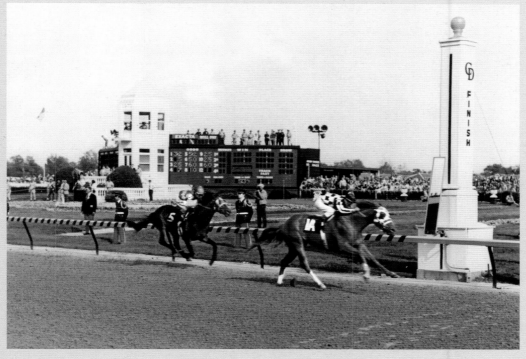

Secretariat became the first horse to win the Derby in under two minutes. His track record of 1:59 2/5 still stands.

Coming out of the first turn, in the space of less than a furlong (an eighth of a mile), Big Red sailed past the entire field as if they were pack horses ambling along on a trail. No one could believe the speed or the power of that move. It set the entire grandstand on its feet, screaming in delight. He carried that momentum right to the end, shooting across the finish line to score an unofficial track record. A few lengths behind came Sham, chasing desperately under a hard whipping by jockey Laffit Pincay. Ronnie later said, "I would have hated to be that horse."

Secretariat had pocketed two of the Triple Crown races. Next came the Belmont Stakes at Elmont, New York on June 9. For Mom, the expectations and the pressure were off the charts.

She called it "hell week," but actually there were almost three weeks during which she could barely leave the house without being photographed. When not consulting with Lucien, she was responding to endless media requests, generally with good humor. In those dark days of Vietnam and Watergate, every editor wanted to cover the feel-good story of the year. Writers new to racing repeated the same dumb questions, seriously trying Mom's patience. On top of that, Mom gave long interviews to *Newsweek, Time,* and *Sports Illustrated*, each of which ran a cover story on Big Red.

Wednesday, June 6, was typical. Mom made a pre-dawn dash in her red Mercedes convertible from our home in Syosset to catch Secretariat's final official work at Belmont. Then she snaked through rush-hour traffic on the Long Island Expressway into Manhattan to arrive at the Today Show by 7:00 a.m. Back home, she returned media calls. The rest of the day she organized transportation and meals for the influx of family and friends joining us for the race. Even some of the grooms who had raised Secretariat were driving up from Virginia. Only Howard Gentry would stay to keep an eye on The Meadow.

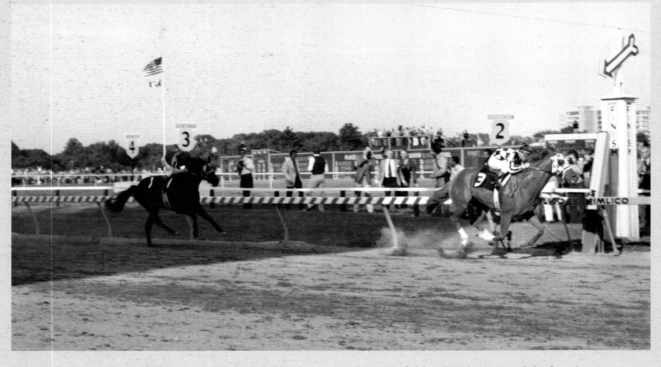

Secretariat won the 1973 Preakness at Pimlico by passing the entire field within about an eighth of a mile.

PEB (Pierre E. Bellocq) caricatured the Meadow team for *The Daily Racing Form*. From left: Howard Gentry, jockey Ron Turcotte, Elizabeth Ham, Lucien Laurin, Miggie Carmichael, Penny Tweedy, Hollis Chenery, Jack Tweedy and Eddie Sweat.

Adding to the hubbub was the Belmont Ball on Thursday night, honoring last year's winning owner— Mom. In a high-necked floral silk gown, she looked beautiful as always. But the gala seemed more like a working convention than a party. Meanwhile, the only event that mattered loomed on Saturday at 5:30 p.m.

Only eight horses had won the Triple Crown because it required both speed and stamina, a rare combination. Citation was the last winner in 1948. Critics expected the Belmont Stakes, the longest leg of the Triple Crown, to stymie Secretariat because they thought Bold Ruler's progeny couldn't last a mile-and-a-half. Certainly Big Red was fleet, but did he have the staying power for this contest? No one imagined how memorably he would answer that question.

At the 1973 Belmont Ball, Ron, Mom and Lucien received trophies for Riva's Belmont win the year before.

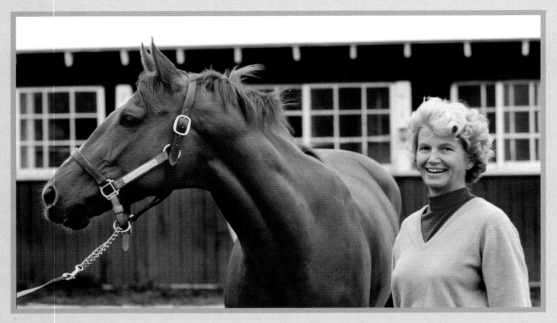

Mom with Secretariat as he was getting settled in at Belmont Park.

On Saturday, June 9, 1973, a near-record crowd of 69,000-plus fans crammed into Belmont Park on Long Island. The sense of anticipation couldn't have run higher for game seven of a Yankees-Mets Series.

That day, neither my sister Sarah nor I rode with the family to the track. Instead, we hopped the Bettor's Special train from my sister's semi-converted loft in Brooklyn. On that hot and humid morning, the train, crammed with track followers, was rank. Glimpses of Mother's media smile flashed from sports pages all around. Sarah and I traded self-conscious glances as her green linen skirt wilted with wrinkles and my paisley polyester dress clung to my pantyhose. Despite Mom's devotion to the "sport of kings," we children remained culturally closer to The Doors than the D.A.R., and our lady-like outfits felt like disguises. At home neither in the owner's box nor on the bettor's train, I felt like a tourist in a foreign country. While we fervently hoped that Secretariat would win, no one anticipated the historic performance that was about to occur, nor how that race would affect our family and everyone who saw it.

When the train reached Belmont, we took the elevator up to the open-air boxes above the stands. My grandfather had owned the same box just above the finish line since 1949, and as children, we had watched races from it before. Today, however, Mother had a large Chenery-Tweedy entourage to accommodate. So Sarah and I sat with our brothers John, age twelve, Chris, seventeen, and two cousins in a borrowed box down the row.

Just before the eighth race, Mom led us down to the saddling paddock for owners and trainers. The atmosphere looked festive but the air was thick with tension. The elbow-to-elbow crowd of well-wishers that lined the paddock regarded us curiously as we tried to look as if we belonged.

Cheers broke out as Secretariat sauntered into the paddock looking loose, alert and fit. His shiny red coat rippled over such taut musculature that he radiated power in each step. When the paddock judge called, "Riders Up!" Lucien tightened and rechecked the extra-large girth strap that ran under

Secretariat's massive torso. He gave Ronnie a quick boost up and adjusted the blue-and-white blinkers that helped keep Secretariat focused. Then he lay a reassuring pat on the powerful red rump and Ronnie wheeled his horse to join rider Charlie Davis on the lead pony. Together they slipped into the procession of Thoroughbreds in the walking circle. Only four other horses dared to challenge Secretariat that day.

We returned to our seats just as the crowd roared its approval at the sight of Secretariat strutting onto the track, neck arched and head held high, finely tuned for this very moment. Ronnie trotted him and then cantered easily up the far turn before returning to the starting gate in front of the stands.

The mile-and-a-half track at Belmont, one of the longest in the nation, covers the exact length of The Belmont Stakes. The race starts conveniently in front of the stands, circles left around the Big Sandy, as the dirt track is known, and finishes right where it began. From our seats above the starting gate, we could see Secretariat tossing his head, his tail sailing in the wind. Soon he loaded calmly into the number one slot and the other contenders took their positions. The moment we'd feared and longed for, ever since the Preakness three weeks earlier, had finally arrived. Silent prayers went up all around the stands. I remember rolling and re-rolling my race program repeatedly. The starter's bell rang. The gates clanged open. They were off!

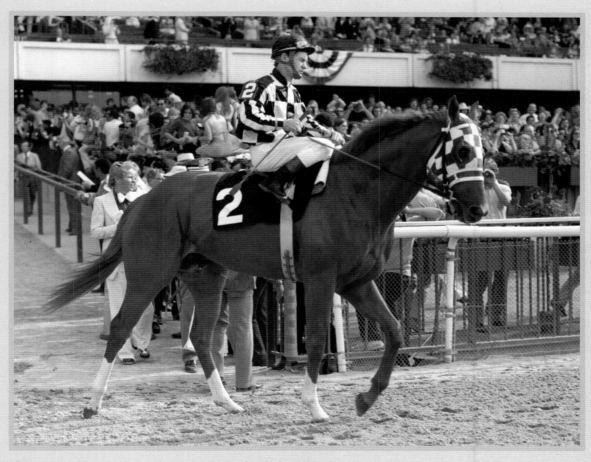

Secretariat radiated power as he stepped onto the track at the Belmont.

Mom and Lucien kept their binoculars trained on Secretariat as he distanced himself from the field.

Our big red horse broke unusually well from the number one post position. Within the first few leaps he had claimed the rail and settled in beside the leaders. We didn't expect Ronnie to take the lead so soon, especially not in such a long race. Had Secretariat picked this strategy himself? It was the first clue that we might witness something remarkable that day.

The phalanx of five horses accelerated toward the clubhouse turn. We expected Sham, the perennial challenger, to grab the lead early as in the Derby and the Preakness, and he did. Right in the middle of the big turn, the dark bay closed from the outside to settle in front. Without consulting a stopwatch, we could tell it was a sizzling pace. Such speed so early in such a long race might be suicidal. What were they thinking?

In response, Secretariat surged up beside Sham on the inside, half a length behind, contesting the lead far sooner than usual. Soon the two had outpaced the others by several lengths. The rivals rocketed out of the first turn with Sham a nose ahead. The Belmont was starting to look like a match race.

At this point I grabbed the binoculars from Chris. Far across the huge green infield, I could see only two horse heads, a chestnut and a bay, streaking down the long straightaway, bobbing nearly in unison, the bay a half-length ahead. Over and over, four pairs of fine-boned legs shot straight out in front and then sliced into the dirt, hooves rising and falling like the teeth of a threshing machine, inexorably devouring the track.

Sham held onto his half-length lead for only thirty seconds or so, but the short span crawled like hours and the furlongs stretched into miles. He fought so stubbornly to stay ahead of Secretariat that it occurred to me that the red juggernaut might fail this time. This might be when Sham, a champion in his own right, exacted revenge for losing the Derby and the Preakness. Winning everything was too much; life was never that perfect. But as soon as I conceded the possibility of losing, I realized how desperately I hoped Secretariat would win. As the dueling horses bore down the backstretch, it seemed as if the whole audience was holding its collective breath.

Suddenly the two horses no longer ran in sync. Secretariat, his stride lengthening, drew even with Sham, hung next to him for a second as if nodding hello, and then rolled past like a Jaguar engaging a secret sixth gear.

The crowd was instantly electrified. Everyone leaped to their feet yelling, "Go, Secretariat, GO!" The cheering and stomping became a deafening cacophony.

In the next seconds, Secretariat's performance ceased to be about beating Sham or any other horse. The race became his own expression of power, of pure athleticism. He stretched himself to his limits, running just because he could, for the sheer joy of speed. It was Secretariat's own personal contest, perhaps to see if he could take wing and fly. Every other person and horse became irrelevant, including Ronnie, who simply held on. He never touched his whip or tried to direct the big horse in any way—nor would it have mattered if he had.

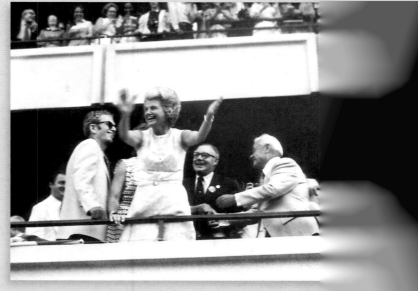

Mom's elation reflected the crowd's feelings as Secretariat swept across the finish line and into the record books.

"He's moving like a tremendous machine!" raved CBS announcer Chick Anderson as Secretariat rounded the final turn for home. Sheer momentum drew his lead over his lagging opponents from five to ten to an unimaginable thirty-one lengths. Still he pounded on, faster and faster, in even rhythmic strides, until suddenly he crossed the finish line. Pandemonium rocked the stands. Secretariat finished so far in front of the field that you had to crane your head to the left to glimpse the remaining horses. He continued plunging on to the far turn, still devouring ground, not slowing a whit. He looked like he could run forever.

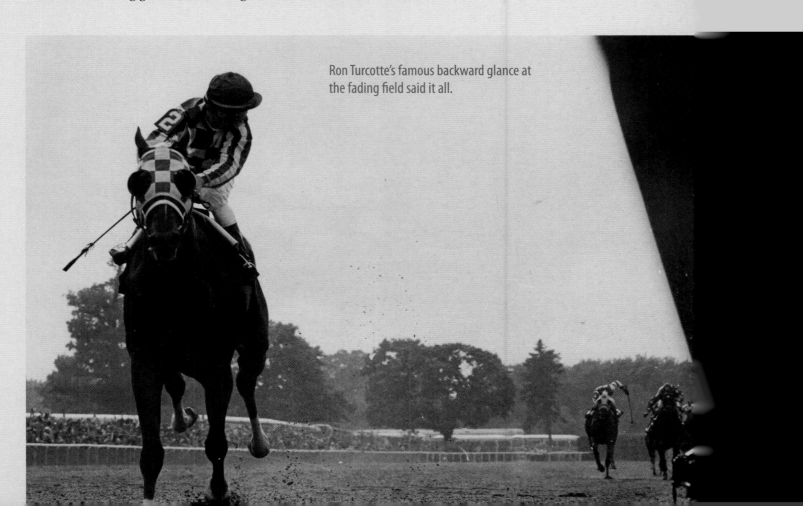

Ron Turcotte's famous backward glance at the fading field said it all.

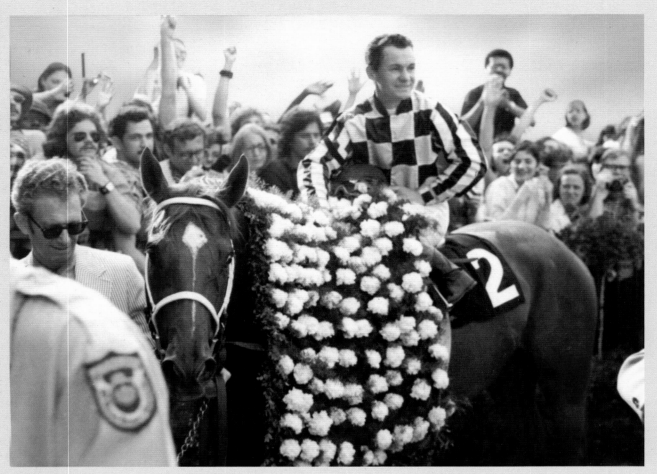

Secretariat electrified the fans by winning the one-and-a-half-mile Belmont by an unheard-of 31 lengths and in the stopwatch-shattering time of 2:24. His feat has never been duplicated.

Only then did the news sink in. The tote board revealed the astounding time of 2:24 flat, two and five-eighths seconds faster than the old record, setting a new world record for the mile-and-a-half. Later we learned that his sizzling pace had broken unofficial world records at nearly every pole, including the furlong after the finish line as he was supposedly pulling up.

My siblings and I stared at each other, jumped and hugged, yelling "He won!" and "I can't believe it." Even so, the realization dawned slowly that he had in fact won the Triple Crown, and in the most spectacular way possible. Ronnie had not fallen off, the horse had not stumbled, and the tote board was now declaring the results official. We could see our jubilant mother in her sleeveless white dress waving her arms in victory. Dad, Uncle Hollis and Aunt Miggy, Elizabeth Ham and Lucien all exchanged hugs and kisses of congratulations.

Mom and Uncle Hollis led the victor in his blanket of white carnations to the winner's circle. Governors Nelson Rockefeller of New York and Linwood Holton of Virginia gave Mother and her siblings an ornate silver Belmont platter engraved with the names of all the previous winners. Then the governors awarded the triangular silver Triple Crown trophy that had been created by Cartier just after Citation won the honor in 1948. The crush of reporters and cameras around them obscured the actual ceremony from

our view. But who cared? Secretariat had exceeded our most extravagant daydreams.

Those of us who were close to the horse felt as much awe and disbelief as anyone else. It seemed impossible that Secretariat had performed so spectacularly, that he had won the Triple Crown, and that this magnificent horse belonged to our family. All we could do was shake our heads, smile, and accept congratulations. We spent that night in happy confusion. In a photo, I am sitting on the arm of a sofa holding a glass of champagne and smiling dazedly. The media so besieged Mom that we didn't see her until hours later. That night we dined out with Dad, but I can't remember where.

In fact, few could fathom what they saw that day. The obvious joy and power with which he ran touched everyone who saw it. In an interview for *Sports Century*, an ESPN series that named Secretariat one of

Mom accepts the Triple Crown trophy from Nelson Rockefeller, Governor of New York (left) and Linwood Holton, Governor of Virginia (right) as Ron Turcotte beams.

the fifty top athletes of the twentieth century, Jack Whitaker, a longtime CBS sportscaster, recalled the moment. "Everybody was speechless, and then when it set in, people were crying. I actually saw people crying, it was such an overwhelming thing."

One reason Secretariat moved people was that he brought solace during a dark and shameful era, May and June of 1973. The bitterly resented Vietnam War was still a divisive factor in American life, and the Watergate scandal was slowly rippling into ever deeper political waters. Daily revelations of cover-ups and presidential lies threatened our national sense of integrity. So when this marvelous red animal in blue-and-white checks dashed across our TV screens, everyone cheered for him as a symbol of things that we feared we had lost: power, character and triumph. His victories became the nation's victories, his success, our successes.

The sports journalist George Plimpton captured our mood in his ESPN interview: "He was the only honest thing in the country at the time, this huge magnificent animal that wasn't tied up in scandal and money." Others put it this way: "Secretariat restored our faith in humanity."

Even seasoned sportswriters, usually at home with hyperbole, found it hard to express their feelings about the big Thoroughbred after the Belmont. "It was like a supernatural experience," recalled Pat Lynch, an NYRA official. Haywood Hale Broun mused that "it was as if he were touched by God."

That day, the big red horse ran so passionately that his performance transcended sport. Famed golfer Jack Nicklaus told Woody Broun years later that he had watched the race alone in his living room and seeing the absolute mastery of Secretariat's run left him in tears.

What has stayed with me over the years was the sense of joy Secretariat radiated that day. He ran because he could and because it felt good. He kept running even after the competition trailed far behind. Mom said, "Nobody knew [he would run like that], not the owner, not the trainer, not the jockey, perhaps not even the horse himself. He just felt great. That day he just felt like running."

The memory of that day still lights up people's eyes three decades later. They ask, "Where were you for the '73 Belmont?" Those who saw Big Red in person gush about the experience; those who didn't, describe their frantic efforts to see him on TV.

The trophies of the Triple Crown races: Left to right: The Kentucky Derby, the Preakness, the Belmont and the Triple Crown trophy in front.

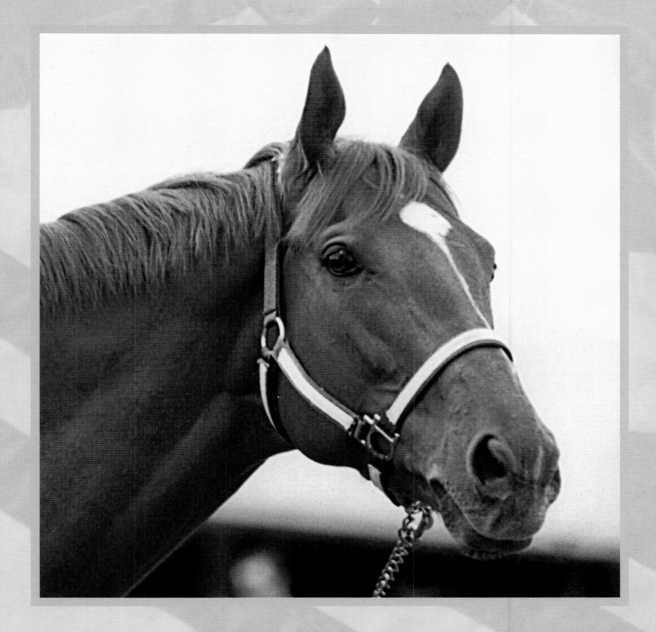

Decades later, fans remember Secretariat, I believe, because for the 2:24 minutes of the Belmont they experienced the pure joy of seeing a performance that so exceeds rational expectations that they know, deep down, they will never see anything like it again. What a rare gift it is to watch a master do the thing they love most—and even rarer to witness it done better than they, or anyone, has ever done it before. On that astonishing day, Secretariat entered not only the record books, but also the hearts of people everywhere.

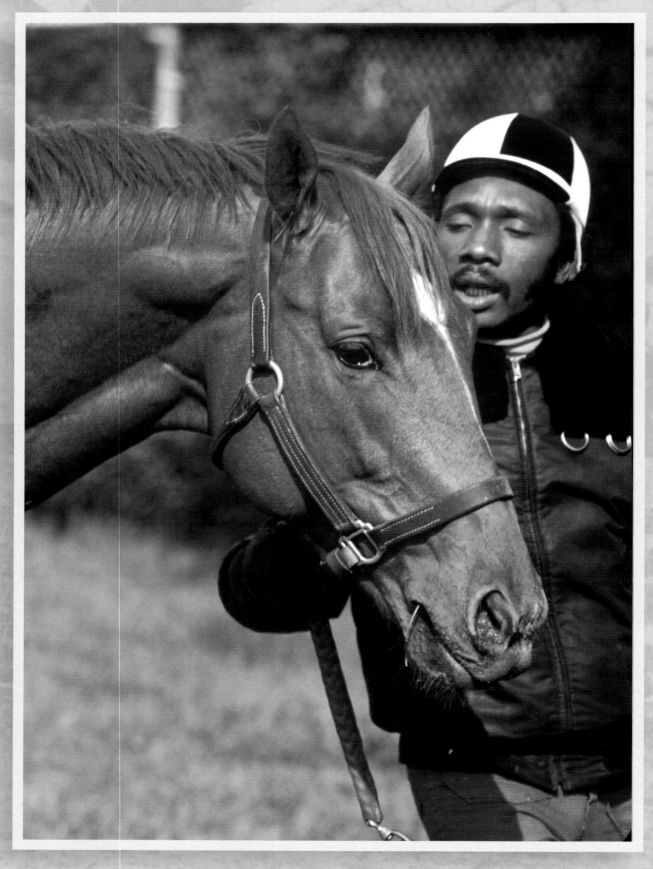

SECRETARIAT IN A QUIET MOMENT WITH HIS EXERCISE RIDER, CHARLIE DAVIS.

Epilogue: The Legend Lives On!

For the rest of 1973, Secretariat continued to win races, thrill fans, and set new records against older horses. Many people still speak reverently of his successful duel with Riva Ridge in the stretch of the inaugural Marlboro Cup; or the turf record he set in the mile-and-a-half Man o' War at Belmont; or the sight of him emerging from the mist in the Canadian International at Woodbine, blowing steam from his huge nostrils, looking like the fabled Bucephalus of Alexander the Great. When Secretariat returned to Aqueduct for a farewell ceremony in November of that year, over 33,000 die-hard fans braved a cold wind to cheer and cry as he danced along the track one last time.

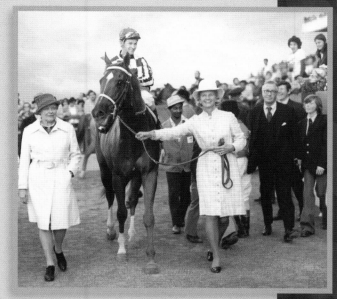

Secretariat set a turf record for the mile-and-a-half Man o' War at Belmont. Here Elizabeth, Mom, Dad, and John lead Secretariat to the winner's circle.

On November 11, 1973, Secretariat and Riva Ridge left Belmont for good and flew to Lexington, Kentucky, in a chartered plane along with Lucien Laurin, Eddie Sweat, Elizabeth Ham and Mom. The two men were ill, and everyone was grieving. No one was ready to get off the three-year roller coaster ride the two horses had provided. Ron Turcotte had said goodbye to his favorite mounts in New York. When the entourage arrived in Lexington, fans were holding signs that said "Welcome Home, Secretariat!" Mom remembered thinking, "He wasn't born in Kentucky. Virginia was his home!"

The Hancock team whisked the champions into their vans without delay. The Meadow team followed them to Claiborne. When the stallions had settled into their new stalls, Eddie sat alone on a wall facing away from the barns in a world of private grief. Mom, for once, had refused all interviews. Needing solitude, she took an hour's ramble in the lanes of Claiborne. Later, Mom said that giving up those two horses was one of the hardest things she ever did.

That wasn't the only difficult thing for her, or us, that fall. After twenty-four years of marriage, Mom and Dad finally called it quits. In the summer of 1973, Dad's new job as vice president of The Oil Shale

Secretariat in his paddock at Claiborne Farm in Kentucky.

Corporation (TOSCO) required him to relocate to Los Angeles. Having already suffered the stress of commuting cross-country for four years, Mom chose not to join him. They divorced in 1974.

In 1977, Mom married Lennart Ringquist, a New York television producer. Ironically, business also took him back to Los Angeles. But the locus of Mom's life remained with the horses in New York and Virginia. She and Len divorced in 1982. Mom lived on Long Island until friends in Lexington lured her to Kentucky in 1991. My father stayed in Los Angeles until he retired in 1980. Then he returned to Denver and married an old friend, Marjorie Sargent. He died in 1999.

Meanwhile, we kids had scattered. I moved to Austin, Texas, to attend university, and later to Berkeley, California, for law school. Chris studied in Burlington, Vermont, and later worked in Vail and Denver. Sarah lived and worked in New York City for twenty years. John attended St. Paul's School, the University of Colorado, Brown University and Stanford Law School. He then spent time in Buenos Aires and Saipan before returning to Boulder. By the 1990s, my sister Sarah and I had also moved our families back to our beloved Colorado.

In the years that followed, Secretariat drew tens of thousands of visitors to Claiborne. Although several star stallions stood at the venerable breeding farm, people always wanted to see Secretariat most. He remained as much a ham at the farm as he was at the racetrack, posing regally for his fans or running along the paddock fence to stop with a dramatic flourish. Mom visited him many times, but I never saw him again.

In late September, 1989, Seth Hancock called Mom out of the blue to say that Secretariat was suffering from laminitis, also known as field founder, an inflammation of the hoof. The news hit her hard, because Seth also told her the condition had become very painful and might be incurable. Just a few days later, on

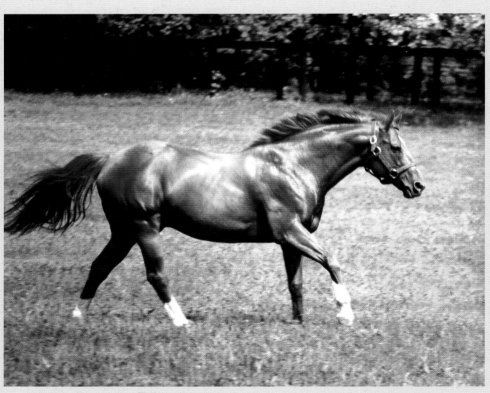

Secretariat was the star attraction for many years at Claiborne Farm.

Wednesday, October 4, 1989, a reporter called asking for her reaction to Secretariat's death—that's how she learned he had been euthanized at 11:45 a.m. He was only nineteen. She felt almost as if she had lost a child, and in some ways, she had. She and her Meadow staff had raised him, and in turn he had given them all a place in history.

I learned of Secretariat's death the next day at my office at the San Francisco Lawyer's Committee. I walked into the lunch room to find a grieving colleague reading about him in the *Chronicle*. I felt sucker-punched. Mom had been too grief-stricken to spread the news.

Dr. Tom Swerczek, veterinary professor at the University of Kentucky, performed Secretariat's autopsy. He discovered to his shock that the champion's heart, while completely healthy, was more than twice the size of a normal Thoroughbred's heart. It was not pathologically enlarged, just a "bigger power pack," as Mom likes to say, which probably contributed to his amazing acceleration and stamina. No one knows its exact weight, as they did not want to remove it, but they estimated it at twenty-two pounds.

135

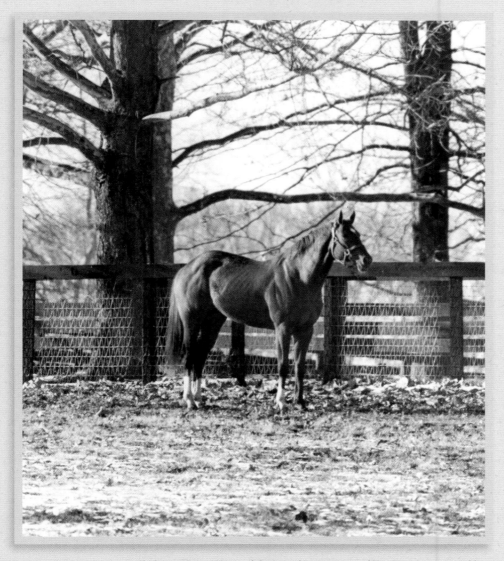

Secretariat in his later years at Claiborne Farm. Howard Gentry, the manager of The Meadow, visited him once and was overjoyed when he whistled for Secretariat and the great stallion galloped across his paddock to greet him.

Mom stands in front of the John Skeaping statue of Secretariat at Belmont commissioned by Paul Mellon. This is where people gathered after they learned of Secretariat's untimely death in October 1989.

Mom penned her own farewell note to Secretariat in the *New York Times* on Saturday, October 8, 1989, which we have excerpted here:

> *Secretariat's death on Wednesday marked the end of a wonderful dream I have been privileged to live. In my eyes, he was the finest Thoroughbred performer of the last 50 years and he certainly provided me with a unique experience.*
>
> *I used to think that we had created him but, having tried to duplicate him for 15 years, I now realize it was just the luck of the draw. A marvelous horse was born and he happened to be born to us. . . .*
>
> *Secretariat seemed to realize his role then was to be a folk hero. His demeanor was that of a champion in whatever he was asked to do. . . .*
>
> *I'm going to miss him terribly. My family and I join the many people who have been his loyal fans in great sadness at his loss. He was not only a champion race horse, but a cherished friend.*

In the decades since Secretariat's Triple Crown, Mom took on the role of racing's goodwill ambassador throughout the world. As the first female president of the Thoroughbred Owners and Breeders Association (TOBA), she traveled all over the U.S. lobbying on behalf of horse racing. She also served as president of the Grayson-Jockey Club Research Foundation for equine research. In 1983, the Jockey Club finally admit-

ted its first women: Mom, Martha Gerry and Allaire duPont. My mother helped to found the Thoroughbred Retirement Foundation (TRF) and also established the Secretariat Foundation to raise funds for laminitis research and Thoroughbred retirement programs. In 2006, she received the prestigious Eclipse Award of Merit for a lifetime of outstanding achievement in Thoroughbred racing. "Secretariat's Mom" had become, undeniably, "the first lady of racing."

During his sixteen years at Claiborne Farm, Secretariat sired 653 foals, of which 57 were stakes winners, nearly 9 percent. He proved to be a good, if not great sire, leading the list of sires of two-year-olds in 1978. Two of his best offspring were Risen Star, winner of the Preakness and Belmont Stakes in 1988, along with $2 million in purses; and Lady's Secret, a filly who won 19 stakes and over $3 million to become the 1986 Horse of the Year.

Secretariat's first foal for us, Hope for All, born in 1975.

137

Some critics faulted Secretariat for not duplicating himself at stud, an unrealistic expectation. But he became known as a very productive broodmare sire. In fact, by 1992, 135 daughters had produced winners of more purse money, nearly $6.7 million, than the daughters of any other stallion. Indeed, Secretariat topped the national broodmare sire list in 1992. That year, his grandson, A. P. Indy, a son out of Weekend Surprise, one of Secretariat's best daughters, and by Triple Crown champion Seattle Slew, won the Santa Anita Derby, the Belmont Stakes and the $3 million Breeders' Cup Classic. Another standout daughter was Terlingua, a speedster herself, who produced Storm Cat in 1983. He led the sire lists in 2000 and 2001; his stud fee rose to half a million dollars.

One of the most likely reasons for Secretariat's success as a racehorse and a broodmare sire was his large heart. Marianna Haun, pioneer of the "X-Factor" breeding theory, explained that great champions like Eclipse, Man o' War, and Secretariat each had this big heart which they inherited with their dam's X chromosome. That is why they became outstanding broodmare sires.

Howard Gentry with Riva's first foal for us, Straight Flush.

A broodmare sire passes his greatness through his daughters on the X chromosome.

Secretariat's influence is still felt in the twenty-first century.

▪ Smarty Jones, a grandson of Secretariat's daughter Secrettame, won the 2004 Kentucky Derby and Preakness Stakes.

▪ The remarkable Rags to Riches, granddaughter of Weekend Surprise, became the first filly in 100 years to win the grueling Belmont Stakes, beating Curlin, 2007 Horse of the Year. No wonder she delivered an unforgettable Belmont.

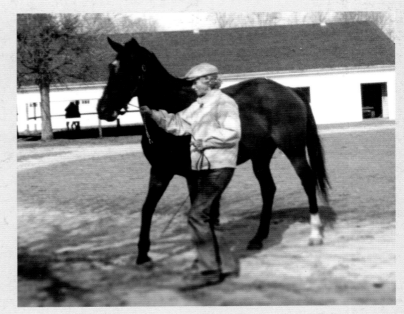

After The Meadow was sold in 1978, Mom leased part of the farm and continued breeding and racing there for awhile. Here she leads Saratoga Dew who became a champion stakes winner.

▪ Summer Bird, "the chestnut thunderbolt," won not only the 2009 Belmont, but also the Travers Stakes and the Jockey Club Gold Cup, earning $2 million and Best Three-Year-Old in the process. He, too, traces back to Weekend Surprise through his grandsire Summer Squall.

Granddaddy's "good eye for a mare" continues to fire the blood of other great racehorses today. There are Meadow genes in the mighty Curlin, who set a new North American earnings record by winning over $10.5 million in 2008. As Horse of the Year in both 2007 and 2008, Curlin claimed the 2007 Preakness Stakes, the 2007 Breeders' Cup Classic, and the 2008 Dubai World Cup. He traces back five generations to Sir Gaylord, son of Somethingroyal, who was the daughter of Imperatrice.

The record-smashing filly Rachel Alexandra has a double dose of Meadow DNA. In 2009, she became the first filly to win the Preakness in over eighty years. Then she stole Saratoga's Woodward Stakes with its

Rainaway, a descendant of Secretariat, held here by Curry Roberts, President of the State Fair of Vrginia, now lives at The Meadow.

138

$750,000 purse from a determined field of males, the first filly ever to do so. As a result, she took Horse of the Year honors for 2009, which no other filly has done in years. Her pedigree shows a link back to Imperatrice through Sir Gaylord as well as through Speedwell, a Meadow mare and stakes winner sired by Bold Ruler out of Imperatrice.

Not to be forgotten, Riva Ridge sired twenty-nine stakes winners. His daughter Alada was the second dam of champion Saratoga Dew. Riva passed away after suffering a heart attack on April 21, 1985. Riva Ridge was elected into the Hall of Fame in 1998, and finished fifty-seventh on a poll of the century's best published by *Blood-Horse*. Mom said Riva, her sentimental favorite, knew her voice until the end of his life.

Secretariat left the Meadow on January 20, 1972, never to return. He transcended being merely our horse and became, in a sense, the property of horse lovers worldwide. As for The Meadow, it too would prove elusive to hold.

In the five years that it took to settle Granddad's estate, the biggest question was what to do with the horses and the land of The Meadow. My grandfather had generously left bequests to many beneficiaries and heirs, among them churches, schools and minor children. That meant that the estate could not legally remain in the business of racing horses. We had to sell the horses, but what of the land? Reluctantly, Mom concluded that she could only afford to buy either some of the horses or the farm, but not both. She chose to take a few horses and lease back the training center from The Meadow's new owner for a few years. In 1978, nearly 175 years after the Morrises first bought The Meadow, it left the family again for the last time. Our stable's dispersal sale scattered some of the best bloodlines in the nation and closed a remarkable era of racing history. Yet that must have been how Granddad wanted it, for as careful a businessman as he was, he

139

Most of The Meadow's 2,652 acres that the estate sold in 1978 were sliced into parcels. The southernmost tract containing the ponds went to the Bear Island Paper Company. By 2003, only 360 acres remained, comprising the heart of the property—the track and training center, the broodmare, stallion and yearling barns, Secretariat's foaling shed and some of the Cove.

Kate Chenery Tweedy at the grave of Imperatrice at The Meadow, 2007.

made no provision to allow his family to carry on Meadow Stable after his death.

After the sale, Mom continued breeding the few horses she was able to buy from the estate, first at The Meadow and later in New York, and racing them with varying results. Her most notable breeding success may have been stakes winner Saratoga Dew, who went to stud in Japan after earning $541,580 on American tracks. As the grandson of Meadow stakes winner Alada, Saratoga Dew carried the genes of his great-grandparents, Riva Ridge and Syrian Sea, and through them First Landing, Iberia, Somethingroyal and Bold Ruler.

The Meadow endured a haphazard succession of owners after 1978. First, a Virginia partnership bought it as an investment. In 1981, they sold pieces to the Bear Island Paper Co., and to Oran Jarrell to raise cattle and corn. Sadly, the manor house remained empty and neglected. During a cold winter in the early 1980s, the pipes froze and burst. Icy water soaked the walls of the 175-year-old house. The wallpaper peeled, the plaster mildewed and flaked, and the wood floors warped.

The next owner, Eric Freedlander, a second-mortgage mogul, bought the house and 857 acres of the farm at foreclosure in 1984. The following year he demolished the house, claiming it was not worth saving. He was convicted of mortgage fraud in 1991 and sent to prison. Many folks in the community cheered, viewing his incarceration as just desserts for tearing down the lovely old manor, the Chenery ancestral homeplace that had stood there since 1808.

In 1992, Richmond businessman Ross Sternheimer fell under The Meadow's magic and bought its remaining 407 acres at yet another foreclosure sale. With dreams of reviving the farm to its former glory, he finished the new mansion,

This door was all that remained of the grand old manor after it was demolished around 1985 by a subsequent owner of The Meadow.

rebuilt miles of fences and shored up the sagging barns. The old farm flourished under his care, but by 2002 family obligations kept him increasingly in Richmond. Once again, The Meadow came up for sale.

Gary Wilson, director of the Caroline County Department of Economic Development, recruited the State Fair of Virginia (SFVA) which was looking to move from its Richmond site to a more agricultural site. The private non-profit SFVA purchased The Meadow in 2003, intending not only to relocate the fairgrounds, but also to preserve the farm's place in equine history.

Mom gave Mike Rich, scriptwriter for the Disney movie about Secretariat, a personal "walkabout" tour of The Meadow in October 2007. Here Mike looks at the yearling barn.

After careful preparations, construction began and The Meadow once again bustled with activity. New exposition halls designed to blend harmoniously with the rolling pastures and existing barns started to take shape. The foaling shed, stallion and yearling barns and the training center all were freshly painted, cobwebs were cleared from the old stalls and rotted wood replaced. The only structure too dilapidated to restore was the old broodmare barn, the former home of Somethingroyal, Hildene, Imperatrice and other matriarchs of The Meadow. Fittingly, the Fair staff saved pieces of wood from the barn and gave them as mementos at the dedication ceremony in 2009 for the newly renamed Meadow Event Park. Then, history truly came full circle when Rainaway, a great-grandson of Secretariat, came to live at The Meadow.

Elsewhere a chain of events paralleled The Meadow's reawakening. Mom sold the rights to her life story to the Walt Disney Company and by 2007 a script began to take shape. That spring, writer Leeanne Ladin and I decided to collaborate with publisher Wayne Dementi on a history of The Meadow as the birthplace of Secretariat. As unofficial family historian, I had long hoped to write the story of The Meadow and Granddaddy's stable. As we began to interview former employees of the farm and others who knew my mother and my grandfather, we realized that most of them had not set foot on The Meadow in thirty years. That's when we decided to organize a reunion.

Saturday, October 13, 2007 dawned sunny and clear. The air held the lingering warmth of an Indian summer not yet stung by the briskness of oncoming fall. A light breeze touched the leaves of the stately elms that stood like ancient sentinels on the lawn of The Meadow, the same elms that Cousin Deenie pointed out to Granddaddy in 1936. It was a good day for an old-fashioned Meadow barbecue.

Penny Chenery Tweedy, (center front), surrounded by many of the people who once worked at The Meadow.

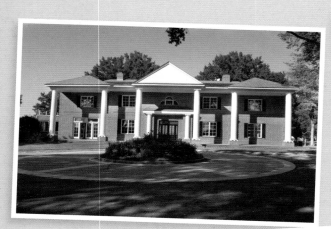

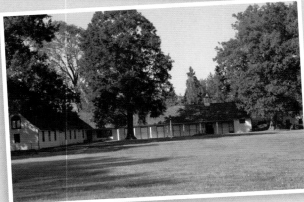

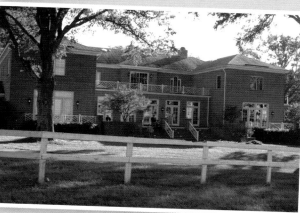

142

143

The Meadow Reunion in October 2007 was celebrated in the spirit of an old-fashioned Chenery barbecue. It brought together people who had not seen each other for over thirty years. Former grooms, field workers, carpenters, office staff, housekeepers, cooks, managers, relatives and friends all congregated at the brick mansion which was built on the site of the original homeplace. The gathering was hosted by the State Fair of Virginia, which bought The Meadow in 2003.

We invited Disney scriptwriter Mike Rich to join Mom, Leeanne and me on a tour of The Meadow. Mom drove us around the property, much as she had made the rounds of the farm with her dad.

At the yearling barn, Mom showed us the stall that Secretariat and Riva Ridge had occupied at the far end of the building. "We always gave stall number eleven, by the Coke machine and the feed storage room, to the most promising colt," she told us. The constant traffic of grooms past the stall helped accustom the youngster to noise and people, something he would need when he reached the racetrack. Then we explored the old broodmare barn and the small white foaling shed sitting nearby in the field. Mike was visibly moved at the sight of the humble structure where our Super Horse and all our other homebreds were born.

We eventually made our way to the dike at the North Anna River. Mom led us deep in the woods and nearly 190 years back in time to the levee that was built in 1821.

"The levee initially was twenty-seven feet high," Mom told Mike, "and it curved for three-quarters of a mile around the fields." In 1936, Granddaddy reinforced it as part of The Meadow's restoration, raising it by twenty feet.

"In 1969, after Hurricane Camille, the river split the levee open and flooded the Cove," Mom told Mike. "The water went all the way up to the broodmare barn." Twice during her tenure managing The Meadow, she had to repair the levee.

Our next stop, directly across Route 30, was the site of the old training center. The SFVA has made it an equestrian center where the future Museum of the Virginia Horse will be. Mom pointed out the former site of the three-eighths-mile covered track for training horses in poor weather, as well as the imprint of the mile-long outside track, which was still clearly visible in the dirt.

"Let's take a spin around the track!" Mom proposed suddenly, a mischievous twinkle in her blue eyes. She goosed the rented SUV, making it jump as if a starting gate had clanged open, and the first lady of racing took off around an oval which had been pounded by some of the fleetest hooves in turf history. With all of us laughing at her impulsive "breezing" around the track, my eighty-five-year-old Mother soon wrapped up the tour and drove us to Doswell for lunch.

Later that afternoon, dozens of former grooms, field workers, carpenters, office staff, housekeepers, cooks, managers, relatives and friends streamed to the new mansion. I'll never forget the look of nostalgia on the face of our former stud manager, Howard Gregory, as he walked through the former stallion barn repeating softly, "There sure is a lot of history here."

The spirit of my grandparents' famous barbecues filled the air as we sought to re-create their tradition of hospitality and community. We decked the house with the blue-and-white of Meadow silks. The centerpieces were vases filled with red roses, black-eyed susans and white carnations, all the flowers of the Triple Crown races. My cousin Bobby Lanier assembled a slide show of Meadow images that played in one room and we displayed a collage of farm and horse photos in another. Guests helped themselves to Secretariat T-shirts, caps, posters and other souvenirs.

After the buffet, we invoked the names of all the people no longer with us whose lives had been entwined with The Meadow. The roster began with my grandfather and grandmother and included Howard Gentry, Elizabeth Ham, Lewis Tillman, Bob and Mert Bailes, Harry Street, and on and on. That's when the stories began to flow. One by one, people stood up and spoke about what The Meadow had meant to them.

145

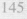

Since The Meadow left the family, Mom has visited it many times. Neither time nor distance have diminished its place in her heart.

Then came the highlight of the evening. Secretariat's former grooms began to relate some of the mischievous colt's capers, ones they had kept quiet at the time, for good reason. Larry Tillman remembered, "One time Somethingroyal came up from the pasture without Secretariat, who was then about six months old. We were alarmed and went to look for him. We found him swimming in the river, happy as could be. I always said there would have never been a Triple Crown winner if I hadn't jumped in the river to get that colt! "

Howard Gregory related a more serious escapade. "Secretariat and all the yearlings would crowd around the gate when it was time to be turned out in the pasture," he began. "He was big and strong and could push his way through the herd. One time, he got loose and ran out to Route 30 and up the hill. A truck driver coming from the sawmill down the road stopped and caught him." The crowd glanced nervously at Mom as these stories came out, wondering what she would say, but she only laughed, as amused and shocked as the rest of us.

That evening, I looked around the room, marveling at the assortment of people—young and old, black and white—who had come together after three decades to celebrate the land, the family and the equine legend that united us all. I thought about the love in people's voices as they talked about their Meadow days. Many called them the best days of their lives. I thought about Mom's comments during our tour of The Meadow's broad expanses. She took us not simply on a geographic tour of the farm, but on a life journey recalling the hopes, dreams and sorrows of many generations, all bound up in this beautiful land. That she wanted scriptwriter Mike Rich to experience the farm through her eyes displayed both pride and possessiveness about The Meadow that the years have not diminished.

Then I reflected on my own journey at The Meadow, beginning with the sense of its magic I felt as a child sitting under the weeping willow beside the old cemetery. Researching its history has not only helped me understand my grandfather, my mother, and their racing stable, but it has also highlighted the traditions of community obligation, of family pride, and of high standards of behavior and achievement that permeate the very soil of The Meadow. Perhaps that is what gave rise to Secretariat—the love and devotion of everyone who touched the farm—all their pride of work and family—the magic in the air—the ancient trees, the muddy river, the flood plain, the wide pastures, the old house—my grandfather's passion and my mother's determination—all these things somehow combined to foster a climate just right for raising a genetic marvel of equine perfection.

In his biography of Secretariat, Bill Nack said, "In the end, it was the land that made them all." This land, rooted deeply in our souls, a land that gave the world a peerless horse with an enormous heart, will always be "Secretariat's Meadow."

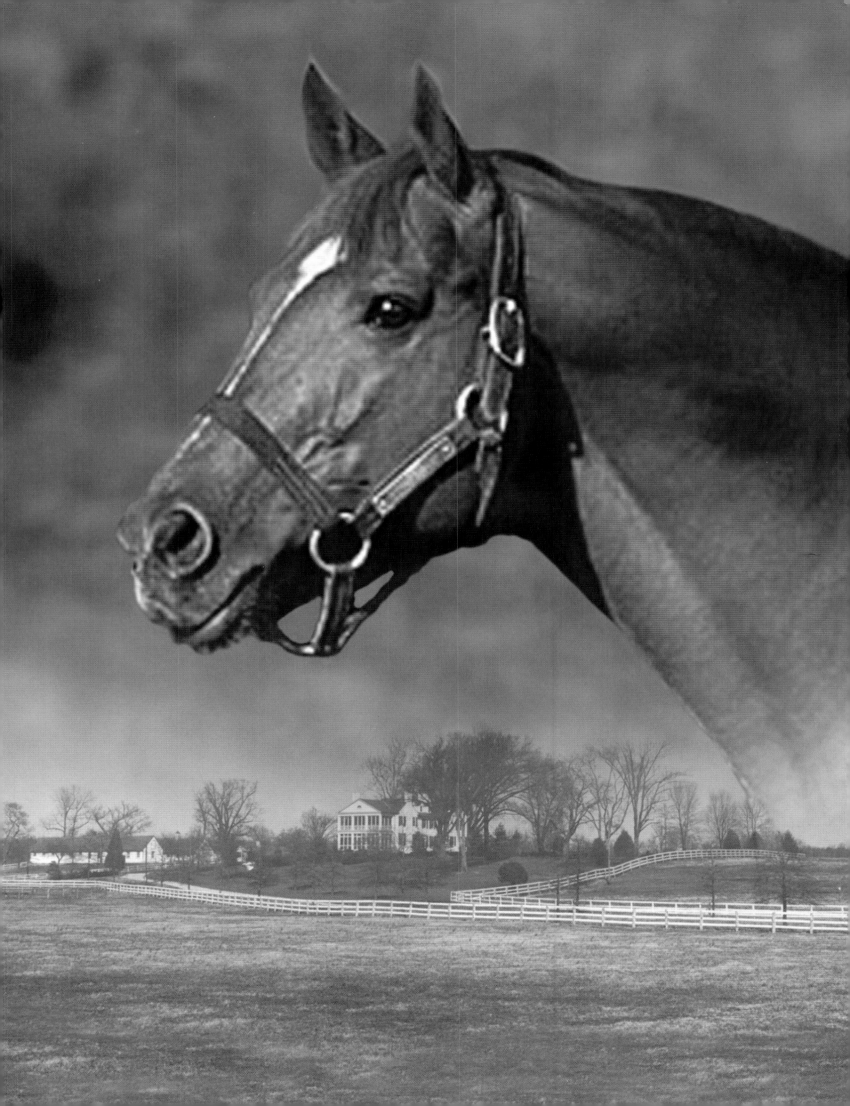

Edmund Taylor 1741 - 1822

Ann Day 1753 - 1835

William Day Taylor 1781 - 1858

Sallie Garland Swan Burnley 1783 - 1815

Mary Taylor 1778 - 1858

Christopher Tompkins 1776 - 1826

Sarah Taylor 1772 - 1850

William Winston

Edmund Lewis Taylor 1814 - after 1861

Sarah Anne Robertson 1805 - ?

Elizabeth Taylor Winston 1796 - 1876

Jourdan Woolfolk 1796 - 1868

Sarah Anne Tompkins* 1805 1882

Unk Pendleton

Emily Sophia Tompkins 1819 -1852

James Gunn Chenery 1809 - 1866

Edward Robertson Taylor 1839 - 1917

Martha Frances Jeffries 1841 - 1915

Anne Farrel Woolfolk*+ 1825 - 1897

Barton W. Morris*+ 1818 - 1862

Mary Anne Pendleton*+ 1829 - 1911

Edmund Taylor Morris*+ 1821 - 1865

James Hollis Chenery + 1850 - 1918

Ida Burnley Chenery + 1863 - 1925

Ida Burnley Chenery + 1863 - 1925

James Hollis "Jimmy" Chenery + 1850 - 1918

Ellen Broadmax Morris + 1852 - 1931

Bernard Doswell + 1860 - 1929

Emily T. Morris + 1853 - 1928

James Hollis Chenery, Jr.* 1883 - 1883

William Ludlow Chenery 1884 - 1972

Christopher T. Chenery 1886 - 1973

Helen Clementina Bates 1887 - 1967

Charles Morris Chenery 1888 - 1948

Alan Jeffries Chenery 1890 - 1983

Blanche Browning Chenery 1894 - 1973

Margaret Emily Chenery 1919-1993

Helen Bates "Penny" Chenery 1922 -

Hollis Burnley Chenery 1918-1994

Connected Meadow Families:

the descendants of Edmund and Ann

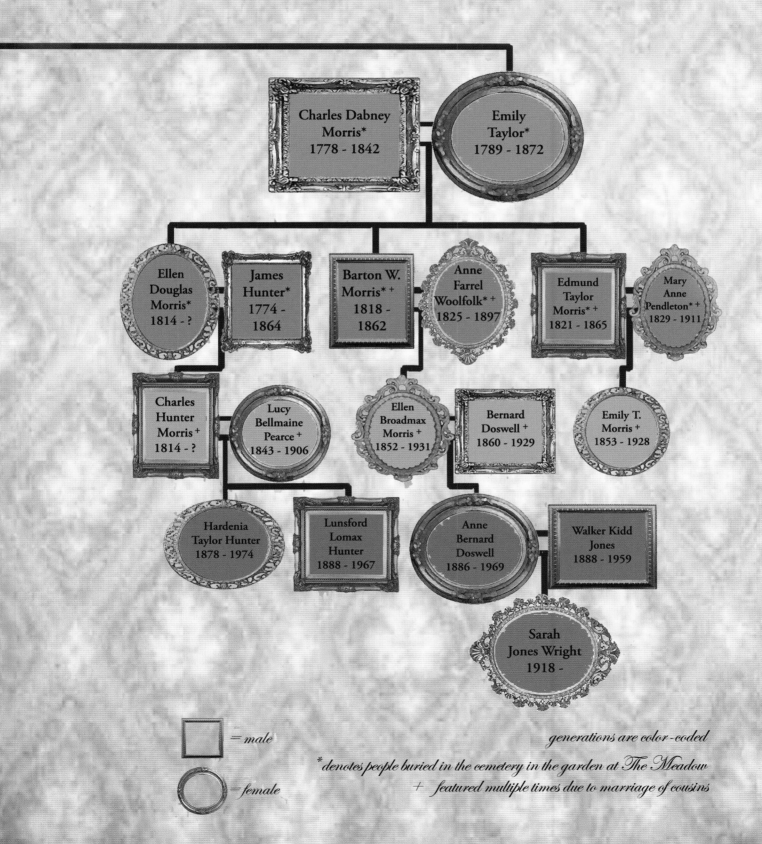

Charles Dabney Morris* 1778 - 1842

Emily Taylor* 1789 - 1872

Ellen Douglas Morris* 1814 - ?

James Hunter* 1774 - 1864

Barton W. Morris* + 1818 - 1862

Anne Farrel Woolfolk* + 1825 - 1897

Edmund Taylor Morris* + 1821 - 1865

Mary Anne Pendleton* + 1829 - 1911

Charles Hunter Morris + 1814 - ?

Lucy Bellmaine Pearce + 1843 - 1906

Ellen Broadmax Morris + 1852 - 1931

Bernard Doswell + 1860 - 1929

Emily T. Morris + 1853 - 1928

Hardenia Taylor Hunter 1878 - 1974

Lunsford Lomax Hunter 1888 - 1967

Anne Bernard Doswell 1886 - 1969

Walker Kidd Jones 1888 - 1959

Sarah Jones Wright 1918 -

= male

= female

generations are color-coded

* denotes people buried in the cemetery in the garden at The Meadow

+ featured multiple times due to marriage of cousins

ACKNOWLEDGMENTS

In 2007, we began this book with a sense of joyful destiny. That has remained our mantra over the past three years, even as this project began to wear on us like the last furlong of a race. But, like Secretariat, we were determined to go the distance and many people have helped us along the way.

First we thank our spouses for their forbearance and longstanding support: Jerry Nelson, Dianne Dementi and Gary Ladin. An extra large mint julep goes to Jayne Hushen, our book designer, whose abundant creativity was surpassed only by her limitless patience with the authors. To our eagle-eyed copy editor and proofreader, Monica Rumsey, we are extremely grateful for her thorough review of our manuscript. Next we thank Curry Roberts, president of the State Fair of Virginia, who connected us as a book team and graciously hosted The Meadow reunion. His staff, especially David King, Sue Mullins and Jay Lugar were also very helpful.

Many people shared with us their memories of The Meadow, its community and the horses. If we couldn't include all the stories, they all contributed to our understanding the workings and spirit of The Meadow. Some of the following people read drafts, provided leads, gave us interviews, fed us, comforted us, inspired us, transcribed for us, lent us photographs, and advised us. Many thanks and big hugs go to: Sarah Wright, Sumpter Priddy, Bobby and Joyce Gentry, Alan and Sarah Chenery, LuGay and Bobby Lanier, Cortne Lanier, Alvin Mines, Bannie Mines, Howard Gregory, Raymond Goodall, Larry Tillman, Wesley Tillman, Charlie Ross, Iola Fells, Eloise Morris Romaine, Maude Tillman, Christine Tillman, Dr. Clint Turner and Mitchell Patterson of Virginia State University, Catherine Hart Busbee, Robert Hart, Ross Sternheimer, Leonard Lusky, Julie Campbell, Elena McGrath, Alice McGrath, Susan Corbett, Susan and Chris Tweedy, John Tweedy, Sarah Manning, Beret Strong, Janet Chenery, Lee Carmichael, Etta Mason Ferguson, Janet Reuger, Sylvia Acors, Charlie Stone, Rik Sargent, Marianna Haun, Mike Rich, Diane Lane, Jon Ringquist, Farley Chase, Dell Hancock, Clay Hancock, and many others who know who they are. We are also grateful to Bill Nack, Ed Bowen and Ron Turcotte for commenting on the manuscript and to the late Jim Gaffney for his wonderful stories about Big Red and Riva Ridge.

We could not have created this pictorial history without the generosity of Penny Chenery in allowing us access to her tremendous array of photographs of family and horses. Many of those images came from the lens of William L. Chenery, some from Hollis Chenery and some from Jack Tweedy. Penny herself took two wonderful sets in 1937 and in 1947. Wayne Dementi took most of the modern images. Sarah Wright contributed all the images of Bullfield and the Doswells. In addition, we are indebted to the following artists and photographers (or their heirs) for their photos or art. They include: Pierre Bellocq (PEB), Dale Brittle, Michael Brohm, Susie Chatfield-Taylor, Bob Coglianese, Jamie Corum, Edgar L. Daub, Ken Egan, Kathryn Dudek, D. Farrell, Howard Gentry, Howard Gregory, Dell Hancock, Robert Hart, Cortne Lanier, Barbara Livingston, Leonard Lusky, Enzina Mastropolitano (PhotosbyZ), Bert Morgan, J. Noye, Thomas Allen Pauly, Jim Raftery, Ken Regan-Camera 5, Richard Stone Reeves. We also thank Jenny Liesfeld and Leo Caldas for creating our website, www.secretariatsmeadow.com, and we appreciate all the enthusiastic support of Patsy Arnett.

In addition, we thank the following organizations and institutions for their kind help, permissions, and/or use of their archives: Archives and Special Collections of Mt. Holyoke College, *The Blood-Horse*, Churchill Downs Inc., Bettmann/CORBIS, *Daily Racing Form*, Deitz Publishing, The Jockey Club, Keeneland Library, Library of Congress, Randolph-Macon College Library, Library of Virginia, Maryland Jockey Club, National Museum of Racing and Hall of Fame, New York Racing Association, *Richmond Times Dispatch*, Secretariat.com, Sotheby's Realty, State Fair of Virginia, *Thoroughbred Times*, *Time Magazine*, United Press International, United States Military Academy, University of Virginia Library, Virginia Historical Society, Washington and Lee University.

We also thank the scores of Secretariat fans who have signed up on our Facebook page, written Mom letters and visited us at www.secretariatsmeadow.com.

Of course, we owe the biggest thanks to Mom, Penny Chenery, for her encouragement, time, interviews, collection of photographs, feedback and support.

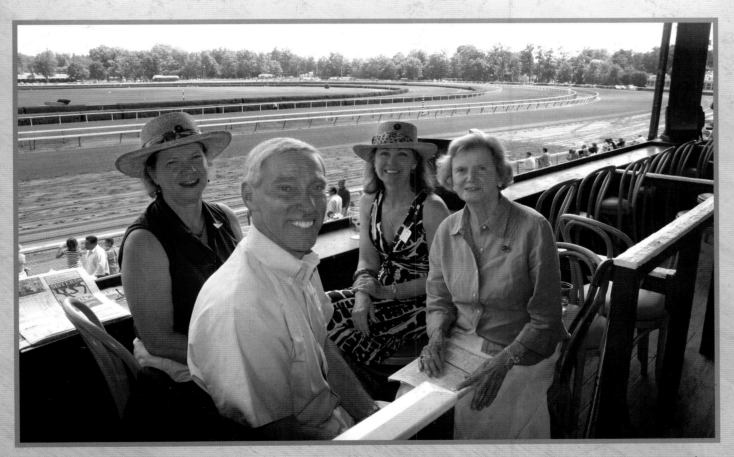

The book team enjoying the view of the track at Saratoga from the Chenery box, August 2007. Front- Wayne Dementi and Penny Chenery. Back- Kate Tweedy and Leeanne Ladin.

FORTY YEARS OF MEADOW STAKES WINNERS, 1939-1978

Name	Year	Sex	Color	Starts	Win	Place	Show	Earnings	Sire-Dam
Secretariat (1)	1970	H	ch	21	16	3	1	$1,316,808	Bold Ruler-Somethingroyal
Riva Ridge (2)	1969	H	b	30	17	3	1	$1,111,497	First Landing-Iberia
Cicada (3)	1959	M	b	42	23	8	6	$783,674	Bryan G-Satsuma
First Landing (4)	1956	H	b	36	19	9	2	$779,577	Turn To-Hildene
Hill Prince (5)	1947	H	b	30	17	5	4	$423,740	Princequillo-Hildene
Gay Matelda	1965	M	dk b/br	37	9	11	7	$409,945	Sir Gaylord-Hasty Matelda
Third Brother	1953	H	b	69	9	13	12	$310,878	Princequillo-Hildene
Hydrologist	1966	H	ch	50	10	12	6	$277,958	Tatan-Iberia
Alada	1976	M	b	26	10	5	1	$245,113	Riva Ridge-Syrian Sea
Upper Case	1969	H	b	24	6	4	1	$241,310	Round Table-Bold Experience
Sir Gaylord	1959	H	b	18	10	0	4	$237,404	Turn To-Somethingroyal
Manotick	1952	M	gr	65	8	8	17	$204,435	Double Jay-Scenery
Slip Screen	1972	M	b	33	10	9	4	$201,569	Silent Screen-Orissa
First Family	1962	H	ch	44	7	6	7	$188,040	First Landing-Somethingroyal
Syrian Sea	1965	M	b	26	6	3	8	$178,245	Bold Ruler-Somethingroyal
Pepperwood	1964	M	b	21	3	n/a	n/a	$168,174	Hill Prince-Tourmaline
Bryan G	1947	H	ch	62	14	18	4	$165,625	Blenheim II-Anthemion
Shelter Half	1975	H	br.	20	8	2	2	$136,337	Tentam-Gay Matelda
Second Coming	1971	M	b	25	6	4	3	$118,609	Sir Gaylord-Next Hill
Mangohick	1944	G	b.	97	23	17	8	$115,115	Sun Beau-Hildene
Queen's Double	1966	M	b	15	3	3	3	$105,981	Double Jay-Queen's Moon
Bemis Heights	1975	M	b	13	2	1	1	$101,175	Herbager-Orissa
Prince Hill	1951	G	b	35	8	10	10	$98,550	Princequillo-Hildene
Bold Experience	1962	M	ch	10	5	3	1	$94,477	Bold Ruler - First Flush
Hornbeam	1940	G	ch	74	21	19	7	$80,905	Whiskaway-Annie R
Spirit Level	1974	H	b	19	4	4	5	$79,958	Quadrangle-Due Dilly
Perils Of Pauline	1974	M	ch	10	5	2	1	$75,335	Silent Screen-Hasty Landing
Virginia Delegate	1966	G	b	68	61	3	15	$75,320	Bold Ruler - First Flush
Cicada's Pride	1966	H	b	77	8	8	6	$75,155	Sir Gaylord-Cicada
Lefty	1972	H	ch	22	4	3	5	$71,621	Prince John-Kushka
Copper Canyon	1965	M	ch	40	7	80	6	$66,462	Bryan G - First Flush
Hasty Matelda	1961	M	dk.b/br	10	1	2	3	$63,596	Hasty Road-Matelda
Speedwell	1960	M	b.	33	6	5	5	$56,000	Bold Ruler-Imperatrice
Ross Sea	1958	H	ch	54	4	12	9	$48,641	Bryan-First Flush
Yemen	1955	H	ch	49	8	2	8	$39,172	Caruso-Imperatrice
Potomac	1965	H	ch	15	3	2	0	$37,361	First Landing-Iberia
Cartagena	1955	G	ch	50	4	0	0	$34,721	Nordlicht-Pomparray
Salt Lake	1957	M	b	17	2	2	6	$29,617	Hill Prince-Yarmouth
Cherrydale	1939	M	ch	79	17	10	6	$28,787	Whiskaway-Annie R
Anthemion	1940	M	ch	27	8	3	4	$23,000	Pompey-Sicklefeather
Imperial Hill	1956	M	b	11	2	0	2	$13,695	Hill Prince-Imperatrice
Total of Meadow Stable's Stakes Winners				**1543**	**367**	**250**	**213**	**$8,726,070**	

(1) Horse of Year, 1972, 1973; Triple Crown Champion, Hall of Fame
(2) Champion at 2, 4, Hall of Fame
(3) Champion at 2, 3, 4, Hall of Fame
(4) Champion at 2, Hall of Fame
(5) Horse of the Year, 1950; Champion at 2, 3, Hall of Fame
* M = mare; H = Stallion; G = Gelding
**ch = chestnut; b = bay; dk.b/br = dark bay or brown; gr = gray.

1875
$125,000 ADDED ONE MILE and Q

For three-year-olds. By subscription o
covers nomination for both The Kentuc
All nomination fees to Derby winner,
$1,500 additional to start. $125,000 a

USE THESE NUMBERS FOR BUYING

OWNER

1	Edwin Whittaker White, green triangle, white chevrons on white cap **ANGLE LIGHT** ⚐ B c, 3, Quadrangle—Pilot Light by Jet Action BRED IN KENTUCKY BY HOWARD B. NOONAM
1a	Meadow Stable (Mrs. John Tweedy) Blue, white blocks, white stripes on sle **SECRETARIAT** Ch c, 3, Bold Ruler—Somethingroyal by Prin BRED IN VIRGINIA BY MEADOW STUD, INC.
2	Joseph Kellman Green, white "K" and braces, green chev sleeves, white cap **SHECKY GREENE** B c, 3, Noholme 2nd—Lester's Pride by Mod BRED IN FLORIDA BY JOSEPH KELLMAN
2c	A. I. Appleton White, red apple and braces, red bars on sl **MY GALLANT** ⚐ Ch c, 3, Gallant Man—Predate by Nashua BRED IN KENTUCKY BY LESLIE COMBS II
3	Elkwood Farm (Margaret Jones, Betty B. Iselin, Norma H Deana Gross) White, red dots, blue sleeves, re **RESTLESS JET** B c, 3, Restless Wind—Sittin 'on Ready by In BRED IN FLORIDA BY MRS. M. E. TIPPETT
4	E. E. Elzemeyer Blue, green sleeves, blue cap **WARBUCKS** ⚐ Ch c, 3, Seaneen—What A Lark by T. V. Lark BRED IN KENTUCKY BY E. E. ELZEMEYER
5	Sigmund Sommer Green, gold diamond belt, gold sleeve **SHAM** ⚐ B c, 3, Pretense—Sequoia by Princequillo BRED IN KENTUCKY BY CLAIBORNE FARM
6	Joe Stevenson & Ray Stump J. O. Keefer 30 Blue, red hoops, white bars on sleeves, red cap **NAVAJO** 126 WESTON SOIREZ Gr c, 3, Grey Dawn 2nd—Doublene by Double Jay (P. P. 5) BRED IN INDIANA BY JOE STEVENSON & RAY STUMP

Churchill Downs
KENTUCKY DERBY
1875 · 1973
25¢